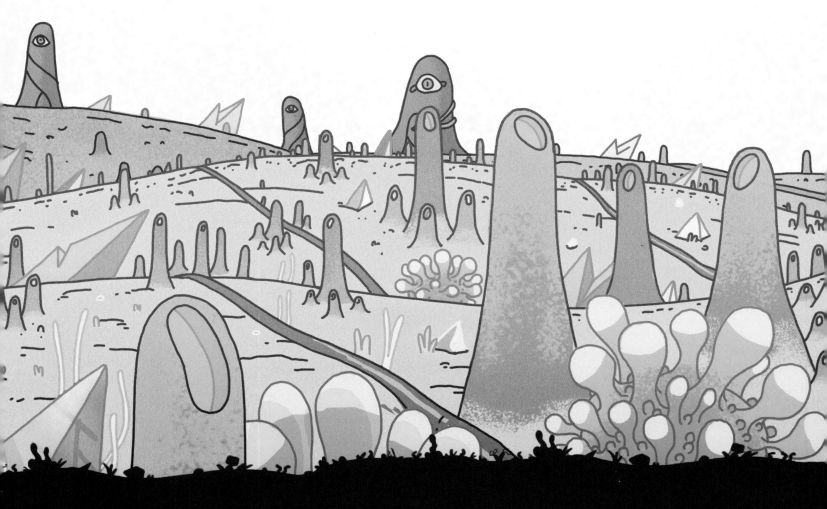

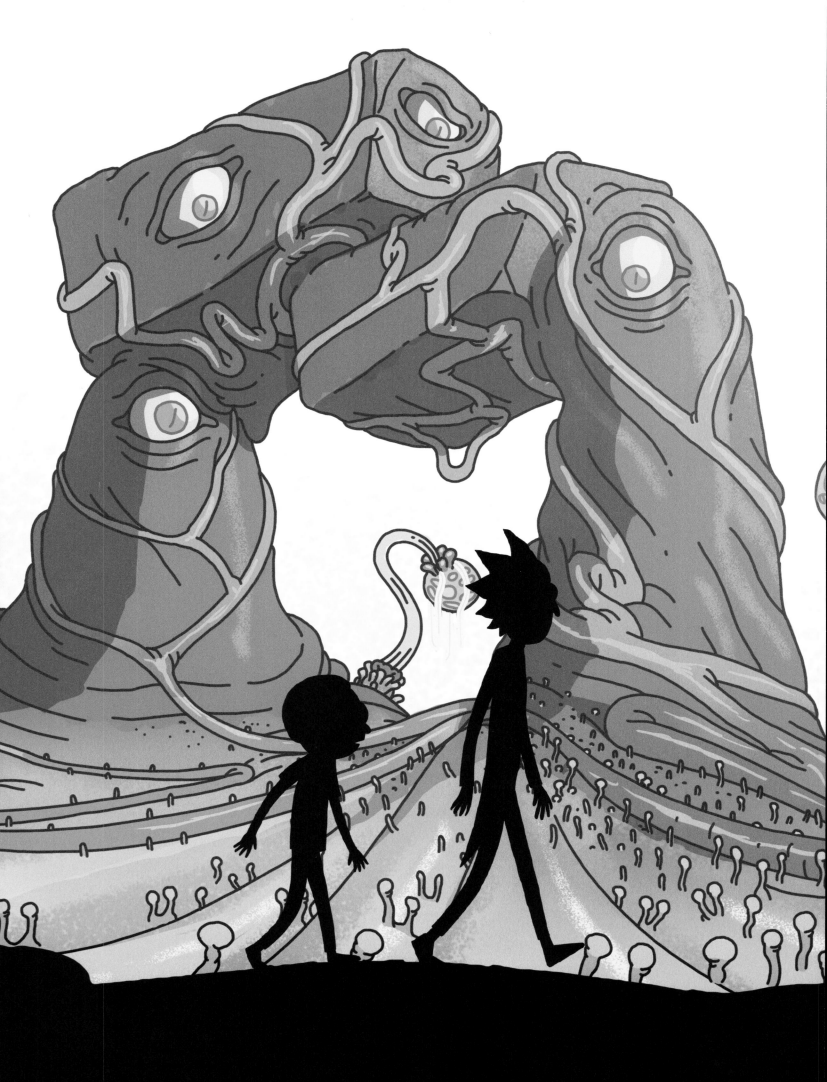

the ART of Rick and Morty™

Written by
James Siciliano

Foreword by
Justin Roiland

DARK HORSE BOOKS

President & Publisher
Mike Richardson

Editor
Ian Tucker

Assistant Editors
Roxy Polk & Megan Walker

Designer
Rick DeLucco

Digital Art Technician
Melissa Martin

Special thanks to:

Nick McWhorter at Dark Horse Comics and Marisa Marionakis at Cartoon Network. Also, (BURP) extra thanks again and-and a good job congratulations to Melissa Martin. You did a real good job, bro! It's-it's like a you're a *Rick and Morty* digital art machine, just-just crankin' away up there in a dusty-uh-crappy old office! Just crankin' on the old *Rick and Morty* digital (URRRP) art there, bro!

THE ART OF RICK AND MORTY

Rick and Morty and all related characters and elements are trademarks of and © 2013, 2017 Cartoon Network. All rights reserved. Dark Horse Books® and the Dark Horse logo are registered trademarks of Dark Horse Comics, Inc. All rights reserved. No portion of this publication may be reproduced or transmitted, in any form or by any means, without the express written permission of Dark Horse Comics, Inc. Names, characters, places, and incidents featured in this publication either are the product of the author's imagination or are used fictitiously. Any resemblance to actual persons (living or dead), events, institutions, or locales, without satiric intent, is coincidental.

Published by Dark Horse Books
A division of Dark Horse Comics, Inc.
10956 SE Main Street
Milwaukie, OR 97222

DarkHorse.com

To find a comics shop in your area, call the Comic Shop Locator Service toll-free at (888) 266-4226.
International Licensing: (503) 905-2377

Library of Congress Control Number: 2017934805

First edition: September 2017
ISBN 978-1-50670-269-8

10 9 8 7 6 5
Printed in the United States of America

Neil Hankerson Executive Vice President • Tom Weddle Chief Financial Officer • Randy Stradley Vice President of Publishing • Matt Parkinson Vice President of Marketing • David Scroggy Vice President of Product Development • Dale LaFountain Vice President of Information Technology • Cara Niece Vice President of Production and Scheduling • Nick McWhorter Vice President of Media Licensing • Mark Bernardi Vice President of Book Trade and Digital Sales • Ken Lizzi General Counsel • Dave Marshall Editor in Chief • Davey Estrada Editorial Director • Scott Allie Executive Senior Editor • Chris Warner Senior Books Editor • Cary Grazzini Director of Specialty Projects • Lia Ribacchi Art Director • Vanessa Todd Director of Print Purchasing • Matt Dryer Director of Digital Art and Prepress • Sarah Robertson Director of Product Sales • Michael Gombos Director of International Publishing and Licensing

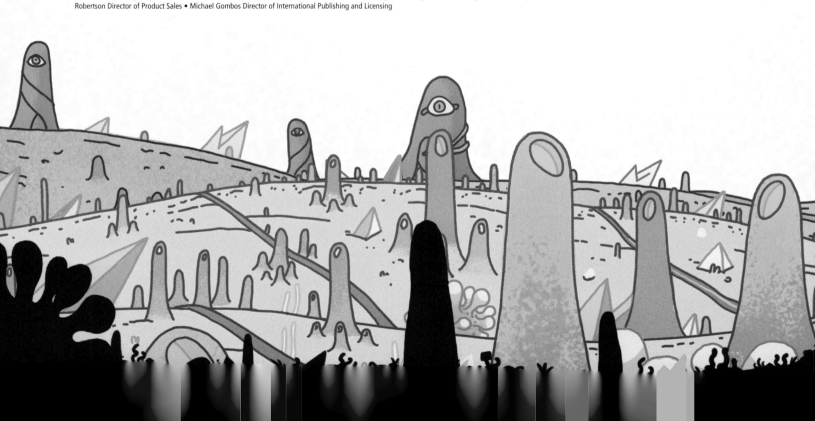

Contents

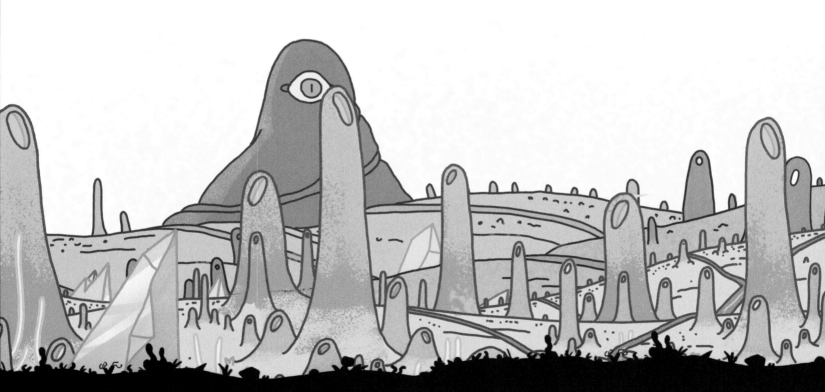

Look At *THIS* Foreword
by Justin Roiland

So you bought an art book today. Or you are just looking at one and you haven't purchased it. Or you bought it online and it just arrived. Or it's your friend's and you're just checking it out. Or you stole it. Or you're in a waiting room and it was on a table or something and you picked it up. In all these cases, one thing remains a constant. You're holding a book in your hands and you're reading this part of the book right now.

This is the foreword of the book. You're reading it right now. Pretty soon you won't be reading it anymore. You may never read it again. You will continue about your life. Grow old. Find love. Lose love. Find love again. Maybe have kids. Maybe not. Eventually the time will come where your body will give out on you. Your remaining years will be spent in pain and on lots of pharmaceuticals. Your loved ones may or may not be there for you during this time. You may be alone. It's possible you may even have outlived everyone you ever knew. Congratulations if you managed to pull that off. You lived the longest. But after some time your body will shut down and you will leave this world for good. This will happen later on.

Right now you're still hanging out somewhere holding this book and reading this incredible foreword that I wrote. What a foreword. Are there awards for book forewords? If so, I think I should be nominated and I think the awards should be called "The Forewordys" because isn't that the standard bit? Just take a thing and add a "ys" at the end of it? For example, an award show for murderers would be called "The Murdererys."

Anyway. I guess I should talk about the contents of this book a little bit. So you're holding an art book for *Rick and Morty* in your unwashed, germ-covered hands. Our season 3 writers' assistant busted his ass along with the team over at Dark Horse to sift through a ton of art and stuff. We really put a lot in here. If you haven't bailed on reading this foreword already, you'll be finished soon and then you'll be able to look at all the incredible art that our super talented team has tossed together over the first two seasons. Lots of great stuff in this here book. Seriously. The show wouldn't look as amazing as it does without the crazy awesome skills of all our artists.

The worst part of this book, you might be asking? This foreword. This foreword is the worst part. You probably thought it was gonna be filled with funny words like "gloopies" or "shloomy shleebs." Maybe you even thought I'd invent a wacky character. Something like Milg Choglit: a man made from chocolate. He could be a newscaster that interviews celebrities or something. Maybe he has a show called Movies Tonight with Milg Choglit. I don't know. He's not in here. There's no Milg Choglit. It's just a terrible, pointless foreword. But enjoy your time with it. You might not read it again. Or maybe you'll read it to your kids. Or maybe you're not even a human but actually you're a robot or a demon or an alien or something. If that's the case, then . . . Wooop-t-dooo. Good for you, edgelord. JK.

One last thing I'd like to say, since this foreword will outlive me. If you managed to finish this whole bullshit thing, I am going to come haunt you when I'm dead. Get ready for some hardcore ghosting. I'm coming for you. Get your WEEGIE board out.

Thanks. Talk 2 u late.

Justin Roiland

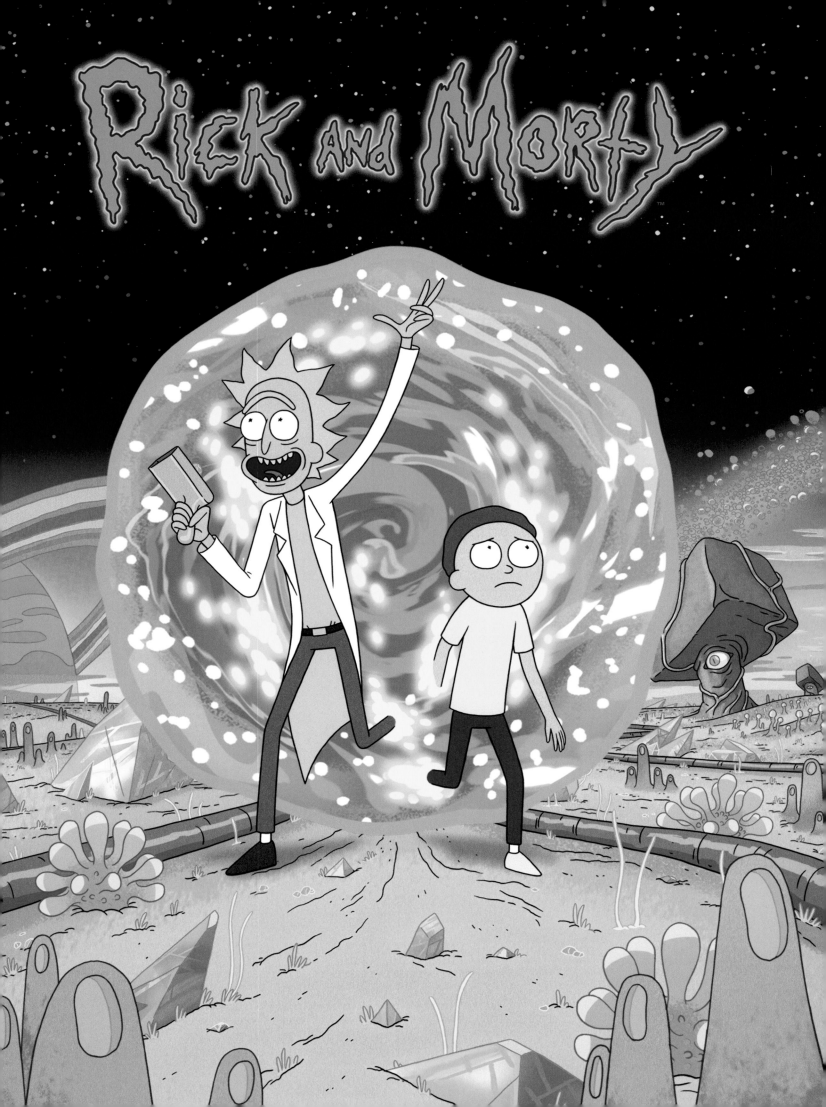

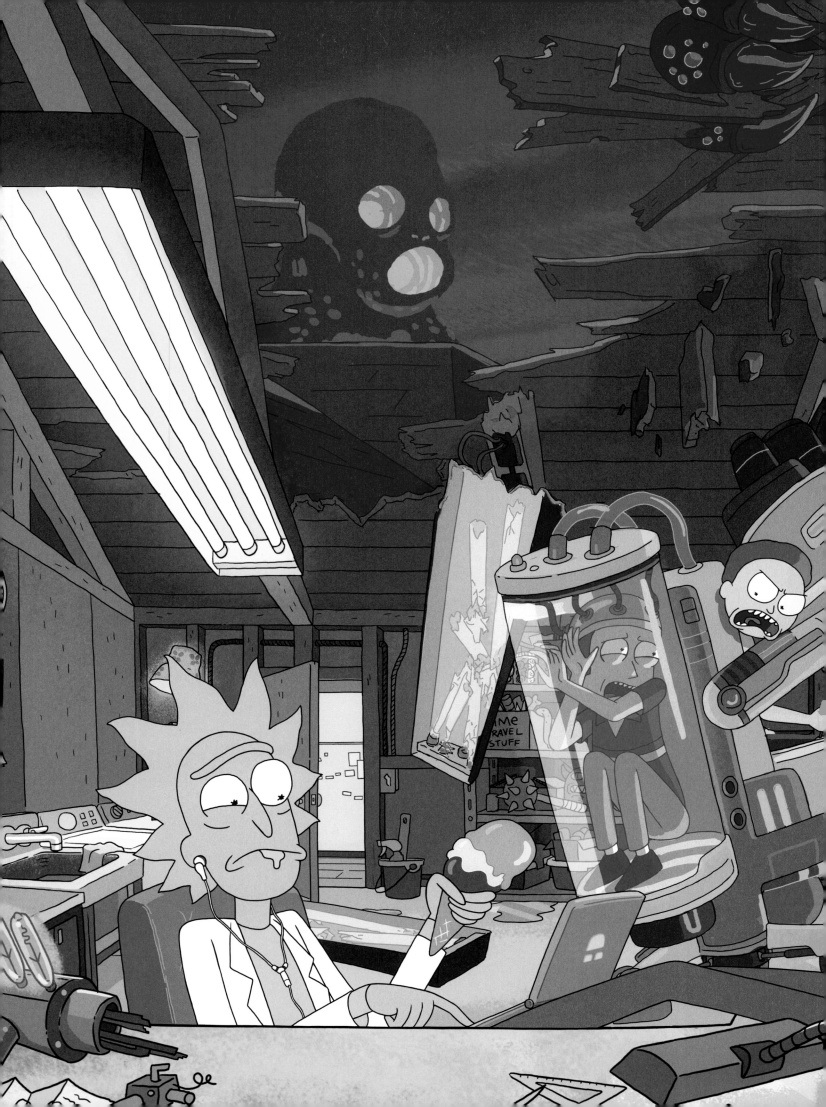

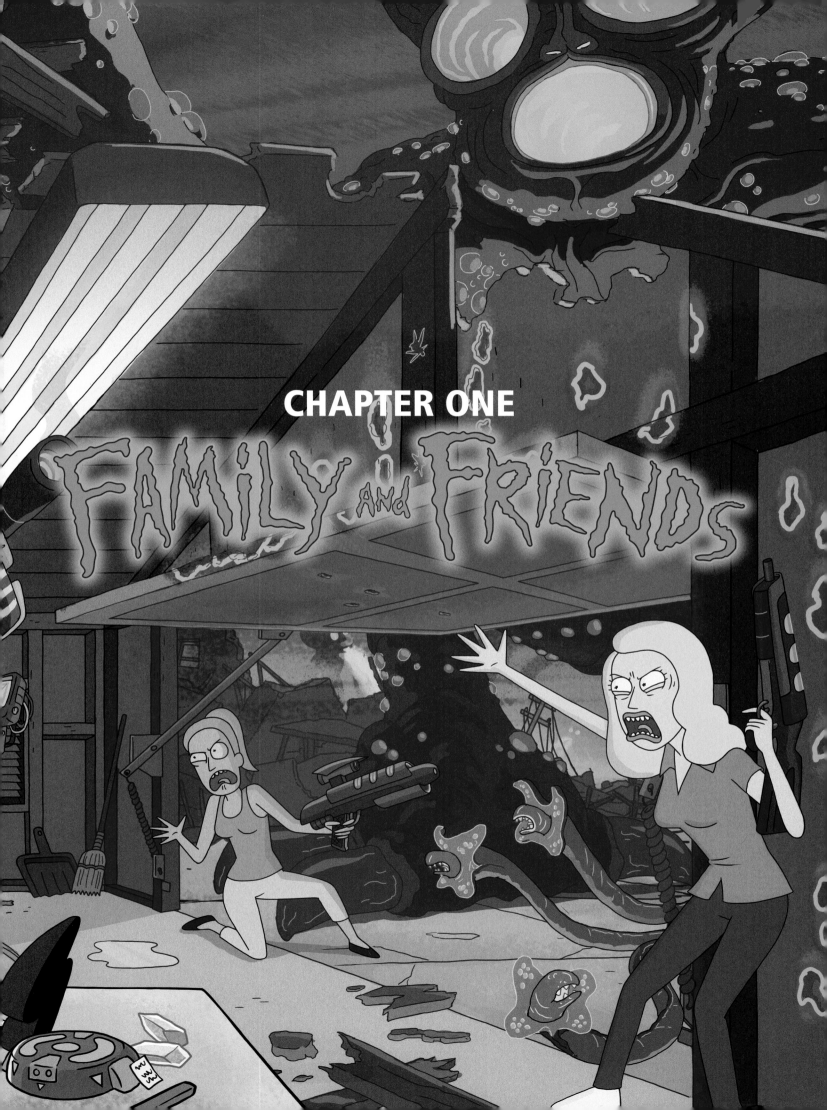

Rick

"Wubbalubbadubdub! It's a *Rick and Morty* art book! Got my own *Rick and Mo*(BURP)*rty* art book, son! Gonna take you- gonna go behind the scenes, gonna see some realllll cool shit, Morty. Stuff no one has seen from seasons 1 and 2. We're lifting back the curtains, Morty, people's minds might explode but that's not our problem. They need to see. Are you listening, Morty? We got our own (BURP) art booooook!!"

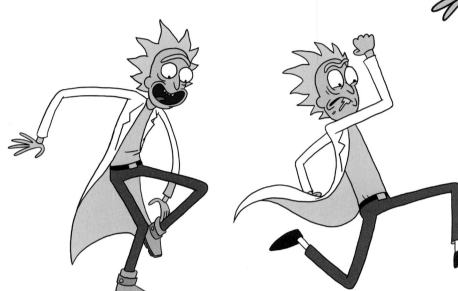

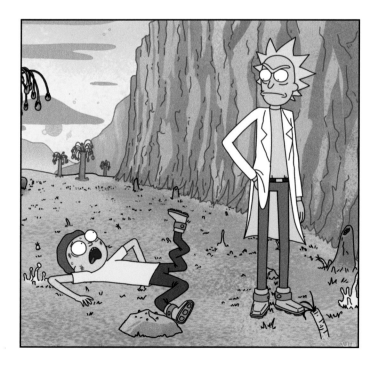

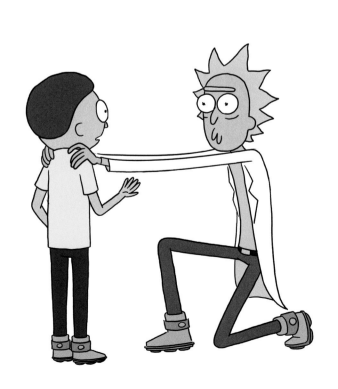

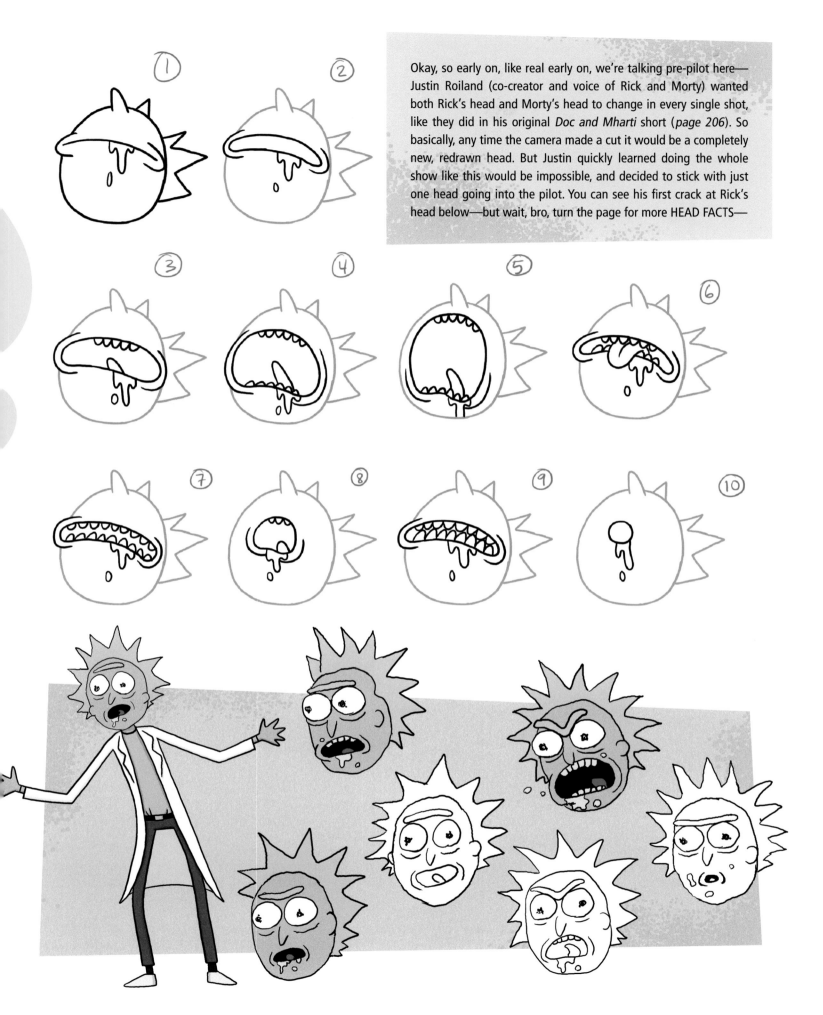

① ② ③ ④ ⑤ ⑥ ⑦ ⑧ ⑨ ⑩

Okay, so early on, like real early on, we're talking pre-pilot here—Justin Roiland (co-creator and voice of Rick and Morty) wanted both Rick's head and Morty's head to change in every single shot, like they did in his original *Doc and Mharti* short (*page 206*). So basically, any time the camera made a cut it would be a completely new, redrawn head. But Justin quickly learned doing the whole show like this would be impossible, and decided to stick with just one head going into the pilot. You can see his first crack at Rick's head below—but wait, bro, turn the page for more HEAD FACTS—

RICK HEAD GUIDE

DON'T !!

Ear sticks out too FAR. Oddly shaped.

HEAD is too ROUND AND SQUISHED. ODDLY SHAPED.

HAIR is too BIG Here.

Pupils too NORMAL.

Avoid thin, Straight Lined Noses!

NO = ∨ ∨ ∨ ∨ ∨| ∨|

DO !

12 hair points

HAIR should tAPER in And get SMALLeR AS it goes DOWN his heAD

head is pill shAPeD.

EAR is A hAlF circle

PAY close Attention to the NOSe shApe.

Yes: ∪ ∪ ∪ ∪ ∪ Front

Rick and Morty

"You see, Morty? This- t-t-t-this is what happens when you try to draw the head of a genius. Those bureaucratic sheep can't handle it, Morty! Their hands are too weak!" So we made the pilot with just one Rick head, right? But here's the thing, dawg. Inconsistencies kept popping up. So Justin whipped up this handy little guide to help the artists come up with a consistent look for Rick. One of the big pointers: making sure Rick's head is always pill shaped and Morty's head is always round—two shapes that are iconic for TV duos (like Bert and Ernie). Iconic!

Rick's Burps

The creators talked about Barney's burps in *The Simpsons* and wanted to stay away from that—the goal was to keep Rick's burps more casual, like he's got it (BURP) under control. Some of these drawings below are "don't do this."

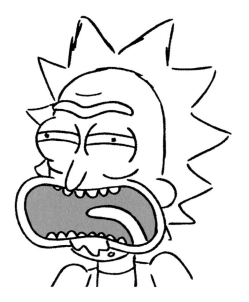

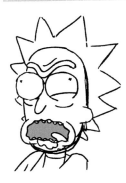

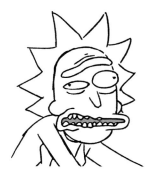

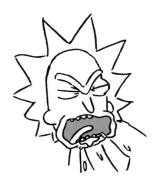

Rick's Unibrow

You know, people probably don't appreciate that unibrow—how it's beautifully centered over the eyes? This was one of those things that kept popping up in the beginning, so we made this guide for the artists. A classic YES-NO guide.

Draw them as two eyebrows

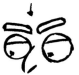

Then just connect them

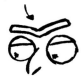

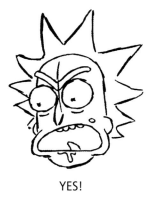

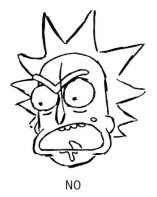

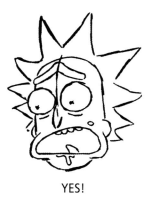

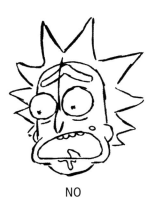

YES! NO YES! NO

Rick's Blinks

Another inconsistency from the pilot was blinks. Man, that pilot, bro! There were four different blinks used in there. So guess what? Going into the series, we decided to pick one and stick with it.

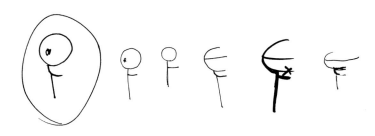

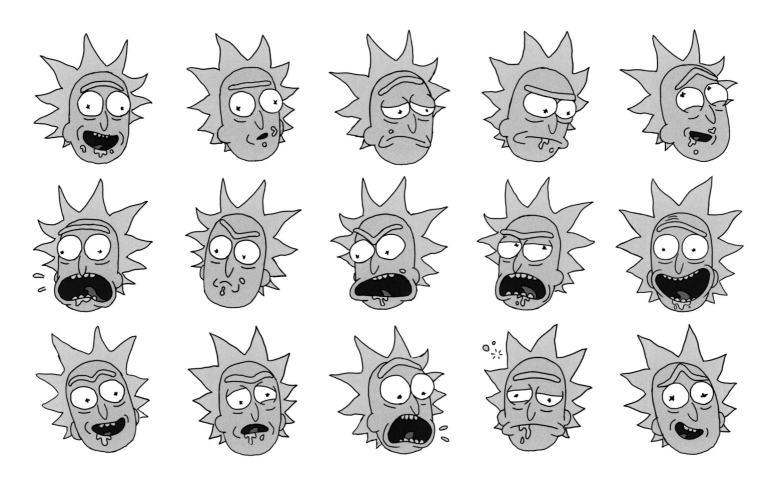

"Look at these- look at these classic Rick heads. Just take a moment to ponder them, Morty. Really soak it in. You know, y-y-you just don't see Rick heads like this anymore, Morty." These were all Justin's original drawings (*above*), before we even started animation on the pilot. And the right page—that's pretty cool because it shows the translation from storyboard panel (*left images*) to clean "key poses" (*right images*) for two scenes in the pilot. I know, you're wondering what "key poses" are. Well, keep reading!

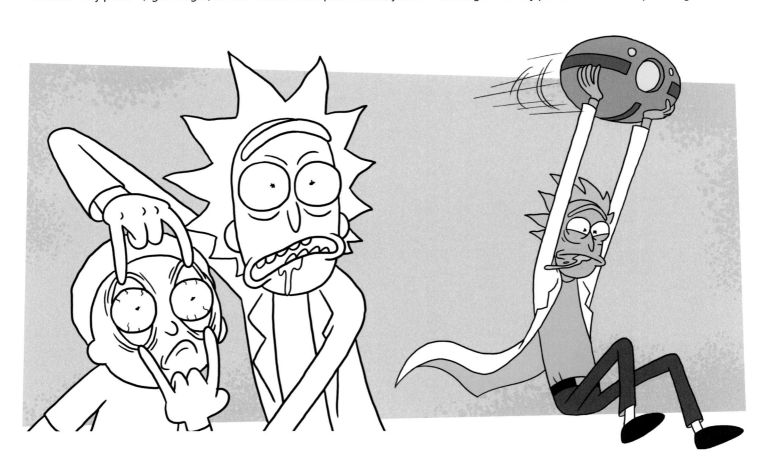

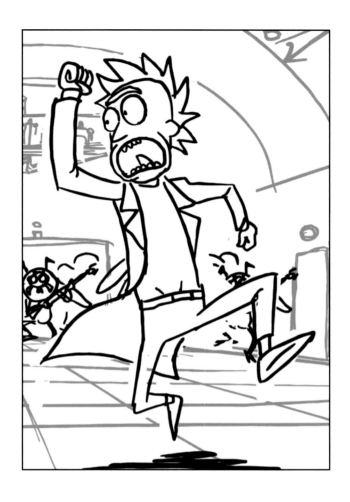

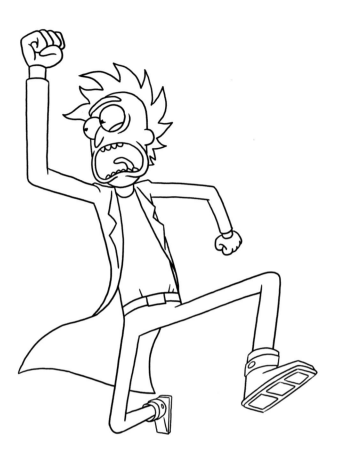

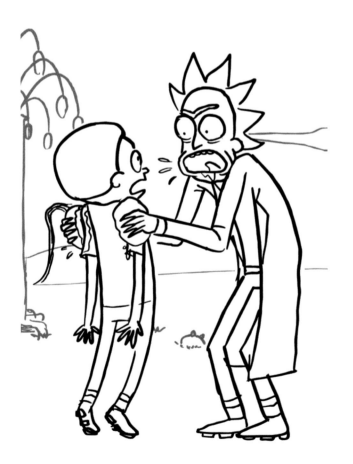

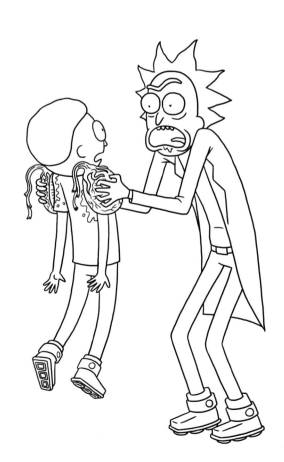

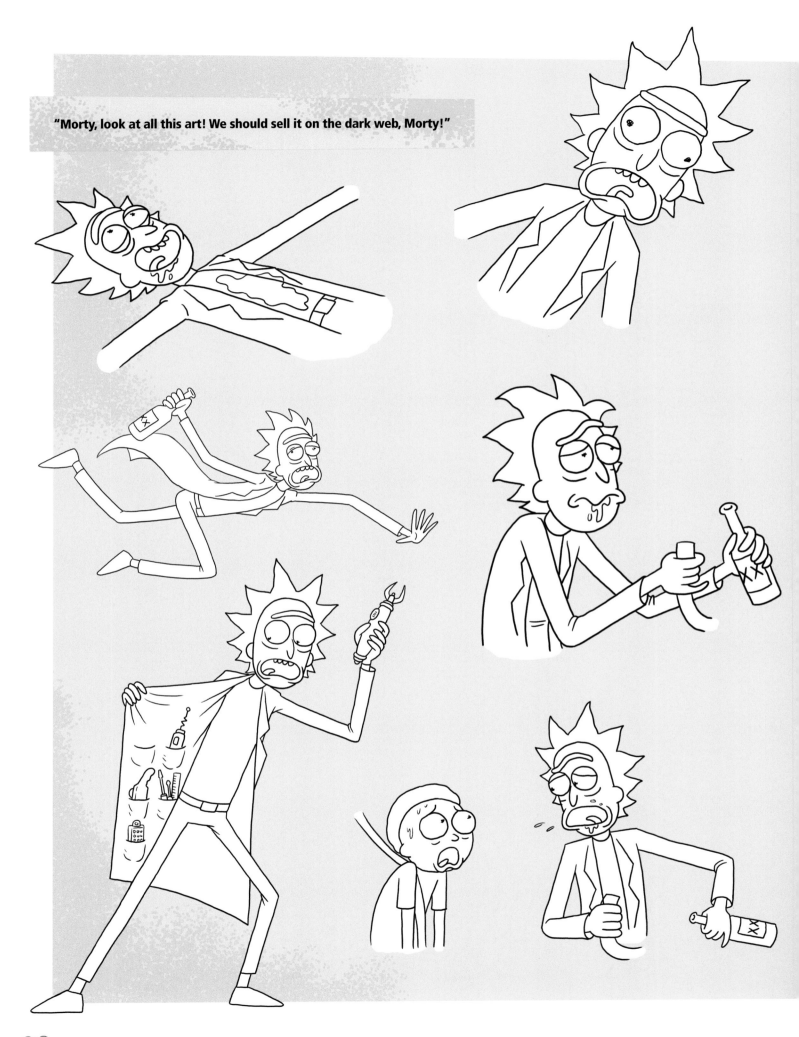

"Morty, look at all this art! We should sell it on the dark web, Morty!"

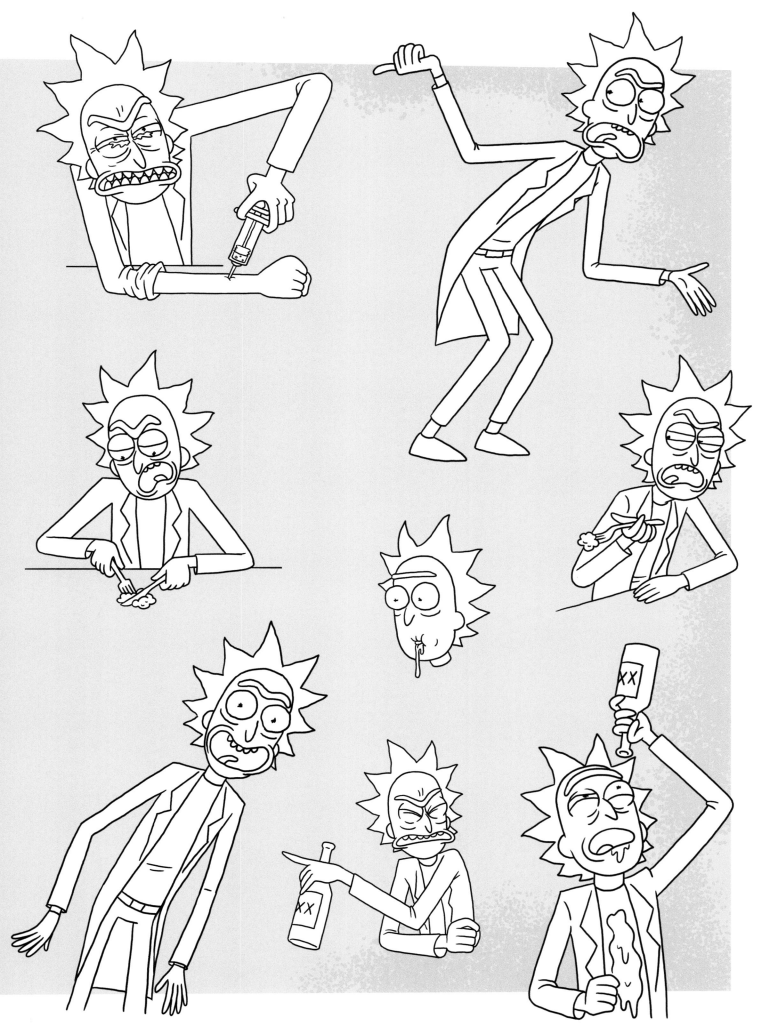

INTERDIMENSIONAL RICKS

"Ha! Check out- look at Doofus Rick down there. You know he eats his own shit, right? Oh my god, this is amazing. I have to tell the Ricks. Hey! Multiverse Ricks! Did- did you guys see this moron over here??"

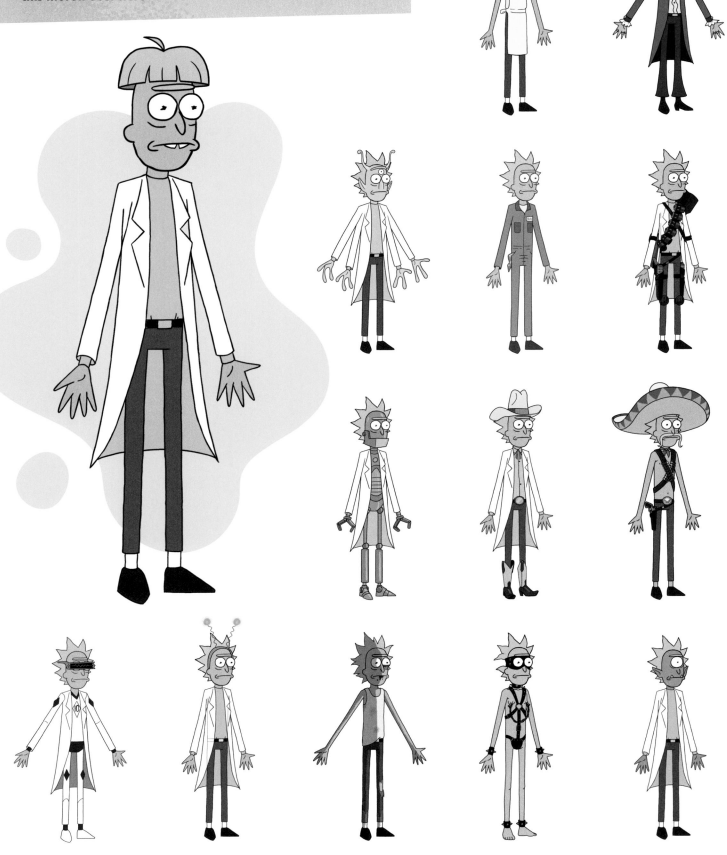

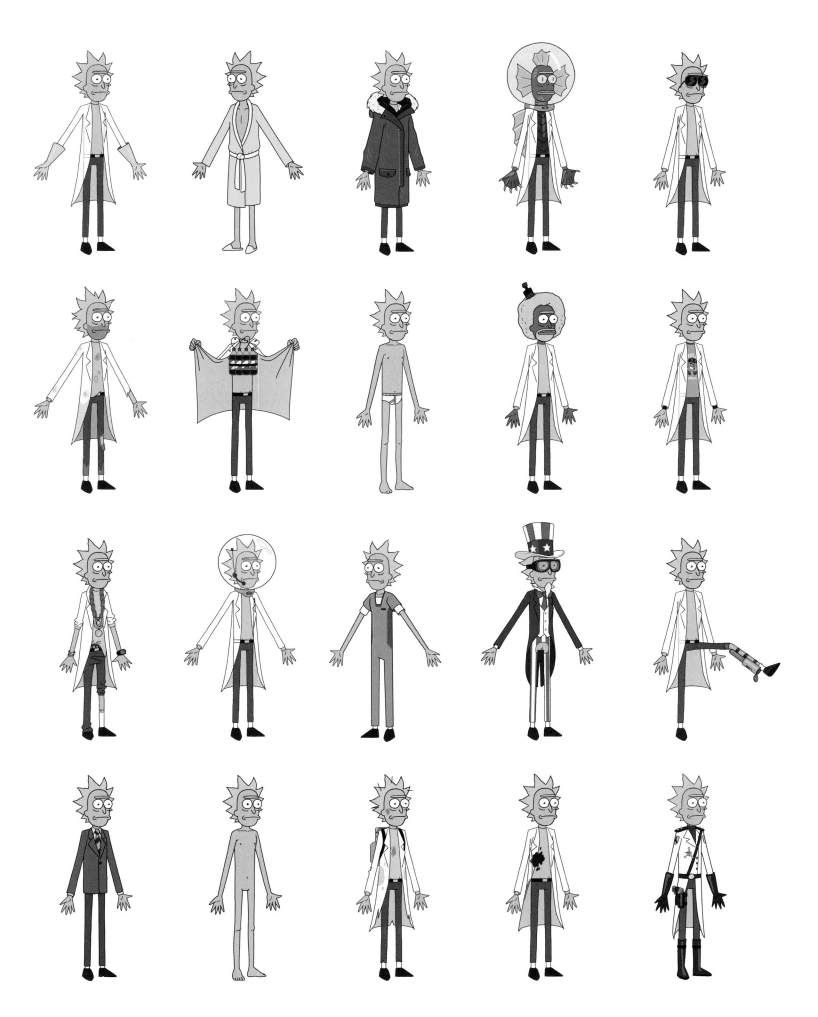

Tiny Rick

"Tiny Riiiick!! Just here to get embroiled in some youthful high jinks, what's the BFD??" Fun fact about that Tiny Rick drawing (*above*): Justin told the designers to make it look as shitty as possible. But he kept having to give it back, at least three times, saying it needed to look even shittier. The final result, he realized later, wound up looking just like the Rick from his original *Doc and Mharti* short. "Wubbylubbydoobdoob! Tiny Rick facts!!"

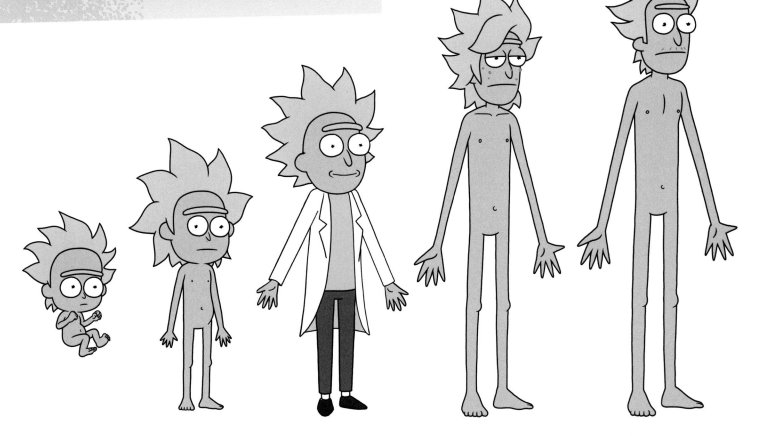

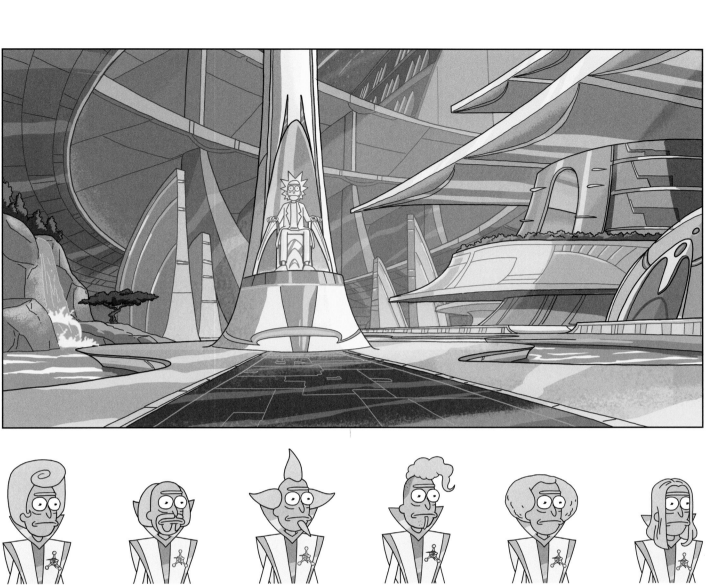

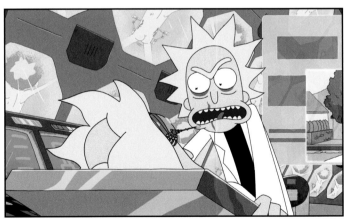

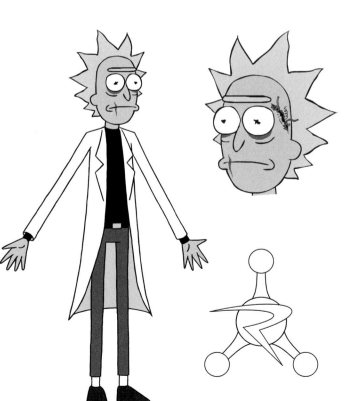

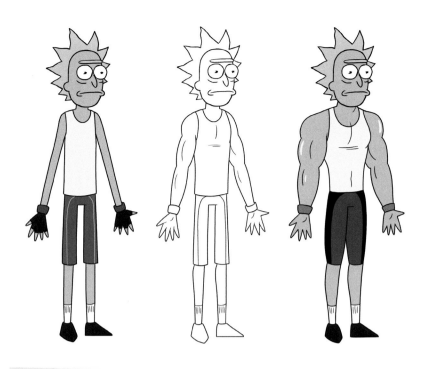

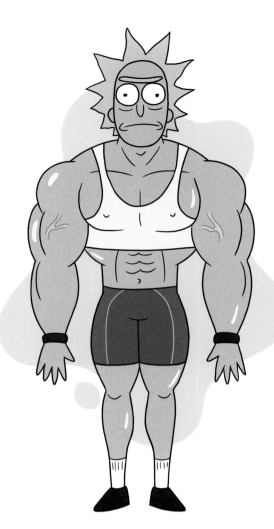

"We did it! (BURP) We- we totally worked it, we just pulled it off! (SPIT)" Check out the key frames in Rick's transformation into a 'roided-out bro (*above*) from "Something Ricked This Way Comes." And then below, you got a little time collar action from "A Rickle in Time." Oh, and go-go Sanchez ski shoes from "The Ricks Must Be Crazy." "Morty! Hop on my back!"

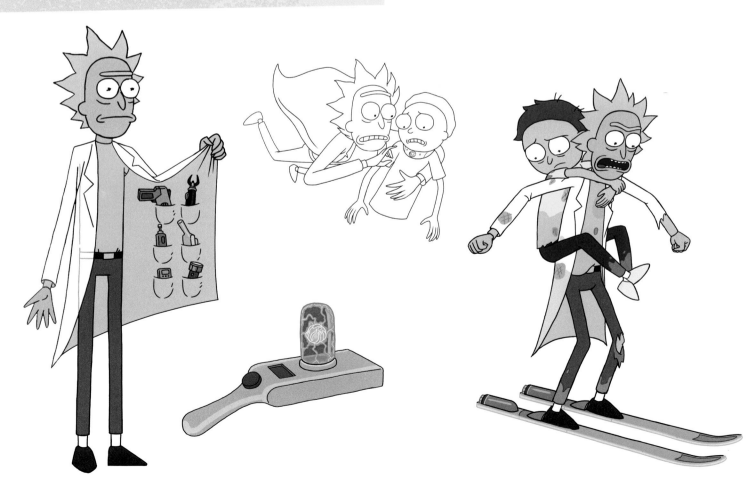

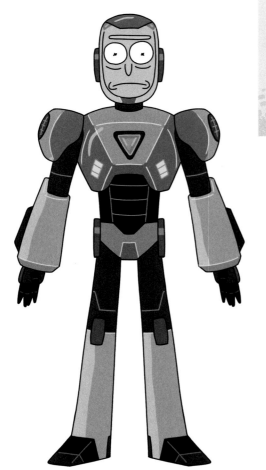

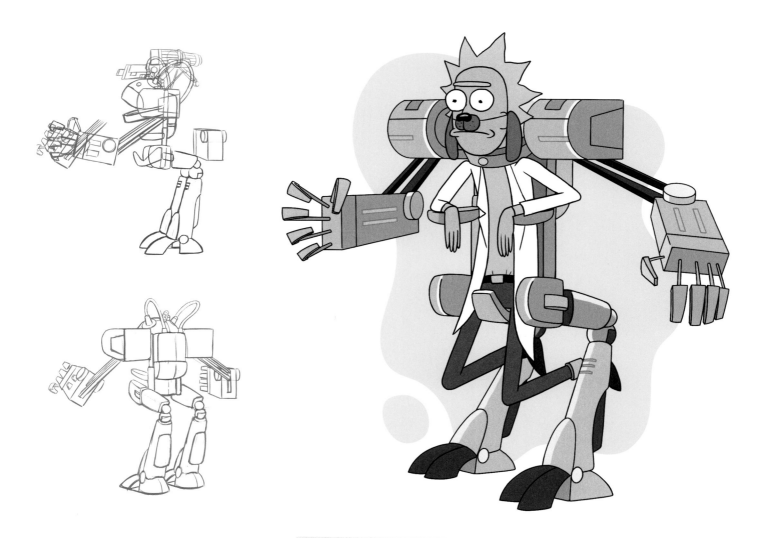

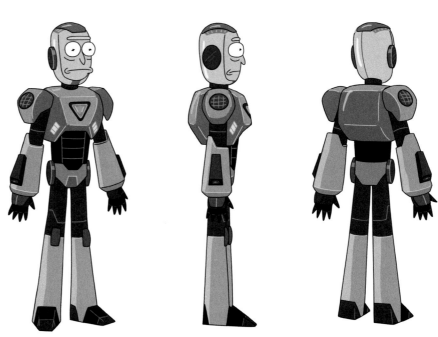

We got two pretty cool mech suits here. That's Rick doing what the artists call a "turn" in his Purge suit (*below*)—it shows the front, side, and three-quarter poses. And up top, that's just Rick blending in with the dogs in "Lawnmower Dog"—you know, after Emperor Snowball took over the world? Crazy fact: "Lawnmower Dog" was actually the first script written for the show after the pilot.

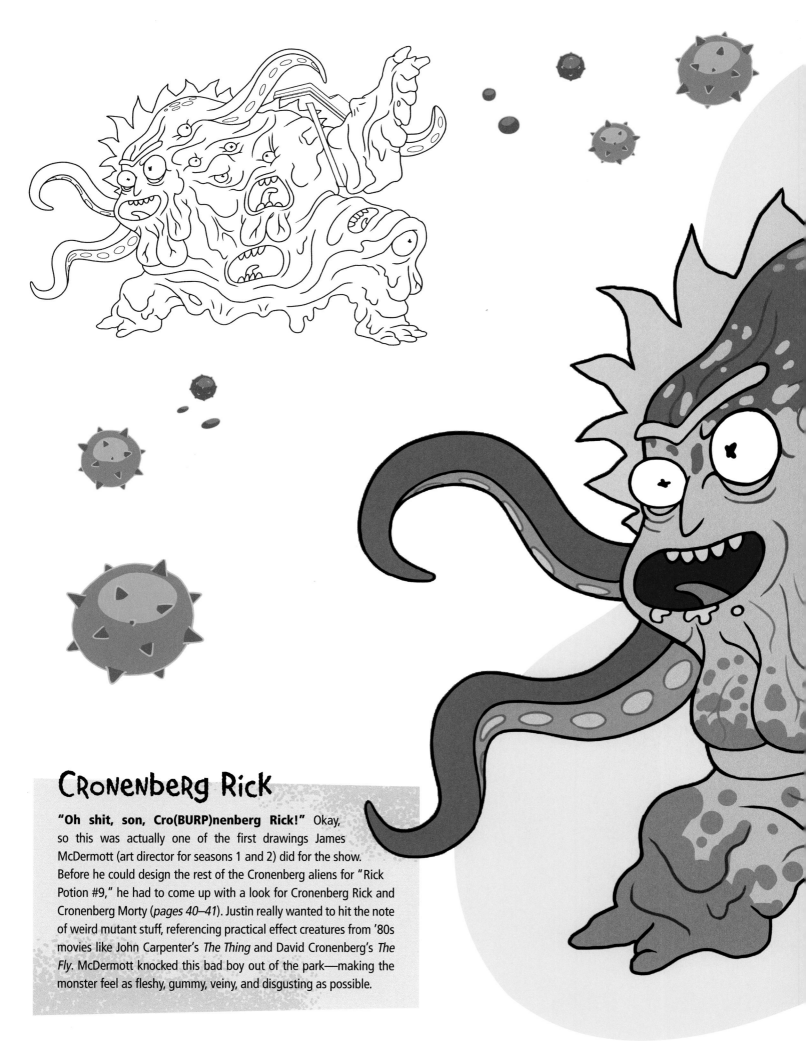

CRONENBERG RICK

"Oh shit, son, Cro(BURP)nenberg Rick!" Okay, so this was actually one of the first drawings James McDermott (art director for seasons 1 and 2) did for the show. Before he could design the rest of the Cronenberg aliens for "Rick Potion #9," he had to come up with a look for Cronenberg Rick and Cronenberg Morty (*pages 40–41*). Justin really wanted to hit the note of weird mutant stuff, referencing practical effect creatures from '80s movies like John Carpenter's *The Thing* and David Cronenberg's *The Fly*. McDermott knocked this bad boy out of the park—making the monster feel as fleshy, gummy, veiny, and disgusting as possible.

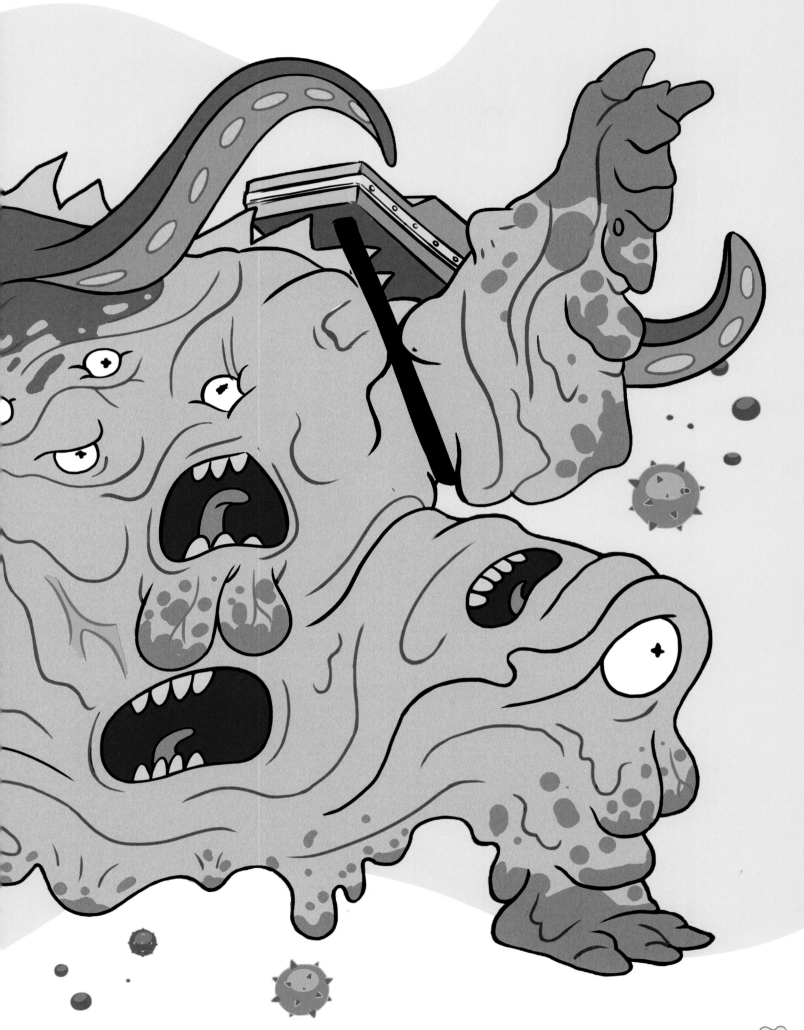

MoRty

"Aw, man, I-I-I hope people don't think this book sucks. I mean, I didn't even show up until page 26. T-that can't-what's the deal with that, Rick? That can't be a good sign, that's definitely not good. I mean, it's my art too, I-I-I had to bury my own dead body in the backyard and I didn't even show up until page 26?? What the hell, man, you know, that- that- that's some real messed up shit."

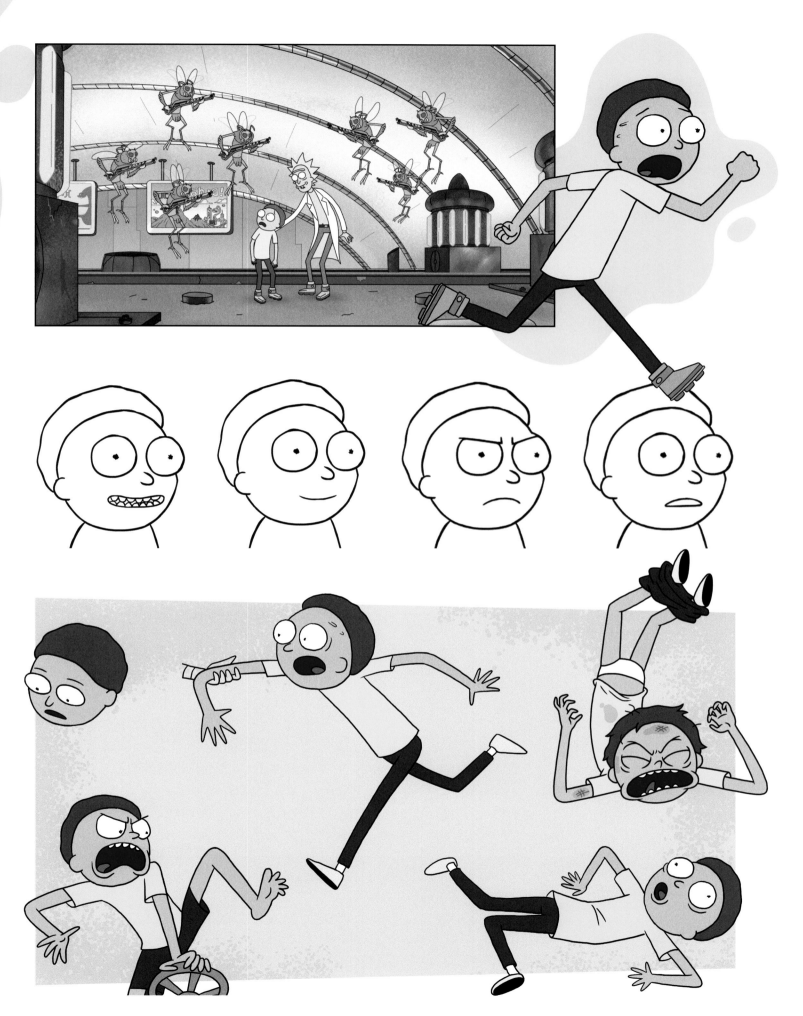

MORty Body Guide !

torso should Be PARAllel,
or EQUAl Distance

DonT DRAw his torso Like
this →

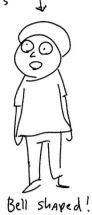

Bell shaped!
NO!

Muscle MAN
SHAPed! NOoo!

NO EXtreMe
Bell shaped
shirts.

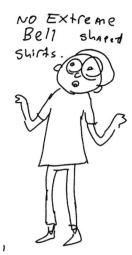

Butt. should Be
FlAT coming out of
Shirt.

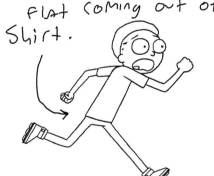

WHeN NOT A Profile
DonT DRAw Butt Like this...

NOoo!

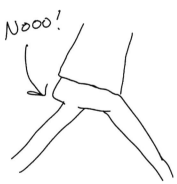

← TRY NOT TO SHOW ANY KNUCKLES

← FINGERS SMALL, LIKE HANDS OF AN 8-YEAR OLD GIRL

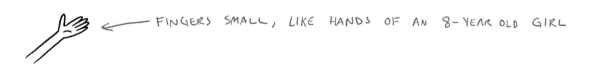

"Wow, Rick, look at my big ol' butt in that drawing! I mean, it-it's like I pooped my pants or something. That's- I mean, that's not cool." Super early in production, we were still trying to lock down Morty's look. Which resulted in shots of Morty like this—with his shirt all belled out, or his ass all huge. Justin drew this bad boy so that everyone on the show had a master body guide. You know, to make sure Morty's hands always looked like an eight-year-old girl's.

MORTY'S HEAD DO's DON'Ts

"Whoa! You know, I-I-I-I-I didn't even think about all this stuff, Rick. I mean, who knew. Who knew all this crazy- crazy head stuff??" As you can see here, two of the most common inconsistencies when drawing Morty were the nose and hair. Justin's basic rules, just so you know: always make Morty's nose horseshoe shaped and pointed down, and don't let that hair go below the ear, bro!

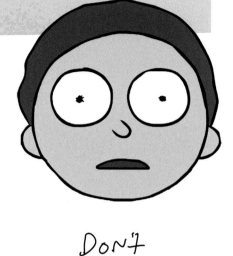

DO
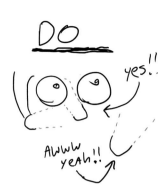
yes!!

AWWW yeAh!!

DON'T !
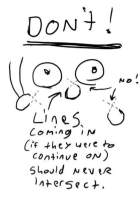
NO!

Lines coming in (if they were to continue on) should NEVER intersect.

NOSE
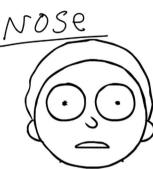

DO
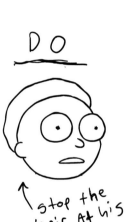
stop the hair At his EAR.

DON'T
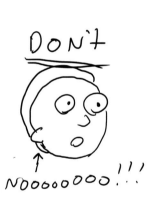
NOoooooooo!!!

DO
$\cup = U$

Draw his nose more As A horse shoe, or "U".

DON'T

Not Like A thumb, or flAt on one side.

DO
point his Nose DOWN, or More DOWN than up.

DON't
point that NOSE up!
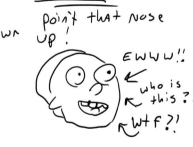
EWWW!! who is this?! WtF?!

DO
give enough "MeAt" under his Mouth.
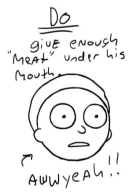
AWWyeAh!!

DON't
Lose his chin DAWg.
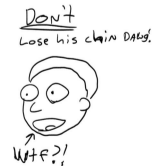
Wtf?!

DO
plAce NOSE closer to the ForwArd facing EYE. try to keep it Just under the EYES.
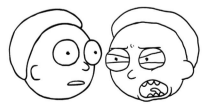

DON't
put his nose too Low, or too fAR BACK.
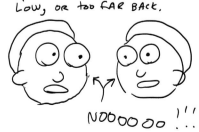
NOoooo oo!!!

the top of Morty's EAR stArts At the sAme hight As the Bottom of his EYE.
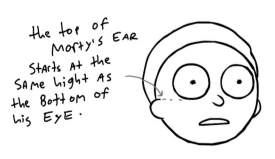

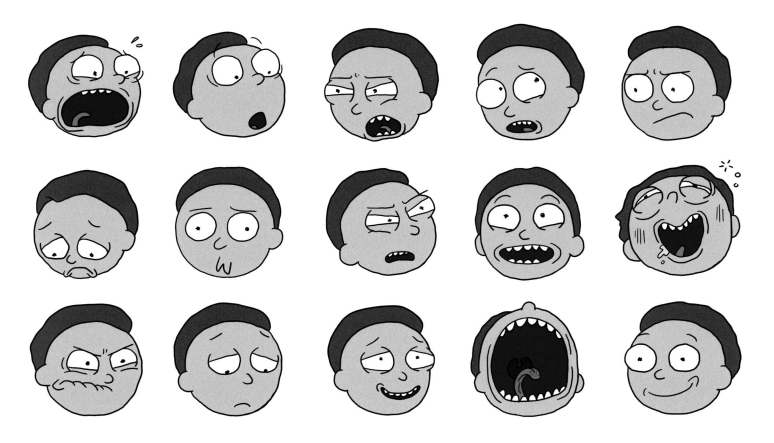

Up top is a suuuuuper early expression sheet for Morty, done by Justin and Myke Chilian. The rest of the art on these pages is pretty much all key poses for the pilot. Remember how we mentioned those earlier? The key poses? Well, those get taken and sent to Bardel—our kick-ass animation house. And the point of them is to basically show Bardel, "Hey, when you're animating this, these are the important poses, you know. These are on model—try to match 'em as best you can."

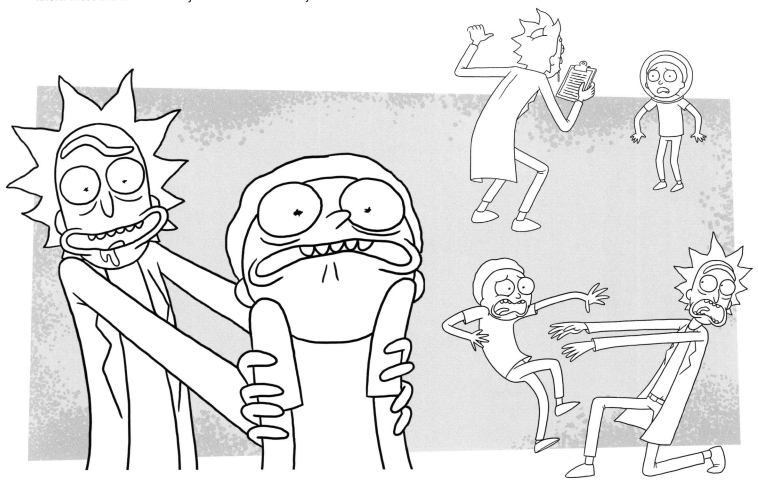

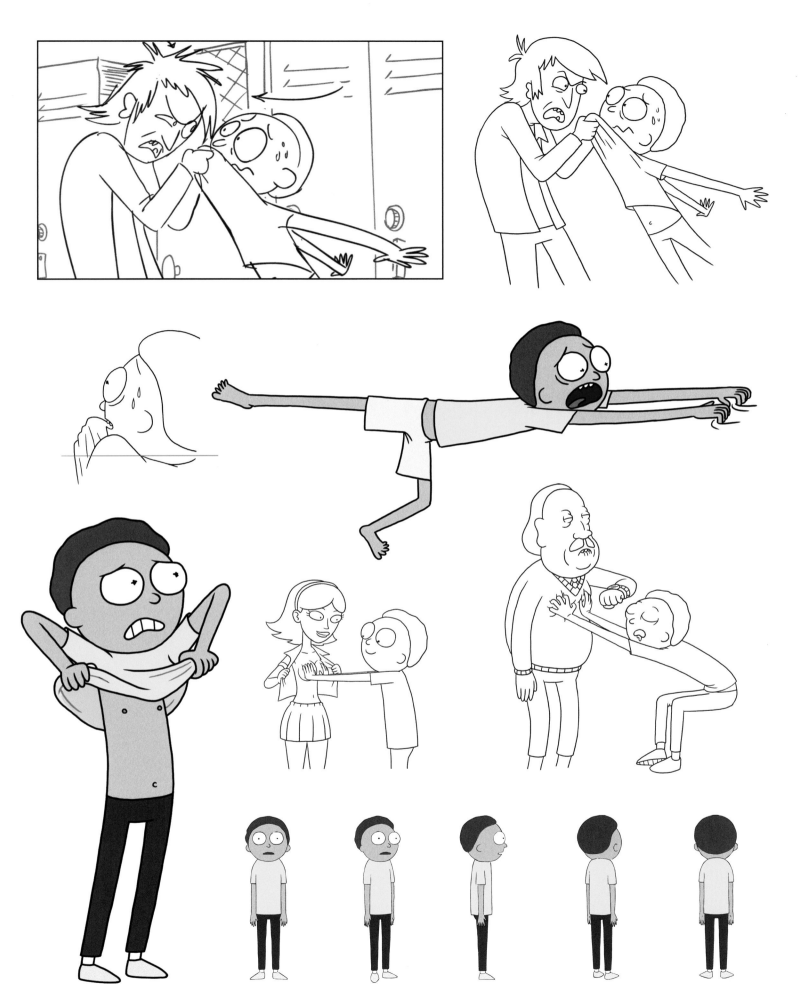

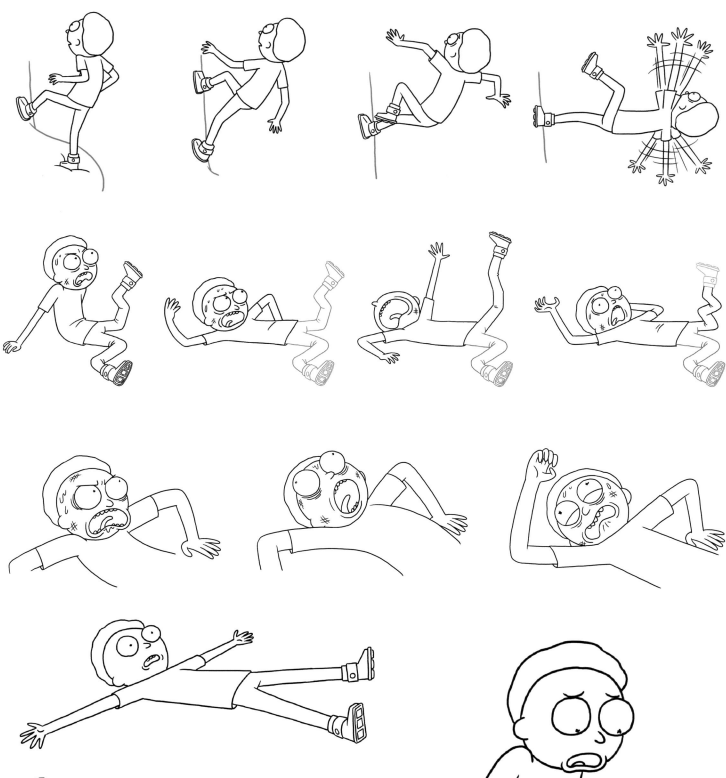

"Grappling Shoes" Scene

"Oh man, this- I mean, j-just classic Rick and Morty adventurin'. Just me and Rick, tack-tackling the galaxy, you know, getting megaseeds and stuff." This is another batch of cool key poses from the pilot, all from the grappling shoes scene—showing Bardel how messed up Morty's legs should look, and how to animate him screaming in pain. Pretty hardcore stuff, you know?

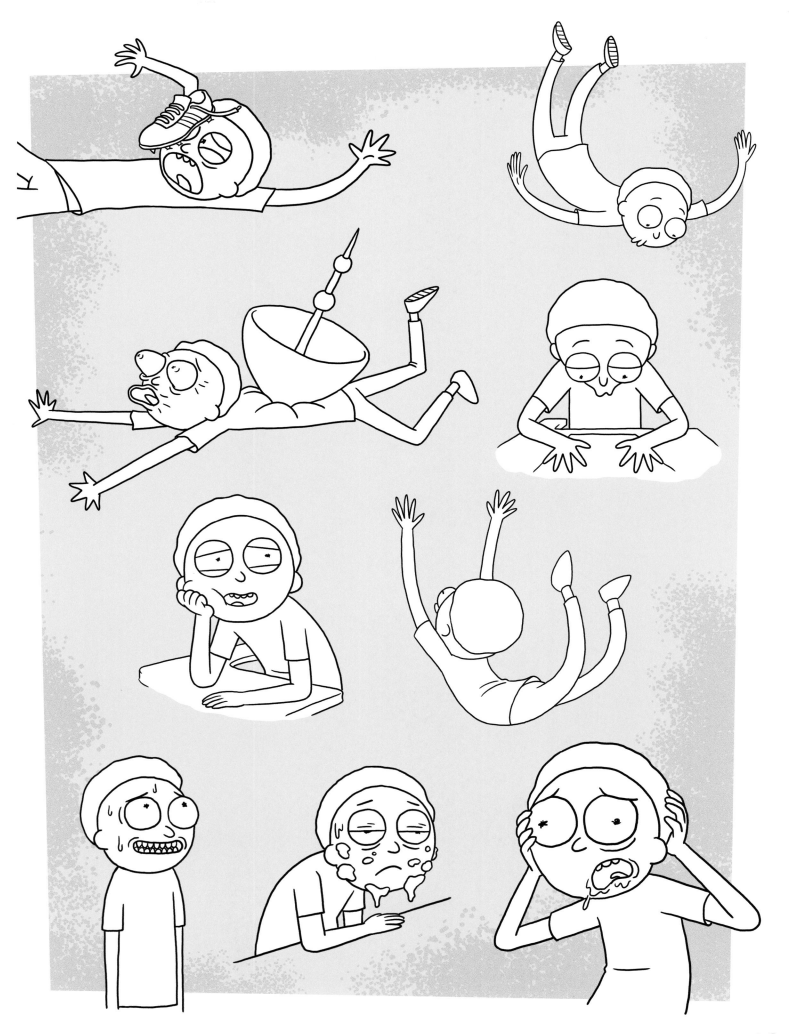

Interdimensional Mortys

"**Hey, what do you know, it's a cowboy version of me! And-and look, a fish monster version, a metal robot version, and-wait . . . is that Eric Stoltz *Mask* Morty?**" We all know there's an infinite number of Mortys across the central finite curve—but in the writers' room, a big favorite is Hammer Morty.

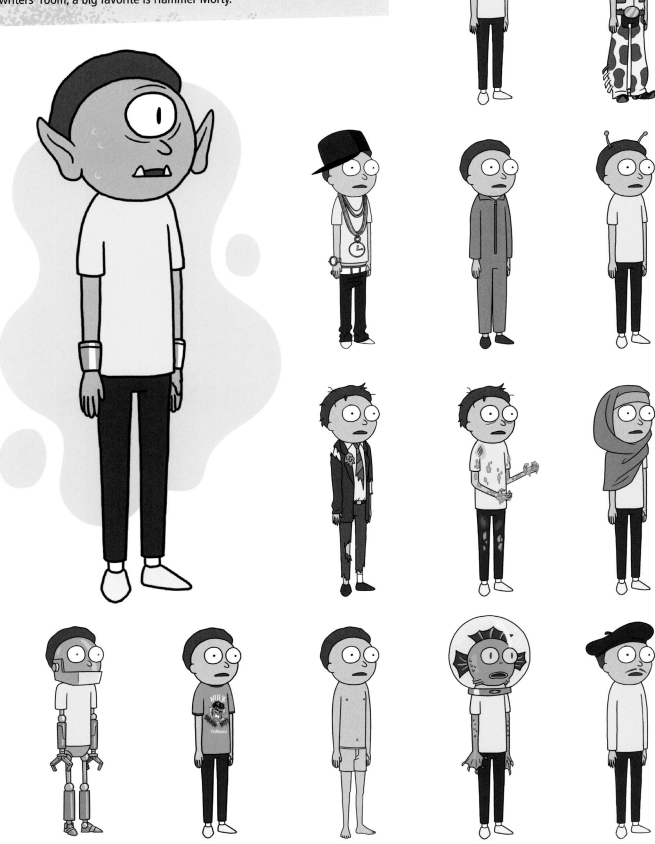

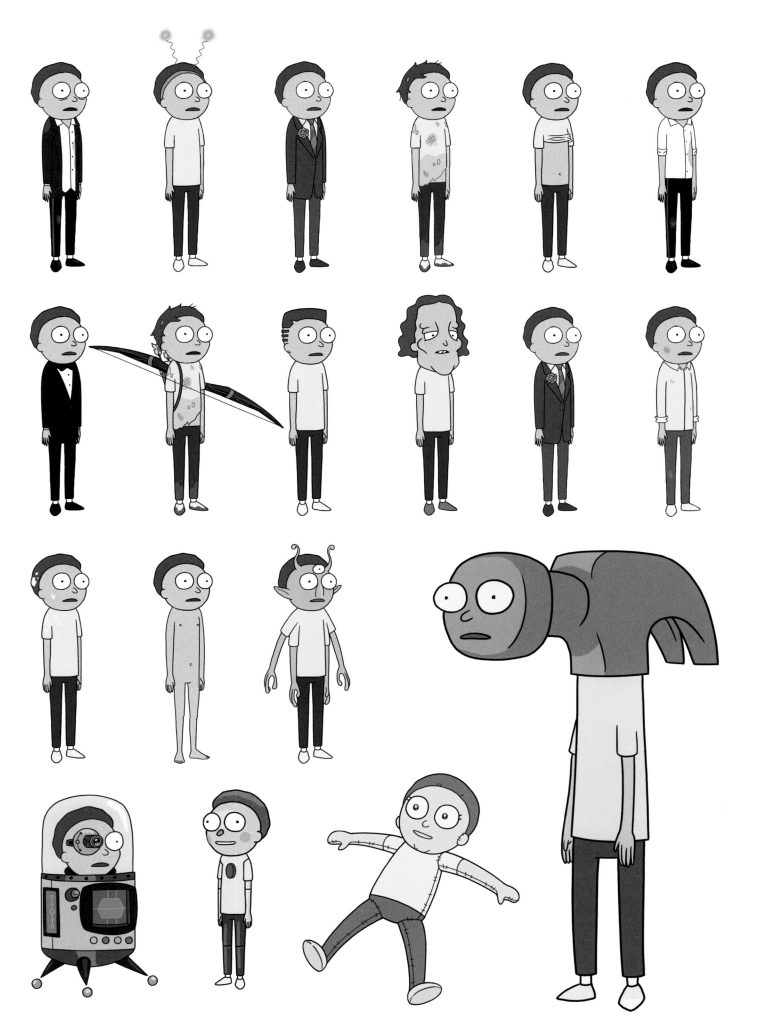

Evil Morty

On the writing side, the Citadel of Ricks episode was a huuuuge breakthrough for the show in terms of exploring the multiverse concept, as well as all the infinite Ricks and Mortys that could possibly be out there . . . including that psychopath, Evil Morty. The writers had dabbled with the concept in "Rick Potion #9," but this episode ("Close Rick-counters of the Rick Kind") really blew the lid off and opened up an insane amount of creative possibilities. "Praise the one true Morty!"

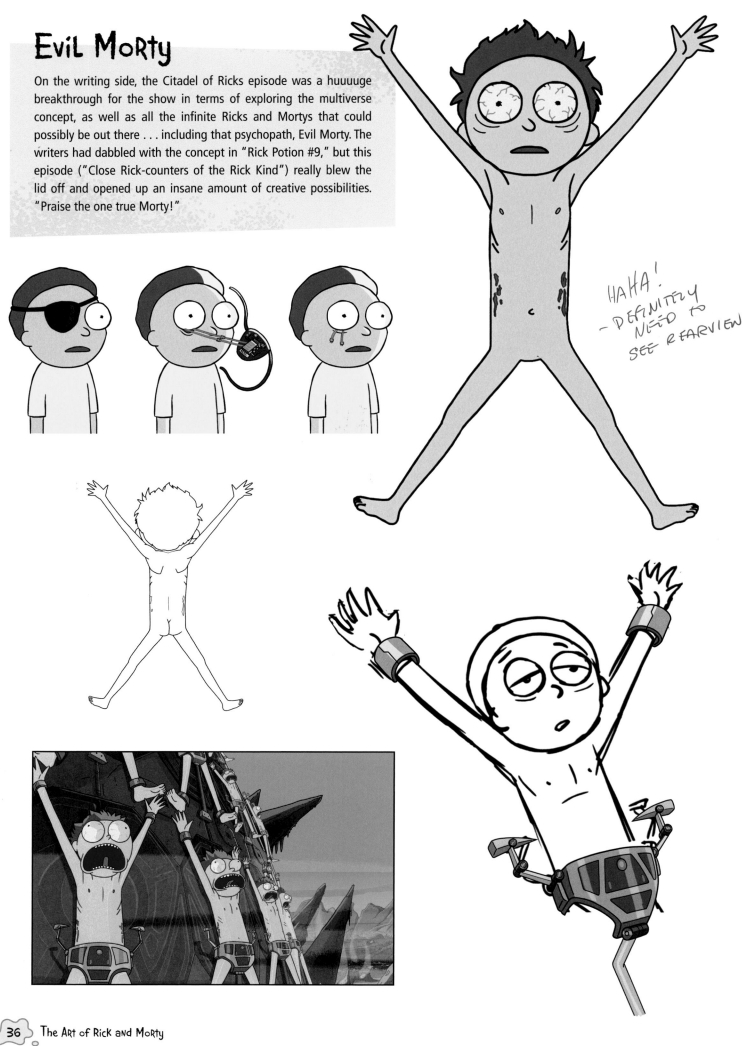

HAHA!
– DEFINITELY NEED TO SEE REARVIEW

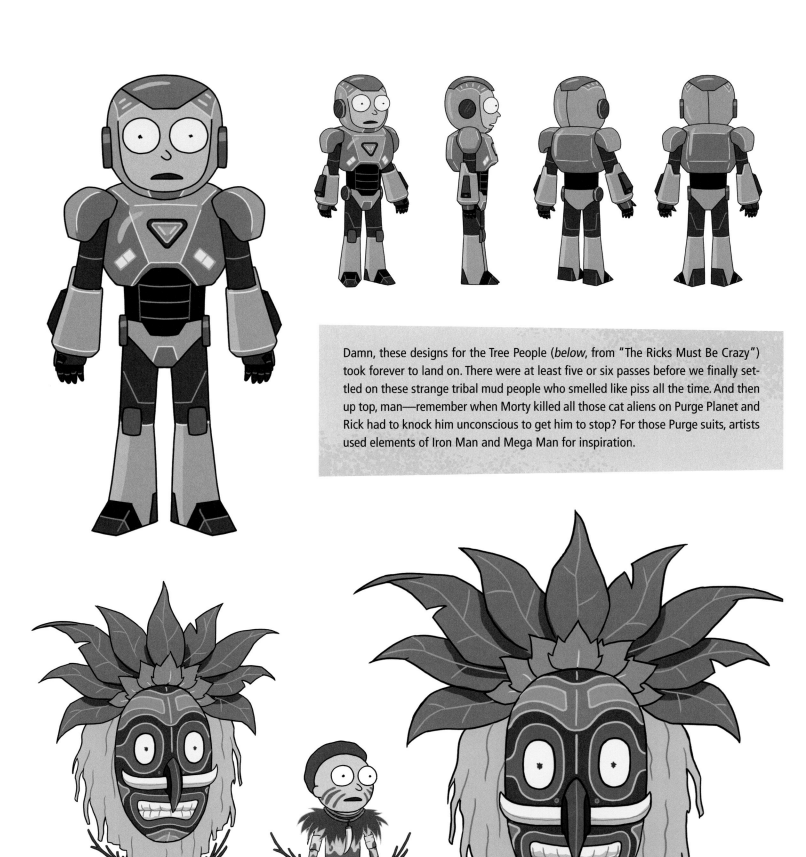

Damn, these designs for the Tree People (*below*, from "The Ricks Must Be Crazy") took forever to land on. There were at least five or six passes before we finally settled on these strange tribal mud people who smelled like piss all the time. And then up top, man—remember when Morty killed all those cat aliens on Purge Planet and Rick had to knock him unconscious to get him to stop? For those Purge suits, artists used elements of Iron Man and Mega Man for inspiration.

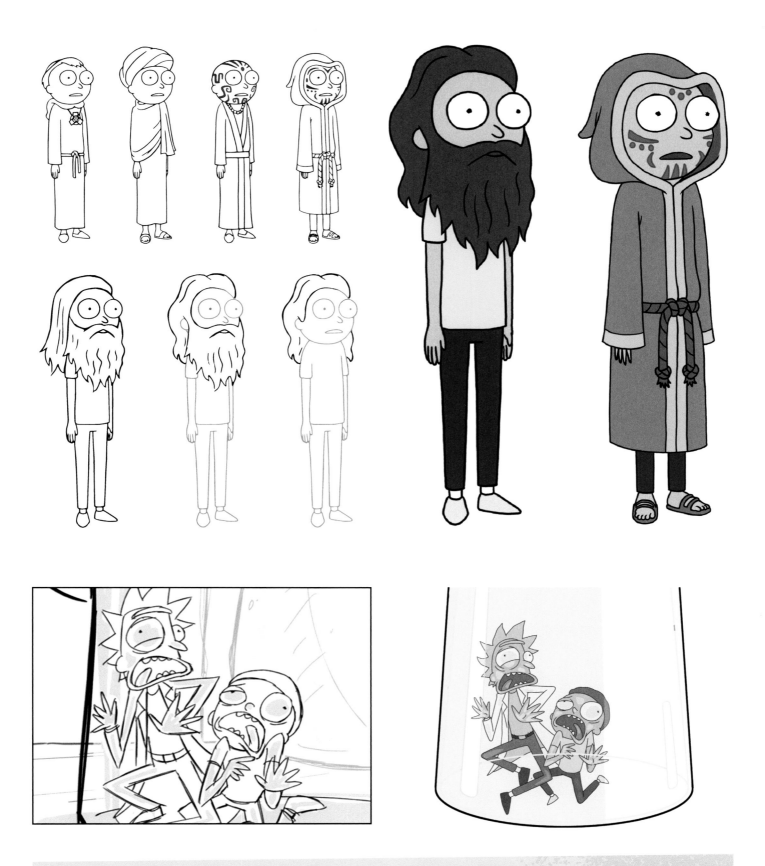

"Geez, Rick, this- this is pretty cool, it's kinda like a before and after. L-like weight-loss pics . . . but for production art, you know?" So on the bottom here, you can actually see the evolution from a storyboard panel to color key frame pose, which then gets sent to Bardel to be animated. For the final version of this shot, check out the Giant World scene in "Meeseeks and Destroy." Oh, and up top, there's some early concepts for the different cult Mortys imprisoned by Evil Rick (in "Close Rick-counters of the Rick Kind"). Not all of those designs got used. Poor little Rickless bastards.

CRONENBERG MORTY

"Now this- this is just an example of shit going ham, man. Adventures going ham. I mean, cou-could Rick be any more irresponsible? He Cronenberged an _entire planet_!"

When coming up with the design for Cronenberg Morty (in "Rick Potion #9"), the art director's first inclination was to have Morty's head coming out of his asshole—you know, have Morty sort of invert himself and crab walk backward with all these extra mouths everywhere. That's another early concept in the bottom left, but we wound up sticking with the head-in-ass one. I mean: first thought, best thought.

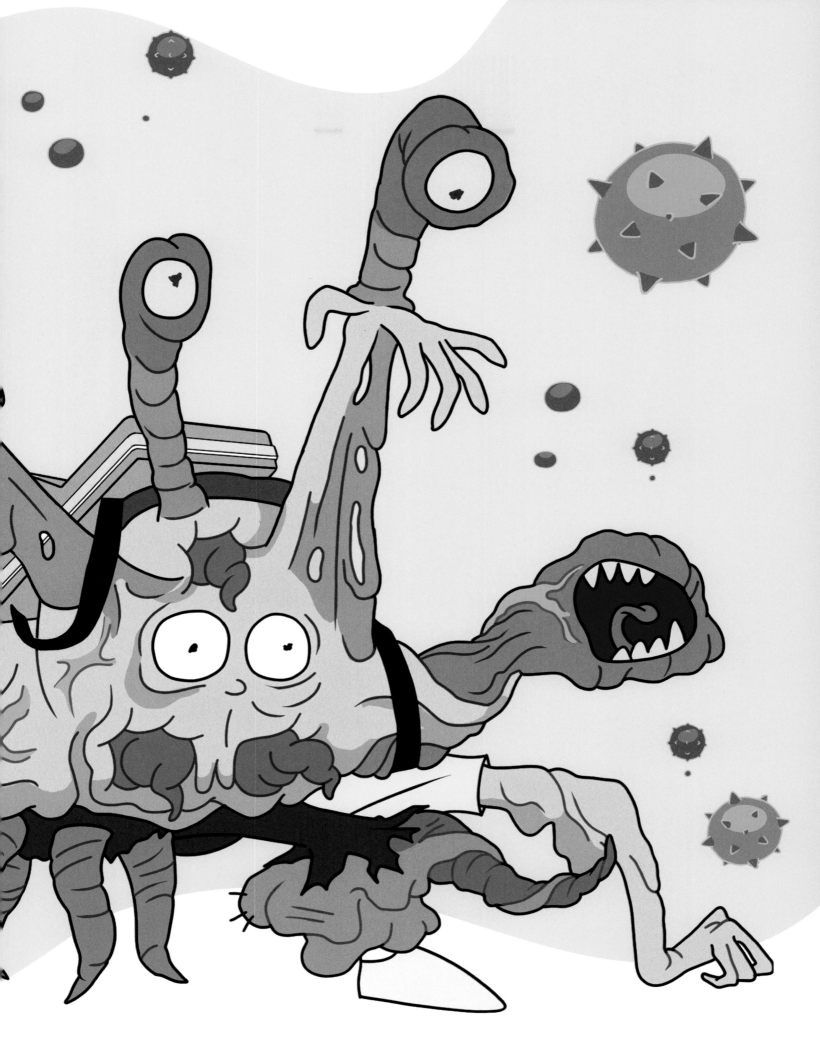

SUMMER

"Um, what is this, a *book*? Oh my god, are you like a thousand years old? Hold on, I gotta text my friends and tell them I met a person who's never heard of the internet. (*Pulls out phone*) No, no, please, keep reading, I'm sure you'll learn something super cool, maybe you can even put it into your printed newsletter or whatever."

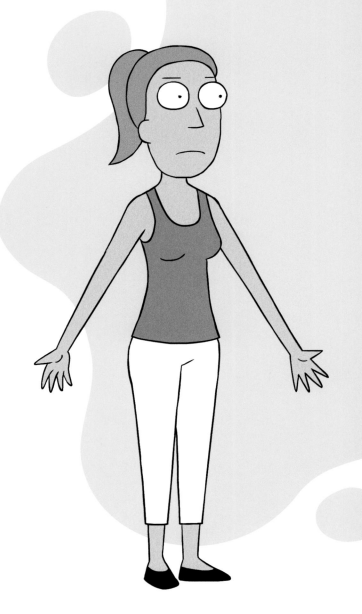

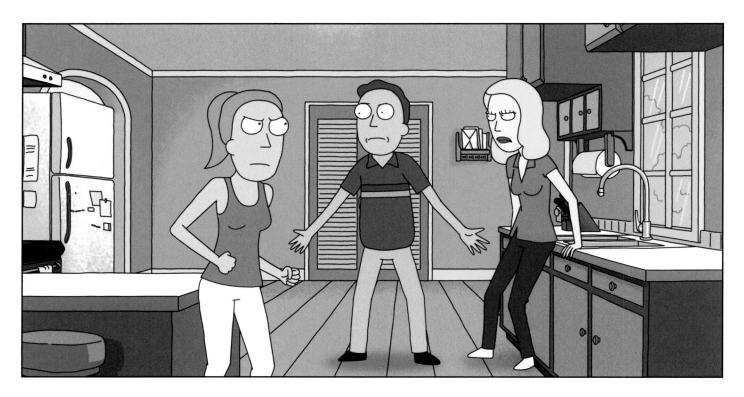

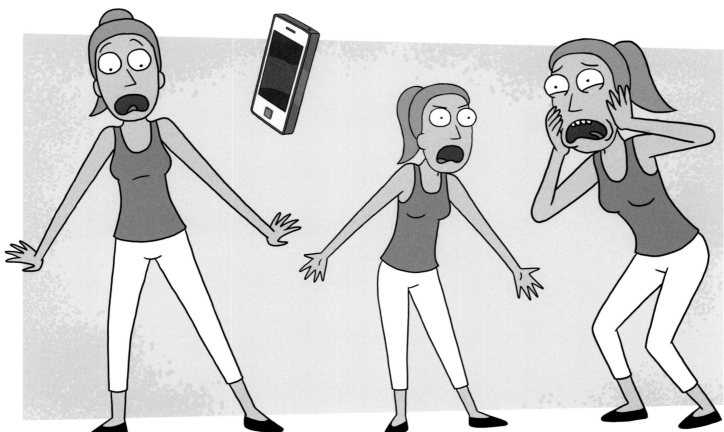

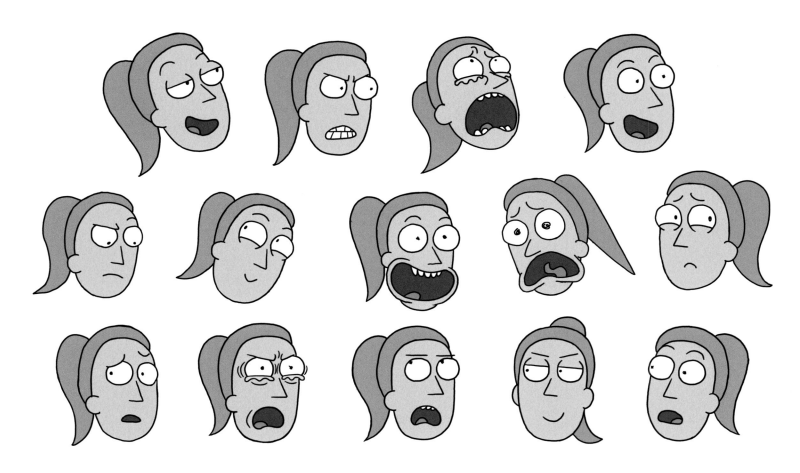

"Okay, can you *not* show these to anyone at school? I mean, some of these aren't even in color, are you trying to shame me or something??" This art is all from before the pilot, just developing characters. Justin designed Summer's general look, then Myke Chilian tackled this expression sheet (*above*) and some of these pre-pilot poses. What you're seeing on these pages really helped shape Summer more than anything else.

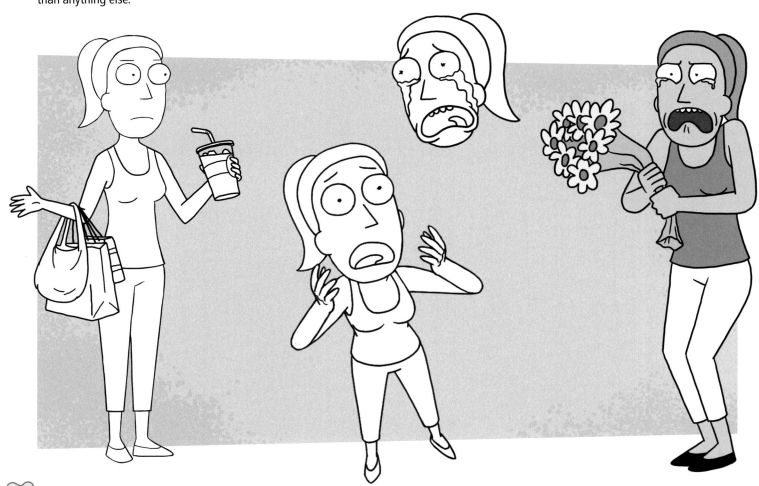

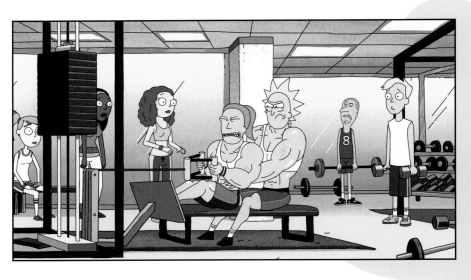

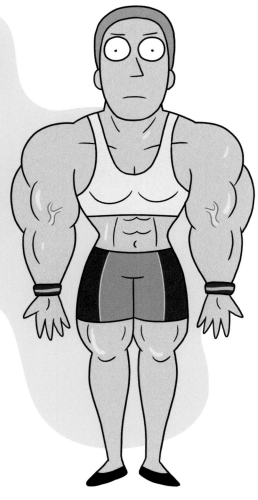

"What the hell, we're jumping right into pictures of me in lingerie? Um, okay, rude." Sooo this is actually a pretty great example of how much Summer (voiced by Spencer Grammer) has evolved as a character over the years. In the pilot and early episodes, she was definitely more of a generic high school girl—you know, despondent, always on her phone. But as the writers involved her in more story lines (like *above*, in "Something Ricked This Way Comes"), she really took on this awesome depth and dimension. Bonus fact: Justin originally wanted Summer to only be wearing nipple tassels in that scene from "Lawnmower Dog" (*below*), but the network was like: uh, no. So we just went with lingerie. Double bonus fact: she's actually Justin's favorite character in the show.

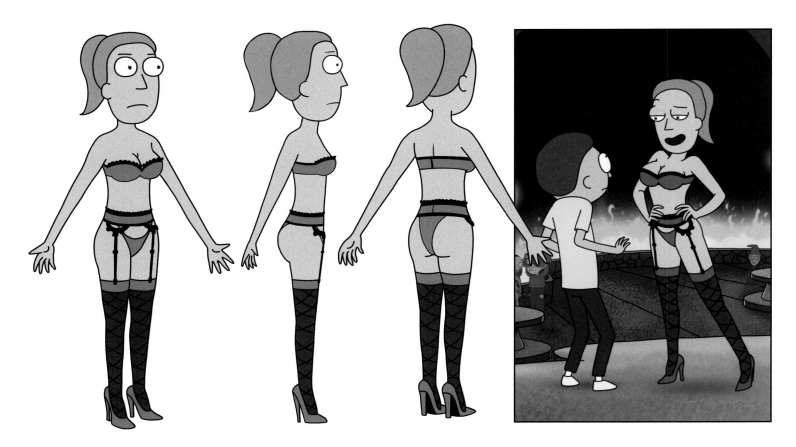

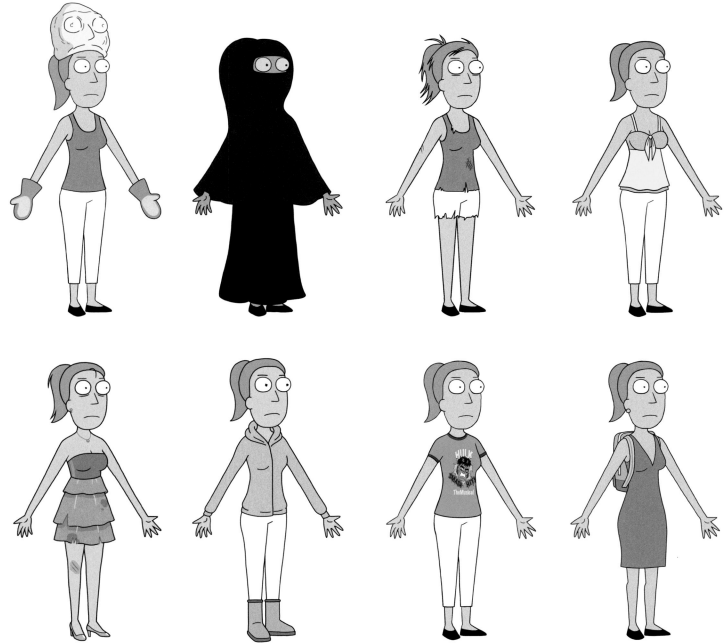

Jerry

"Okay, Jerry, you got this. Just a quick little introduction about yourself, don't want to oversell it, but really let them know who wears the pants around here. (*Clears throat*) Hey, gang, it's your old pal Jerr-diggity! . . . Oh god, was that too much? I think I overdid it. 'Jerr-diggity'? What were you thinking, Jerry, that was *way* too urban! Oh god, can we start again?? Where's the backspace button in this thi—"

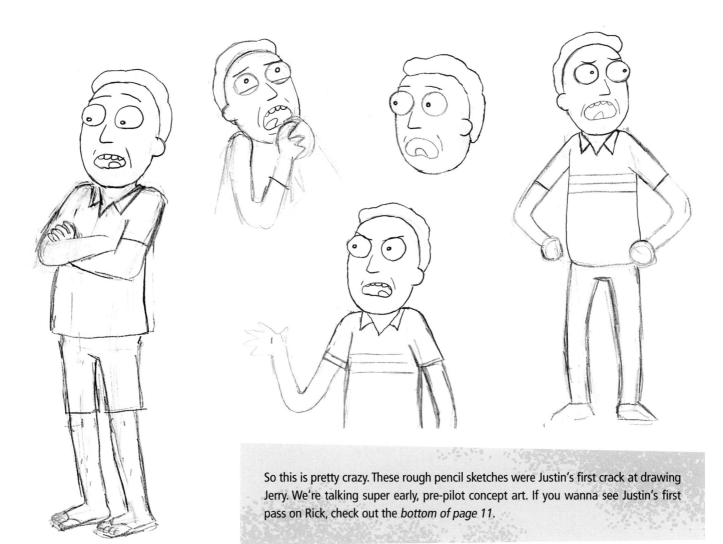

So this is pretty crazy. These rough pencil sketches were Justin's first crack at drawing Jerry. We're talking super early, pre-pilot concept art. If you wanna see Justin's first pass on Rick, check out the *bottom of page 11*.

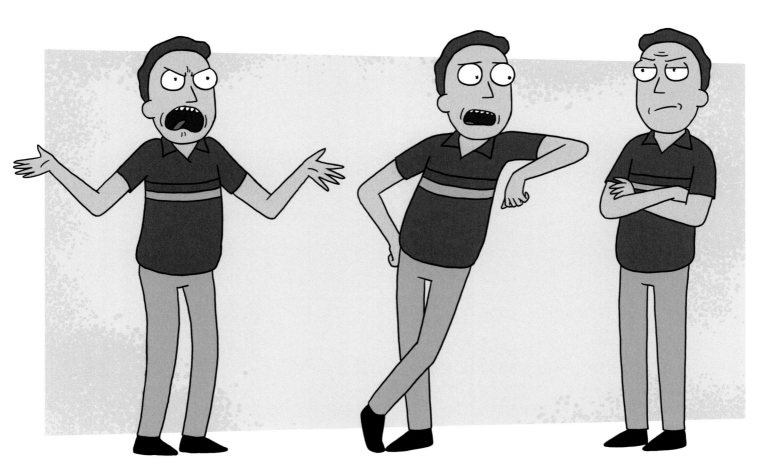

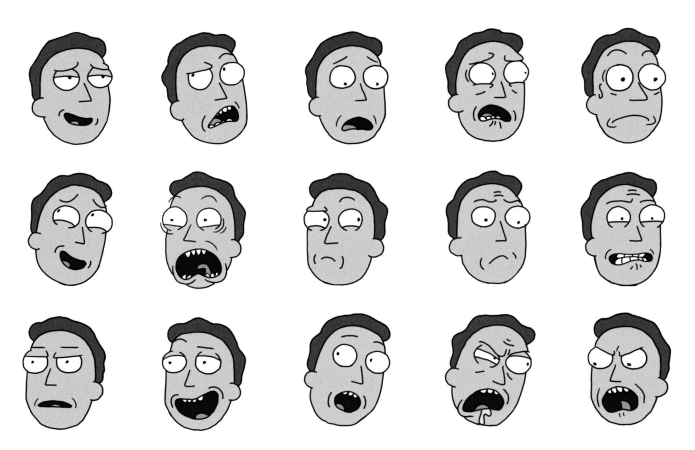

"Pretty cool, huh? I can make all those faces . . . *and more*. (*Pulls out résumé*) Sure, I'm unemployed now, but I'm also a movie star in another reality. So, yeah, suck on that." These drawings above are all early expressions for Jerry (voiced by Chris Parnell), drawn way before animation started. You can see they're a little rough compared to what you see now in the show.

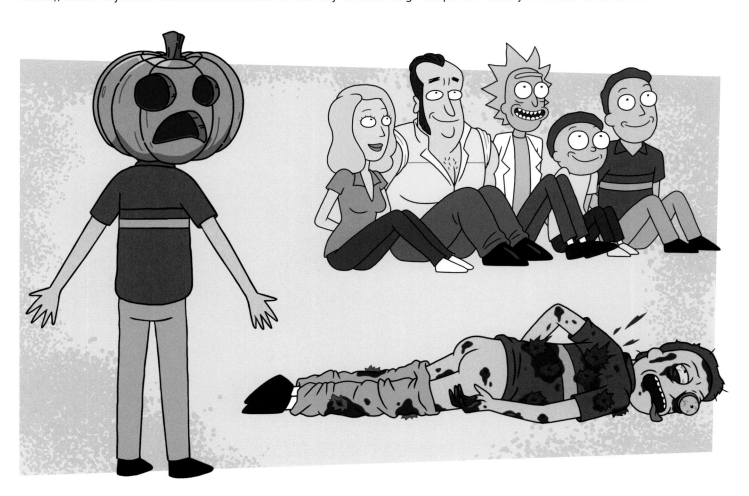

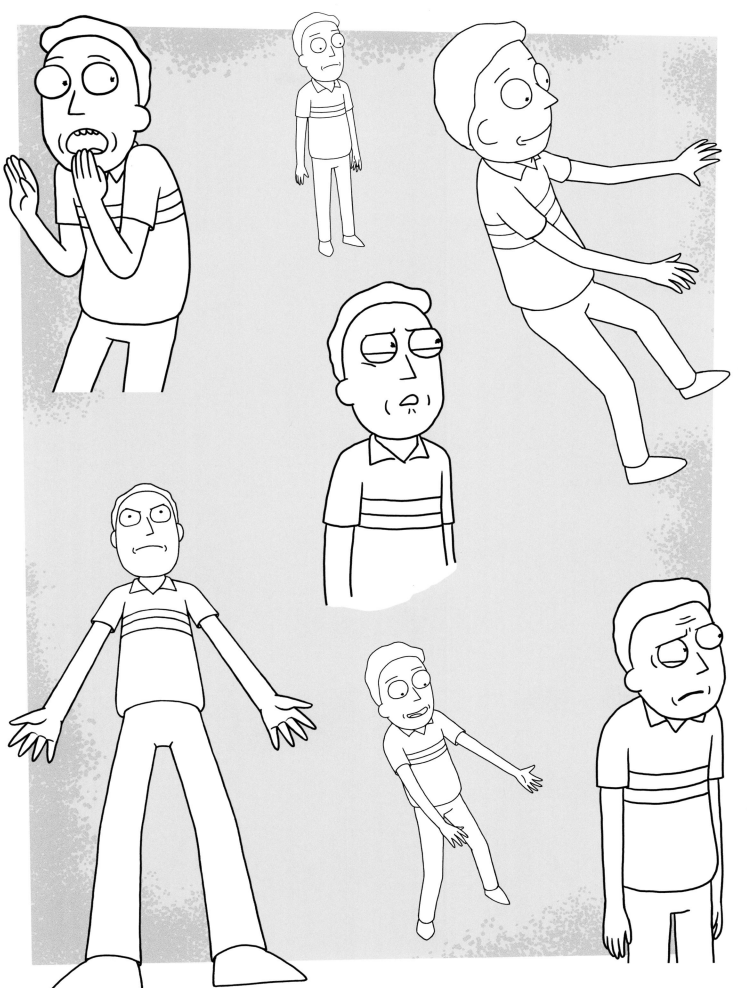

The Many Faces of Jerry

"See! I told you I was a movie star in another reality! That's me starring in *Cloud Atlas* on the right page. I met different-timeline David Letterman, okay. The green room was *delightful*. Sometime small tru-tru diff'rent dan da big tru-tru."

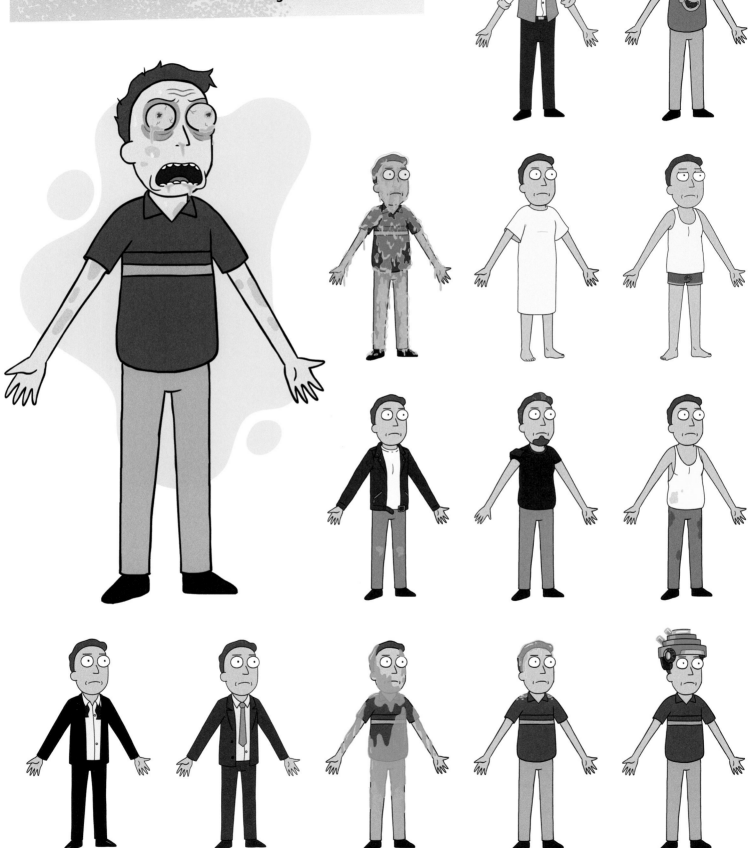

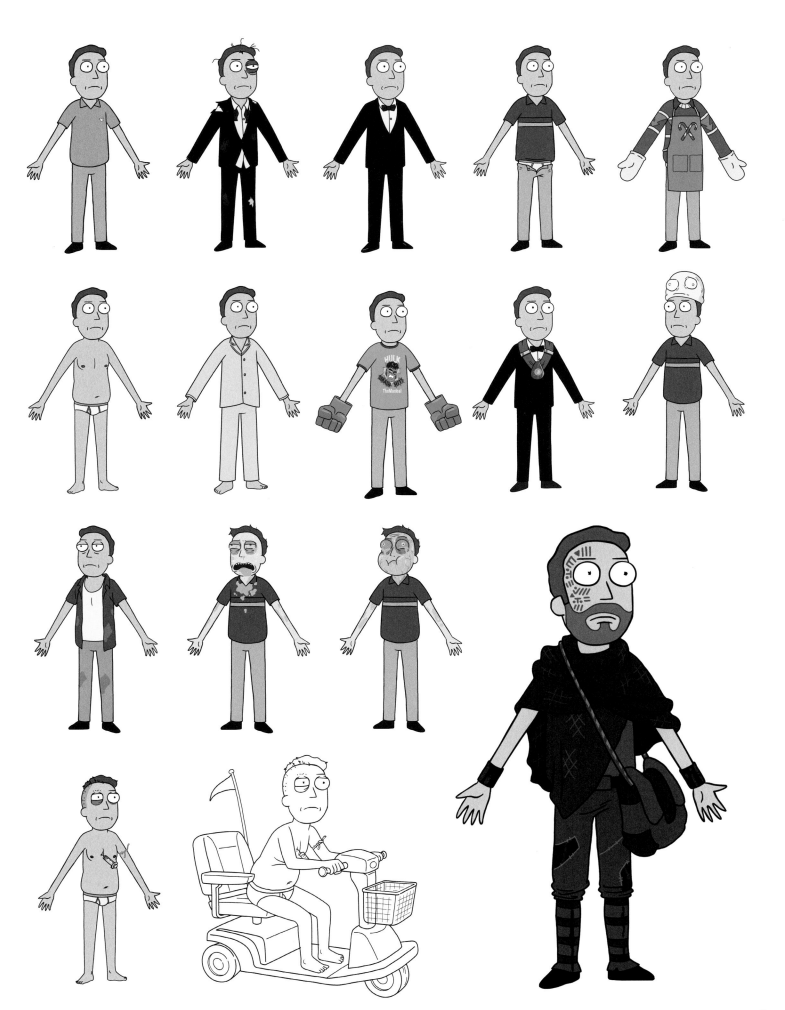

"Make It Weird"

"Oh great, you just had to put this in here, huh? You just had to show the world how Beth sees me!" Okay, so this spineless, slippery, shape-shifting worm man is Jerry's mythologue from "Big Trouble in Little Sanchez." When creating new designs for the show, the general motto among our art team is *make it weird*. The more bizarre and ridiculous you can make it, the more it seems to land.

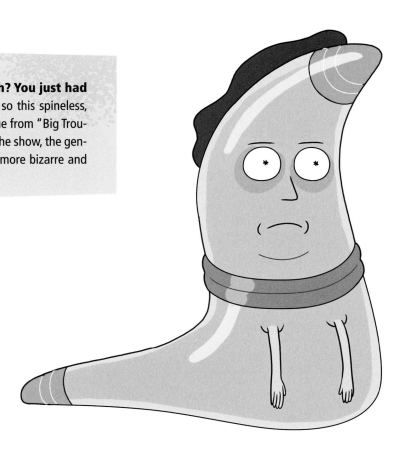

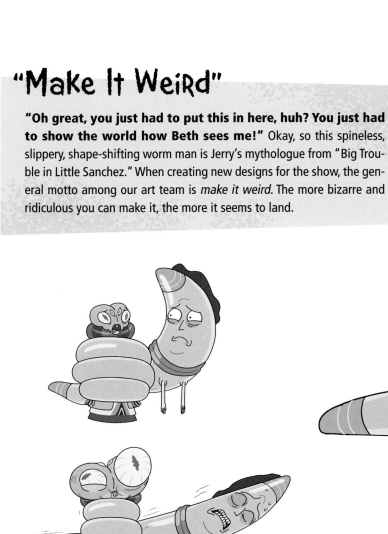

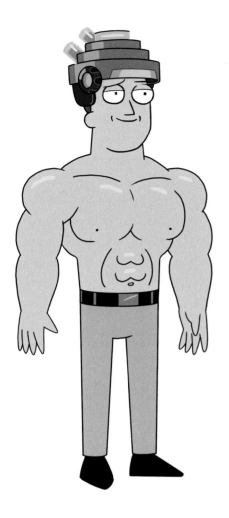

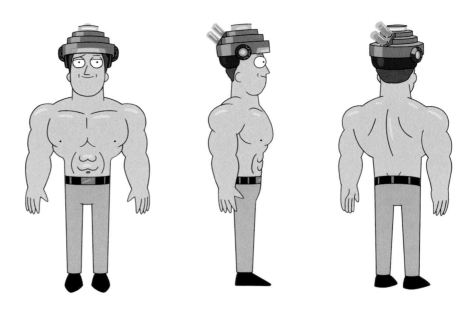

"Finally! Fifty-five pages in, and you finally put a good picture of me! I don't mean to sound ungrateful, but—come on, man. I need this!" Up top is Heroic Jerry's turn, you know, showing off the different angles of the character model (from "Big Trouble in Little Sanchez"). Below is some original concept art for Cronenberg-dimension Jerry—the artists wanted his design to look like end of days, like eating a cockroach would be a luxury. To the right is the final, full-color art we landed on (for "Rick Potion #9").

Blood
Spatter

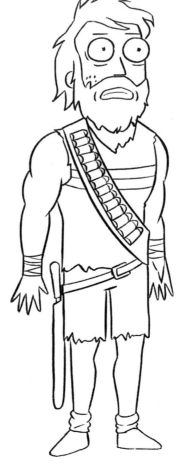

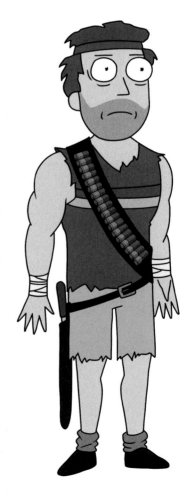

Beth

"Oh please, I don't need an introduction, okay? I'm Rick's *daughter*, and a surgeon, and I can't be boiled down into a pointless blurb in some . . . 'art' book. I'm sorry, but it had to be said. If you want to see real art, watch me do a heart transplant on a two-thousand-pound Clydesdale. Yeah, so . . . *think about that.*"

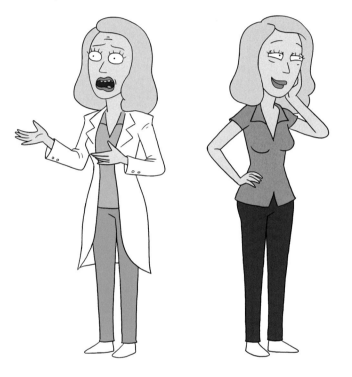

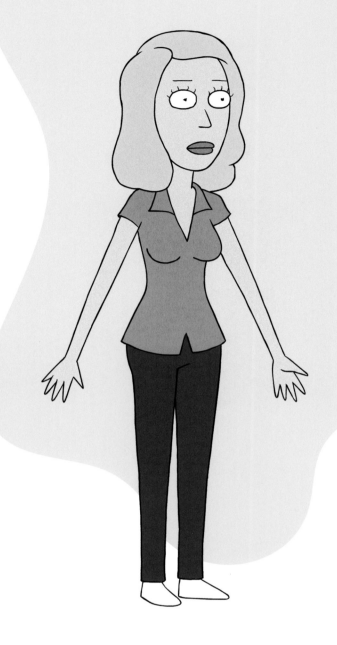

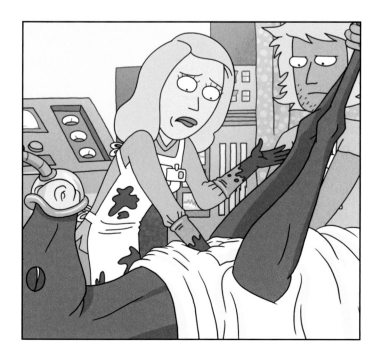

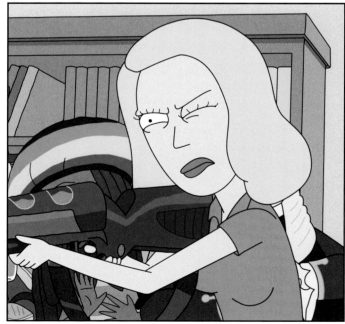

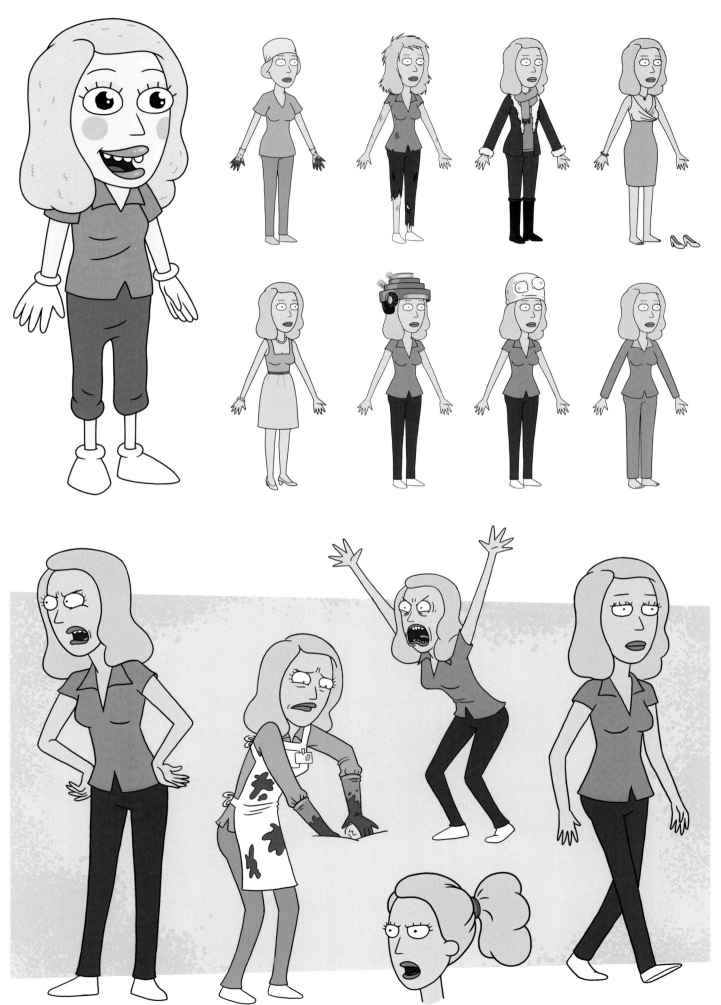

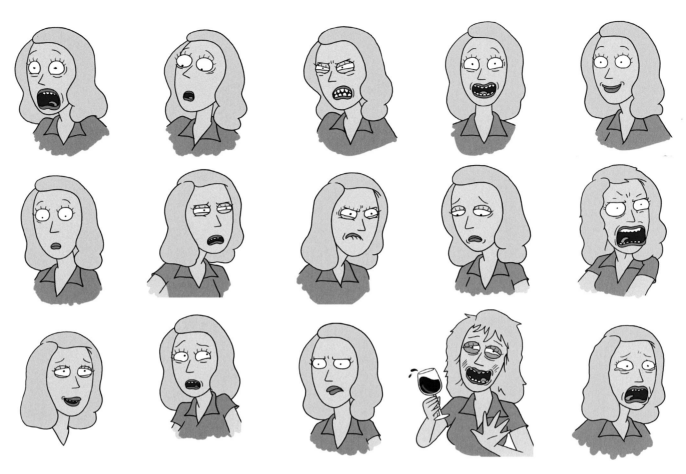

"Cool, just me with a pumpkin on my head. Oh great, and there's me drunk. Come on, if you had a family like mine, wouldn't you drink??" Both pages here are filled with early season 1 art for Beth (voiced by Sarah Chalke). And up top is Beth's pre-pilot expression sheet—these sheets help the artists keep their drawings consistent across her range of emotions.

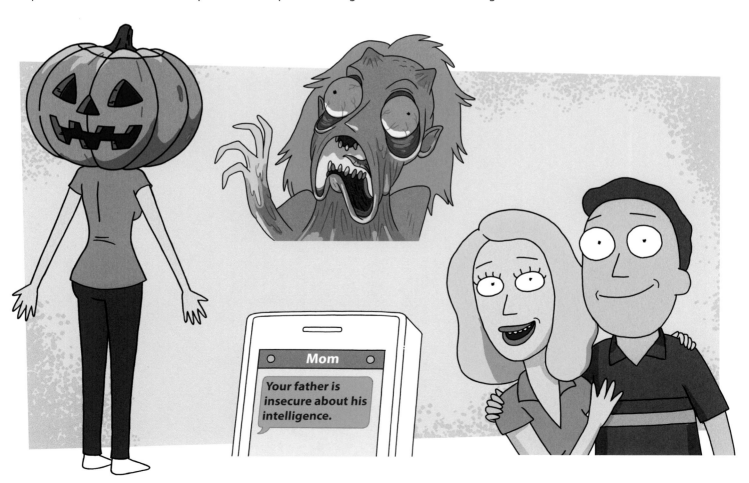

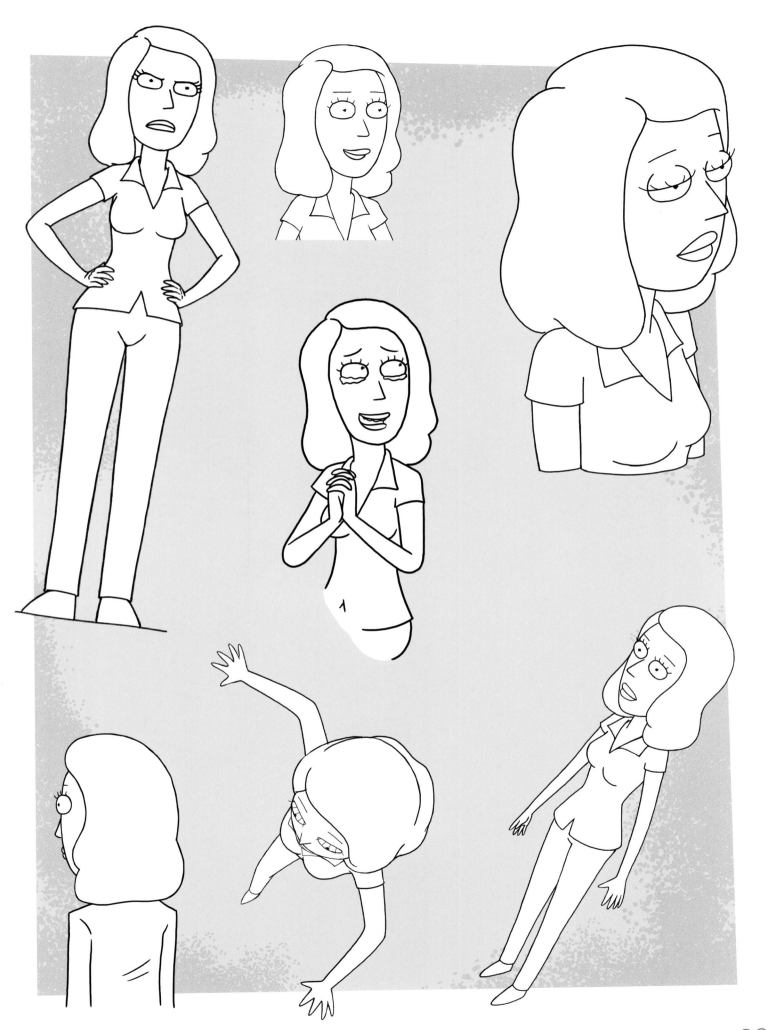

XenoBeth

"Okay, for the record, this alien shit is all _Jerry's_ fault. I mean, no surprise there. Why don't we write a book about that?"
Kinda nuts, but XenoBeth (from "Big Trouble in Little Sanchez") was by far the most complicated character of season 2. There were many, many design iterations of her done by James McDermott, Gerry Galang, and Max Pauson, all of which were too detailed and complicated for Bardel to animate. At one point, we even had a version with a mini Beth head coming out of her mouth, like in _Alien_. These two pages show the crazy process of how we zeroed in on her design: the super insect-y, super xenomorph-y ones below were all first-pass concepts. On the right page (_at the top_) was the second round, where we dialed into her "silhouette"—her general shape. And below that, the artists had basically found the design, but were still toying with the complexity and details of her mouth. The final design (_directly to the right_) was more simplified, but still super badass.

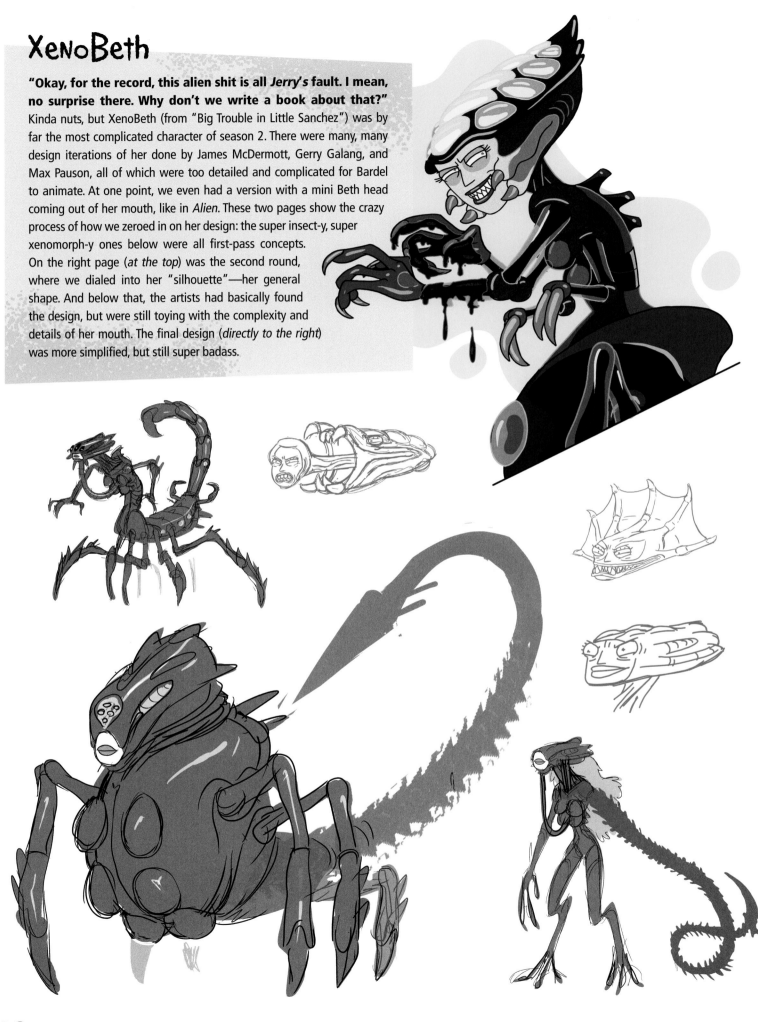

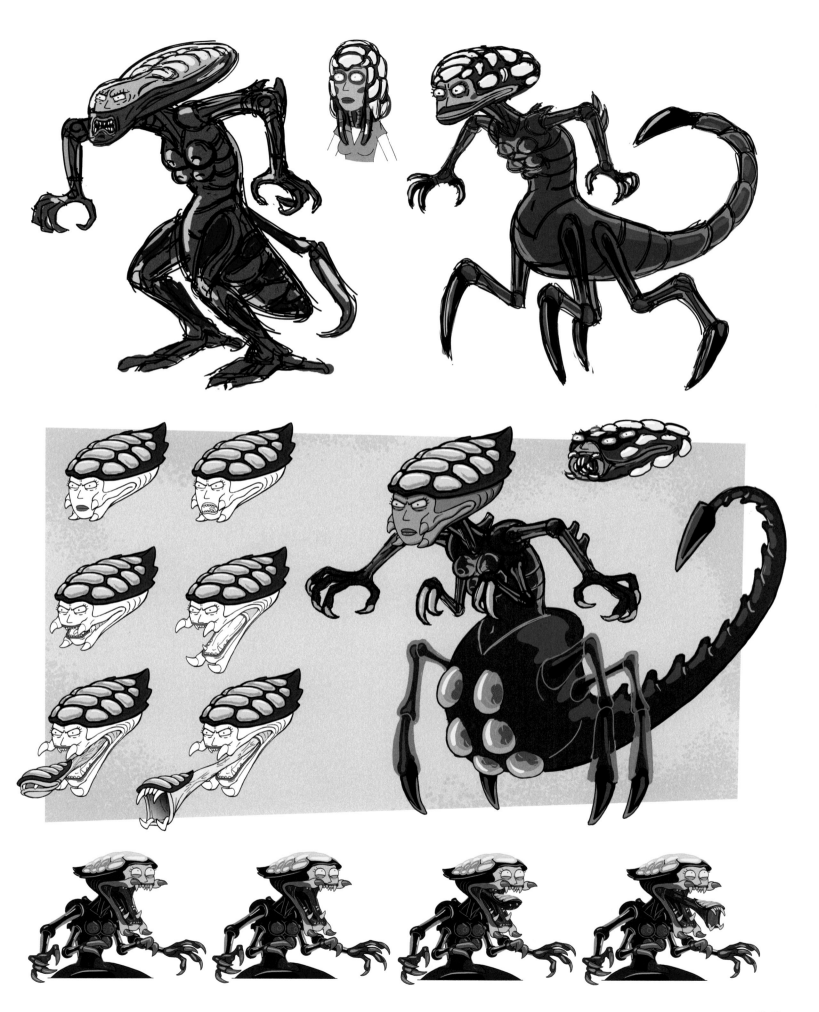

Jerry's Family

Man, Jerry's parents. Their story with Jacob was one of the first things the writers tried to tackle after the show got picked up to series. Early on, they were really trying to stick to the formula of a crazy sci-fi "A story" with a grounded domestic "B story" (without any sci-fi or genre elements). But the writers had a hard time breaking the story sans sci-fi, so they just got crazy with the parents and made them sex-loving swingers.

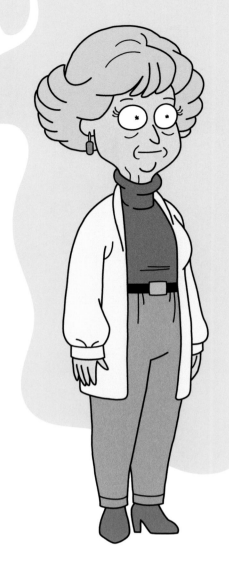

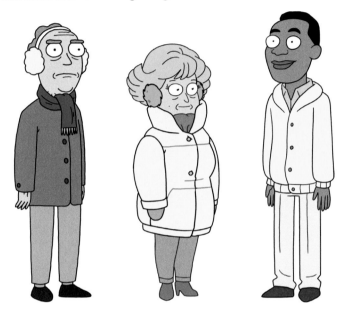

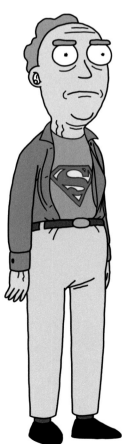

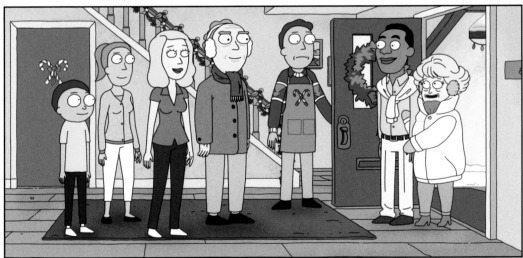

"Jacob is your mother's lover. I watch them, sometimes from a chair, sometimes from a closet, almost always dressed as Superman." Designs for both of Jerry's parents underwent some early tweaks: Leonard (voiced by Dana Carvey) was altered to look more like Jerry, and Joyce (voiced by Patricia Lentz) had her hair changed to make her look more motherly and conservative. Also worth noting: Jacob was voiced by Echo Kellum, who also does the voice of Brad.

High Schoolers

Just a few of Harry Herpson's finest. To the left is Nancy, the nerdy girl who went on a death-defying mission with Abrodolph Lincoler and Morty in "Ricksy Business." Actually, one of the character designers (Stephanie Ramirez) kinda modeled Nancy after herself. Also worth noting is the dude in the green jumpsuit—that's the Flu-Hating Rapper from "Rick Potion #9." And because everyone should know, here's the lyrics to his rap: "Flu. Yo. You gotta be aware, aware of all the flu up in the air. I'm a get me a shot, make the flu go away. I'm a flu-hatin' rapper, just rappin' away."

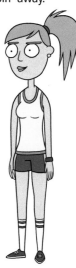

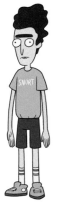

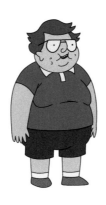

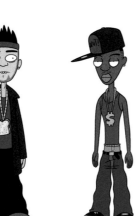
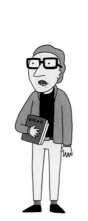

BIRDPERSON

"It has been a . . . *challenging* mating season for Birdperson."
You know—most people think of Birdperson as the guy who mate melded with Tammy, only to find out she was an intergalactic spy and get killed by her. But he's more than that—he's a wonderful person, an incredible bird, and most importantly, he's Rick's best friend. The initial look for Birdperson (voiced by co-creator Dan Harmon) was actually an homage to Hawk from *Buck Rogers*. You can see a bunch of hand-drawn concept art here—but hold up—there's more BP pellets on the next page.

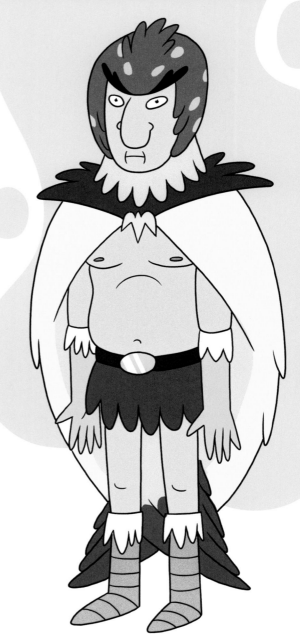

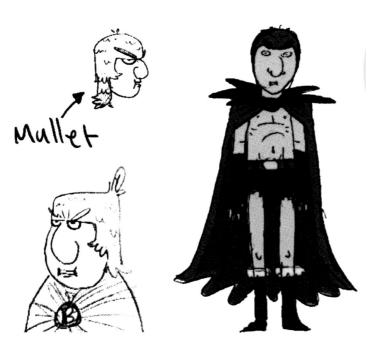

Mullet

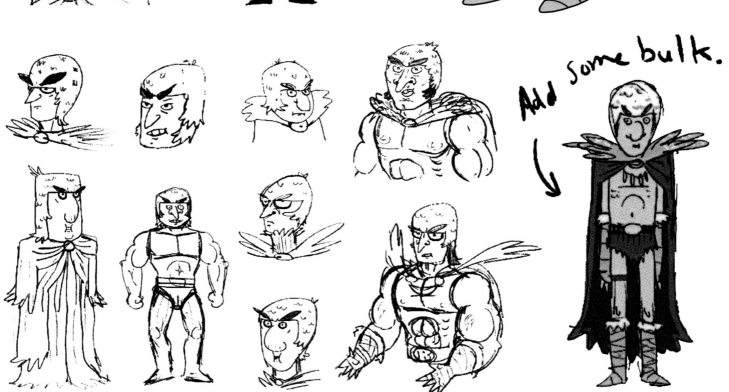

Add some bulk.

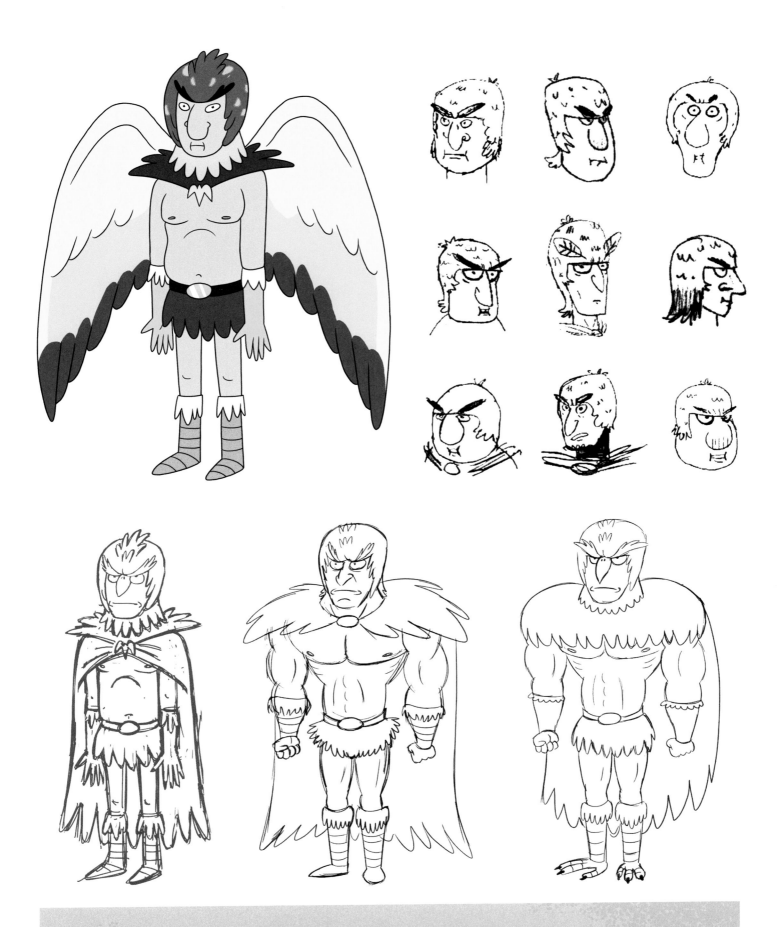

Justin actually drew the original concept for Birdperson on the whiteboard in the writers' room (the *same day* he drew concepts for Squanchy and Gearhead, *page 221*). The art team took that and started to go tougher and cooler with Birdperson's design—as you can see above—but Justin liked the early concepts better with the awkward body and the big, dumb nose.

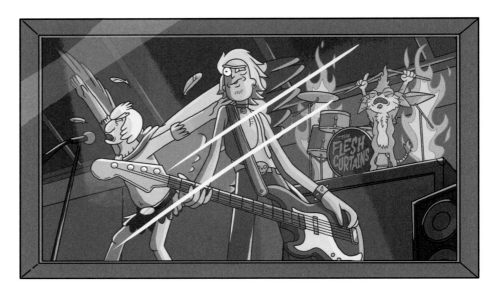

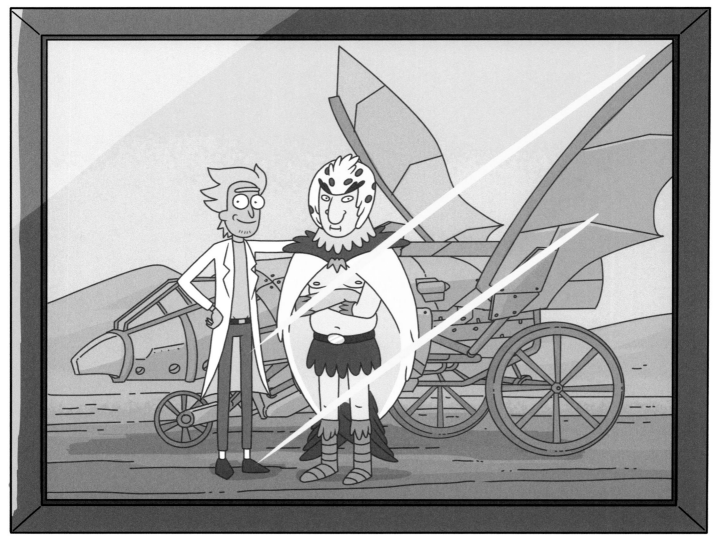

KA-KAW! Just some pics of young Rick and Birdperson, you know, flying things, jamming out in The Flesh Curtains. We saw these two photos in "Get Schwifty," after Birdperson saved Morty's life and fed him random debris from the carpet for nourishment. It's also when we learned that Rick is the only reason Birdperson is alive at all. So yeah . . . deep cuts, bro.

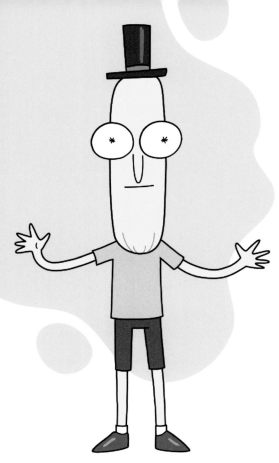

MR. Poopybutthole

"Oooh weeee! This little poopypants is hungry!!" In the first draft of the script, Mr. Poopybutthole was actually this character named Bullet Boy, a big cartoon bullet. But Harmon and Mike McMahan (the writer of "Total Rickall") were trying to figure out something that sounded more like a Justin Roiland character—and at the time, Justin was also trying to get this drawing he had called Titty Long Balls into the show. So their jokey version of Titty Long Balls was called Mr. Poopybutthole. And that, my friends, is TV history.

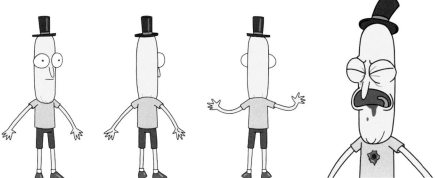

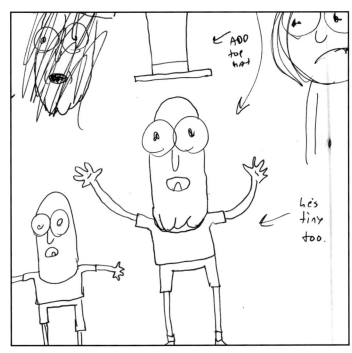

Originally, we wanted Richard Simmons to do the voice for Mr. Poopybutthole. We even sent him the script—but he turned it down. So Justin did the voice instead. You also probably noticed Mr. Poopybutthole in all the opening credit gags in "Total Rickall" (*left*). That's the only time we've ever done that for a character. And those little drawings above? Those are Justin's original sketches, y'all!

Squanchy

"Squanchy party, bro! Is there a good place for me to squanch around here?" When the writers were breaking the house party episode ("Ricksy Business"), they were trying to fill Rick's house with a million different flavors of sci-fi stuff. Squanchy was our universe's version of Snarf from *ThunderCats* . . . You know, a version that drinks out of a paper bag and squanches in the closet with a rope around his neck.

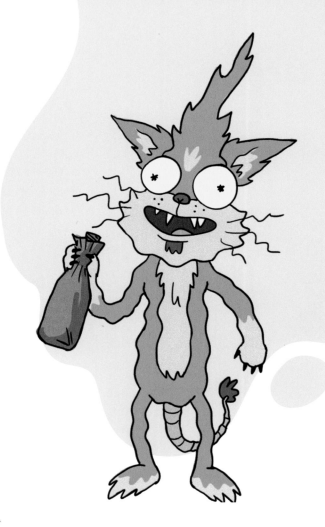

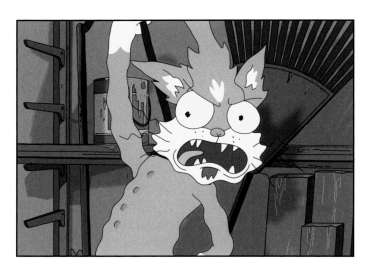

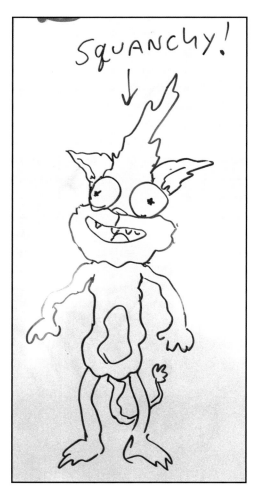

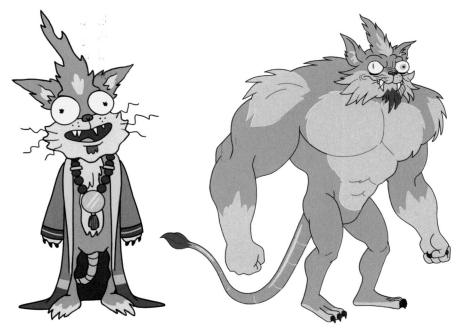

"Hey! I'm squanching in here!" That's actually Justin's original drawing of Squanchy (*left*) from the whiteboard in the writers' room. Over the seasons, Justin has designed a ton of characters on that board, but very few have made such a literal leap to design as Squanchy (voiced by Tom Kenny). Oh, and directly above, you've got a squanched-out version of Squanchy from "The Wedding Squanchers."

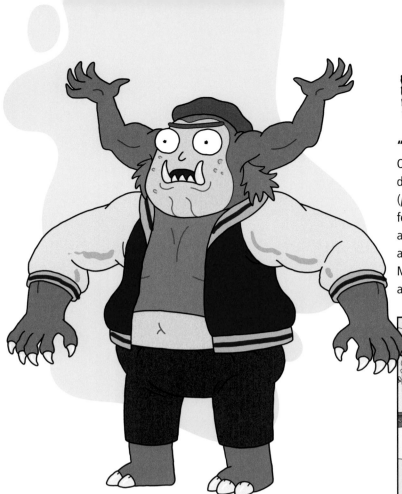

MORTY JR.

"I don't want to masturbate, I want to conquer the planet!"

Once the script was written for this episode, we couldn't just start designing Morty Jr.—we first had to design the Gazorpian aliens (*pages 90–91*) before we could figure out how to make a Gazorpian feel "half Morty." Then on top of that, we had to design Morty Jr. across a bunch of different ages (*bottom*) and have five separate actors play his voice, including two kids. So yeah . . . this was tricky. Maybe next time, Morty will think twice before, you know, making an alien baby with a sex robot he bought from a pawnshop.

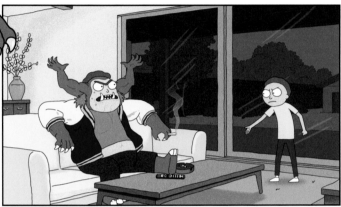

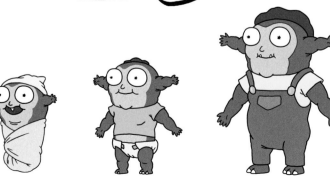

Jessica

When designing Jessica (voiced by Kari Wahlgren) for the pilot, the main thought was—as a fourteen-year-old boy, who would Morty think was the hottest girl in school? Dan and Justin probably drew a bit from personal experience and came up with a cute, redheaded girl-next-door type. All the art featured here is key poses and early expressions done by Myke Chilian—this art really took her character to the next level.

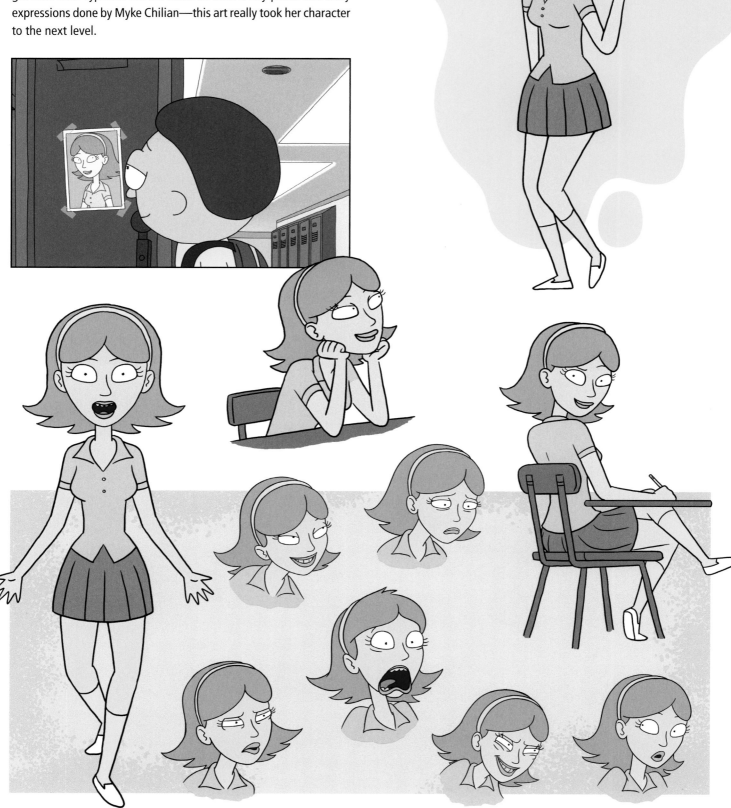

Brad

"I throw balls far. You want good words, date a languager." Crazy story with Brad—the original design for him was this typical white jock bully character. But when we were auditioning for the role, Echo Kellum did this amazing take on it—definitely the funniest audition by far. It was so good we actually changed the design of Brad's character to be a black guy. As far as school goes, Brad's dated Jessica, fought Abrodolph Lincoler, and desperately tried to mate with Morty after being infected by the love flu. "Back off, I'm tryin' to be with my man!"

Tammy

"Gosh, I look around this room and I think, uh, Tammy, you're a high school senior from the planet Earth and you're marrying a forty-year-old bird person, like, whaaat?" Hate to disappoint, but the writers didn't plan on having Tammy be an intergalactic secret agent when they first came up with her. She was just supposed to be more of the generic slutty girl in Summer's school—hence why she hooks up with Birdperson right off the bat in "Ricksy Business." But when we cast Cassie Steele from *Degrassi* (Justin reallllly loves *Degrassi*, BTW), she brought a ton of life to the character. So the writers wanted to use her a lot more—like in "Get Schwifty" and "The Wedding Squanchers."

Ethan

When Summer's on-again, off-again boyfriend debuted in "Anatomy Park," we wanted his design to have a Jorma Taccone kinda vibe (from The Lonely Island). Fun fact: originally, we had cast Rob Schrab to do the voice for Ethan. But after hearing it, Harmon thought he sounded too much like a forty-year-old man. So we recast and had Dan Benson rock his voice. Rob, meanwhile, got to play the voice of Dippity Doo (*page 112*). Oh, and a lot of people forget this, but Ethan's got an amusement park inside him . . . Unfortunately, there's no Pirates of the Pancreas ride.

Principal Vagina

"Mrs. Smith? This is Principal Vagina. No relation." Gene Vagina is not just the principal of Harry Herpson High; he's also the OG founder of Headism (in "Get Schwifty"). You can see his turn below, in full Headism garb, ready for the Ascension Festival. The initial design for this character actually came from one of Justin's old projects, which he brought back and tweaked. We finalized the design before casting Phil Hendrie to play him, but . . . he does kinda look a little like Phil.

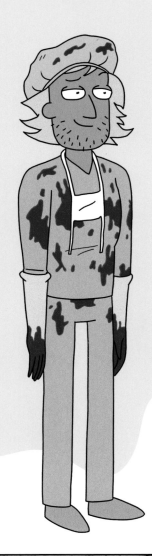

Davin

It's something the average viewer doesn't think about, but Davin's hair is *super* complicated. Boy oh boy, that's some overly complicated hair! If he does any turns, good luck. At the bottom is his early expression sheet—you know, just laying down that dreamy smile. And in the middle, that's Davin (voiced by Harmon) during his mantis transformation in "Rick Potion #9." SPOILERS: Jerry bashed his head in with a crowbar.

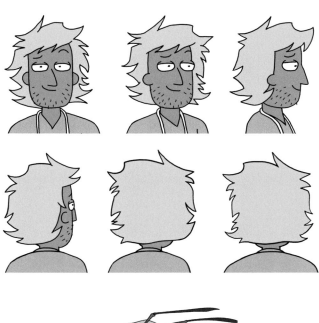

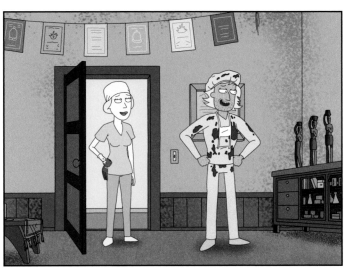

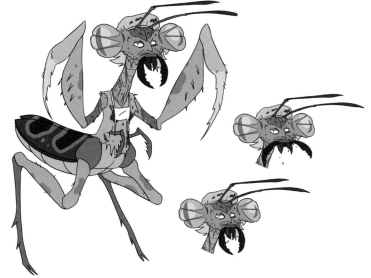

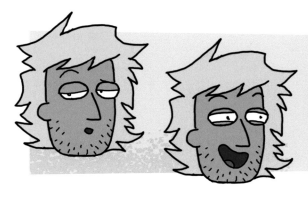

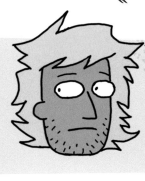

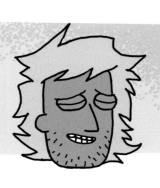

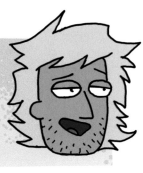

MR. GOLDENFOLD

"Morty, the principal and I have discussed it a-a-and we're both insecure enough to agree to a three-way!" Obviously you remember Goldenfold (voiced by Brandon Johnson) as Morty's math teacher, but you know, there's other important stuff too—like his love for Jamba Juice, his infatuation with Mrs. Pancakes (seen in "Lawnmower Dog"), and the fact that he's a proud Vespa owner (*below*, and in "Get Schwifty"). As far as Goldenfold's look, you gotta go back to the pilot—Villamor Cruz helped create his design based on Justin's art.

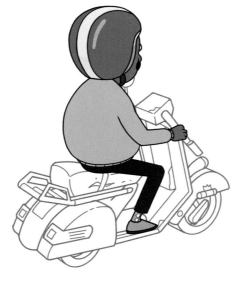

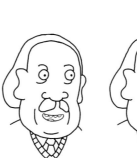

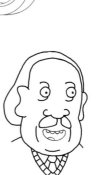

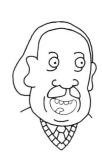

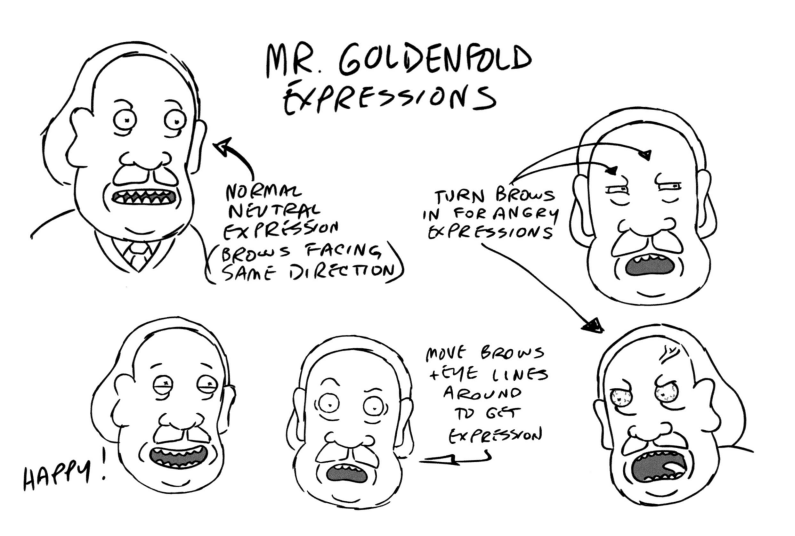

MR. GOLDENFOLD EXPRESSIONS

NORMAL NEUTRAL EXPRESSION (BROWS FACING SAME DIRECTION)

TURN BROWS IN FOR ANGRY EXPRESSIONS

HAPPY!

MOVE BROWS + EYE LINES AROUND TO GET EXPRESSION

Mouth Charts

Okay, so typically there are no more than fourteen or fifteen poses in a mouth chart—and within those poses, you can group in most of the alphabet. Every character has a chart so that lip sync animation stays consistent. But for new characters, or specific poses, an entirely new mouth chart often needs to be created. Below is the back three-quarters for Goldenfold—this was a tricky one. Justin had a lot of notes before this got locked down, dawg!

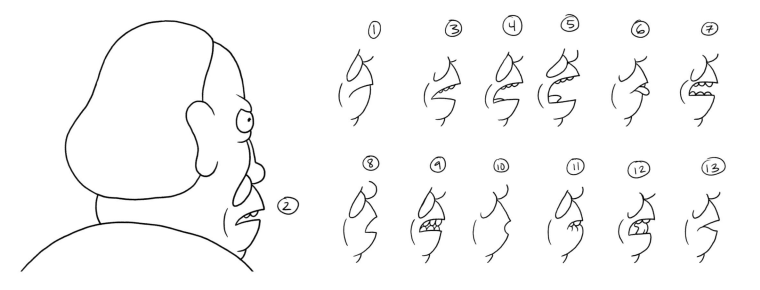

CHAPTER TWO

Disease Creatures

"Don't move. Gonorrhea can't see us if we don't . . . move . . ." Justin really wanted these "Anatomy Park" monsters to have a Rancor (from *Star Wars*) kinda vibe. Those early sketches (*on the right page*) show us exploring that look—but it took at least five or six iterations before we finally landed on designs for E. Coli, Gonorrhea, and the Hepatitis monsters. Worth it though: the final scene with Hepatitis A came out so badass, we used it in the show's intro for all of season 1.

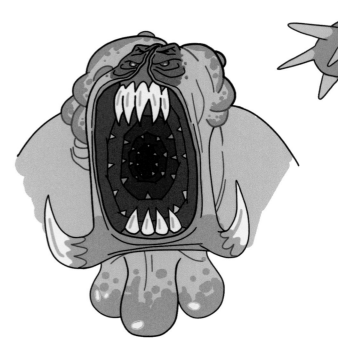

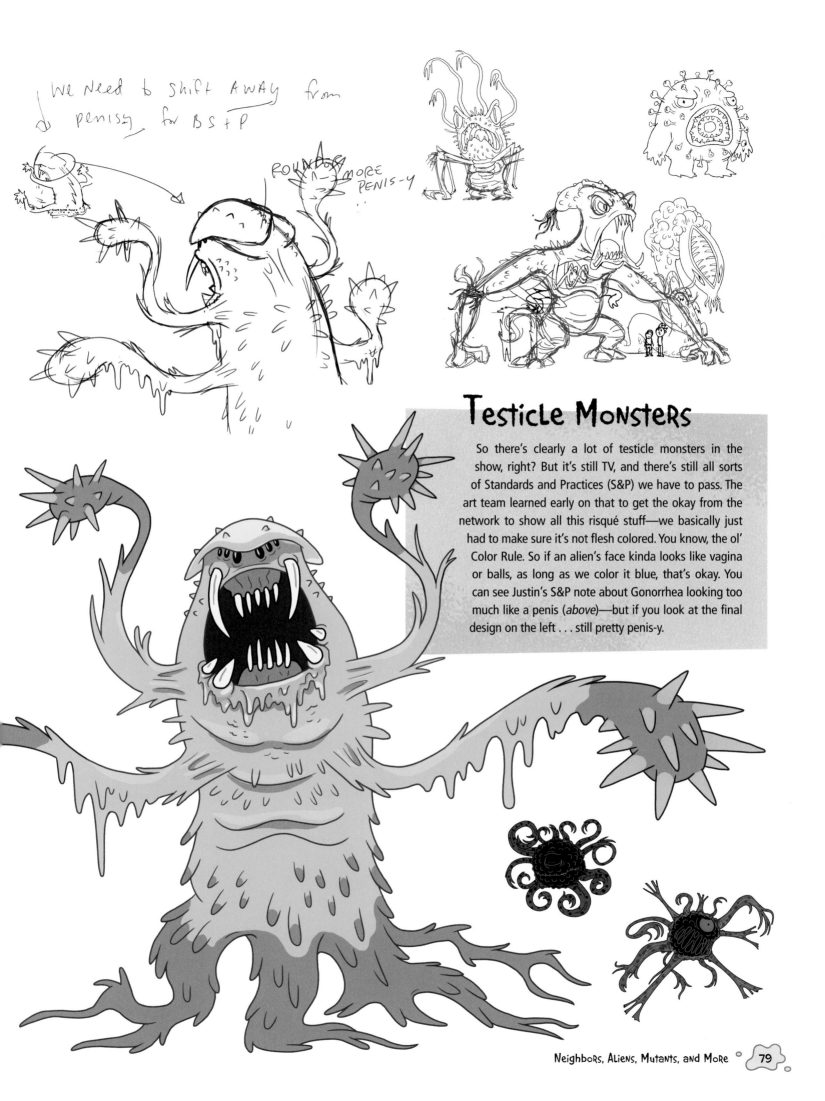

We Need to shift AWAY from penisy for BS+P

ROUNDER MORE PENIS-y

Testicle Monsters

So there's clearly a lot of testicle monsters in the show, right? But it's still TV, and there's still all sorts of Standards and Practices (S&P) we have to pass. The art team learned early on that to get the okay from the network to show all this risqué stuff—we basically just had to make sure it's not flesh colored. You know, the ol' Color Rule. So if an alien's face kinda looks like vagina or balls, as long as we color it blue, that's okay. You can see Justin's S&P note about Gonorrhea looking too much like a penis (*above*)—but if you look at the final design on the left . . . still pretty penis-y.

Dog Robots

"Where are my testicles, Summer?" Fun fact: Snuffles is actually based on Justin's dog Jerry. Double fun fact: Justin had the art director go and hang out with his dog while designing the art for Snuffles (voiced by Rob Paulsen). Oh, and directly below, you can see Justin's original, very crappy drawings of how the cognition amplifier helmet would work (for the second-tier modifications).

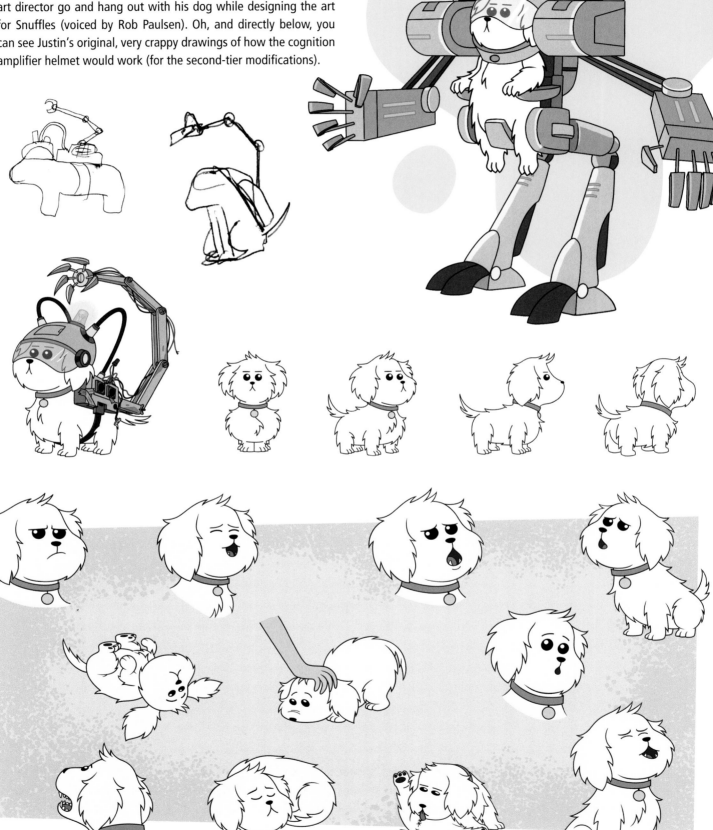

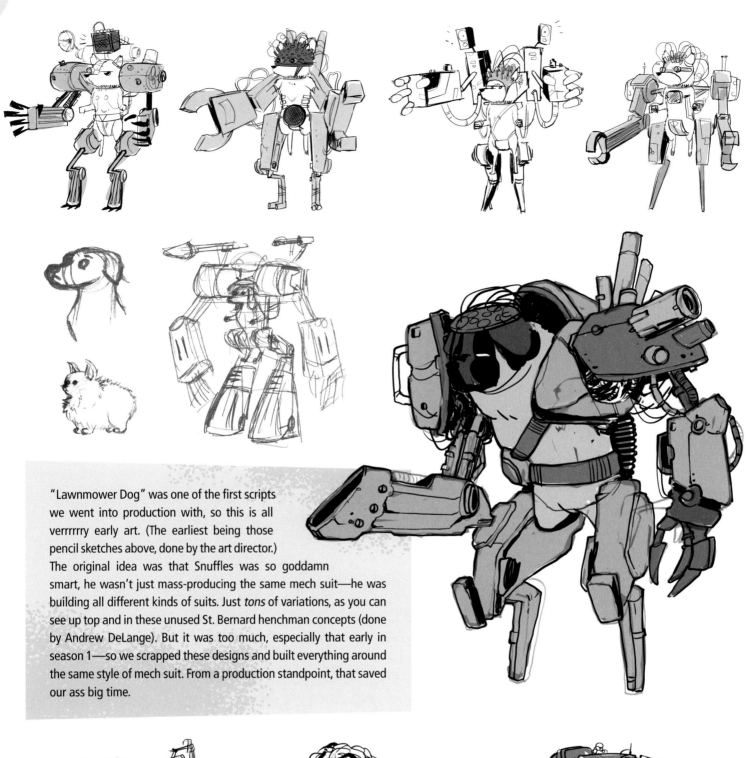

"Lawnmower Dog" was one of the first scripts we went into production with, so this is all verrrrry early art. (The earliest being those pencil sketches above, done by the art director.)

The original idea was that Snuffles was so goddamn smart, he wasn't just mass-producing the same mech suit—he was building all different kinds of suits. Just *tons* of variations, as you can see up top and in these unused St. Bernard henchman concepts (done by Andrew DeLange). But it was too much, especially that early in season 1—so we scrapped these designs and built everything around the same style of mech suit. From a production standpoint, that saved our ass big time.

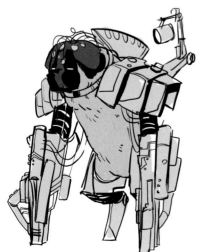

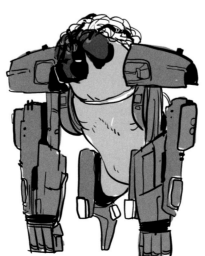

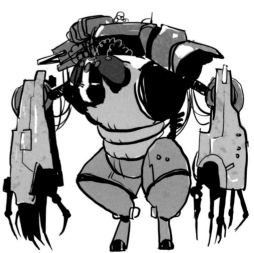

ZigeRions

"Zigerion scammers, Morty. The galaxy's most ambitious, least successful con artists." The workload for this episode was insane. This is a great example of our art team having to design an entire race of aliens, and then create variations on that race. Once the design for Prince Nebulon (*right*, voiced by David Cross) was locked down, our art team was then able to design the rest of the aliens. Unfortunately, Rick blew up their entire ship, so . . . who knows if we'll ever be seeing them again.

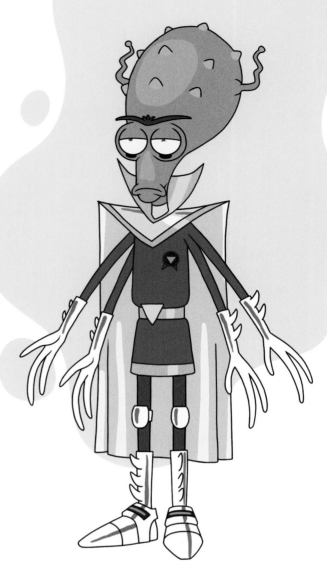

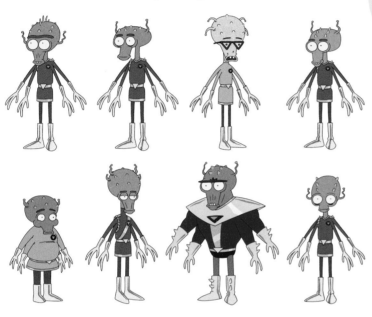

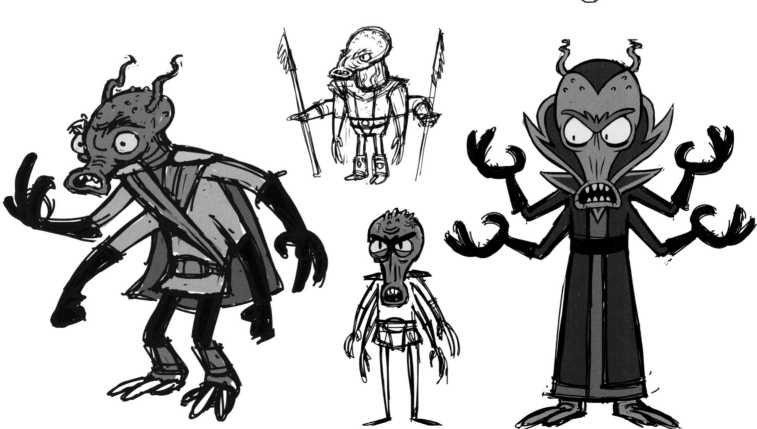

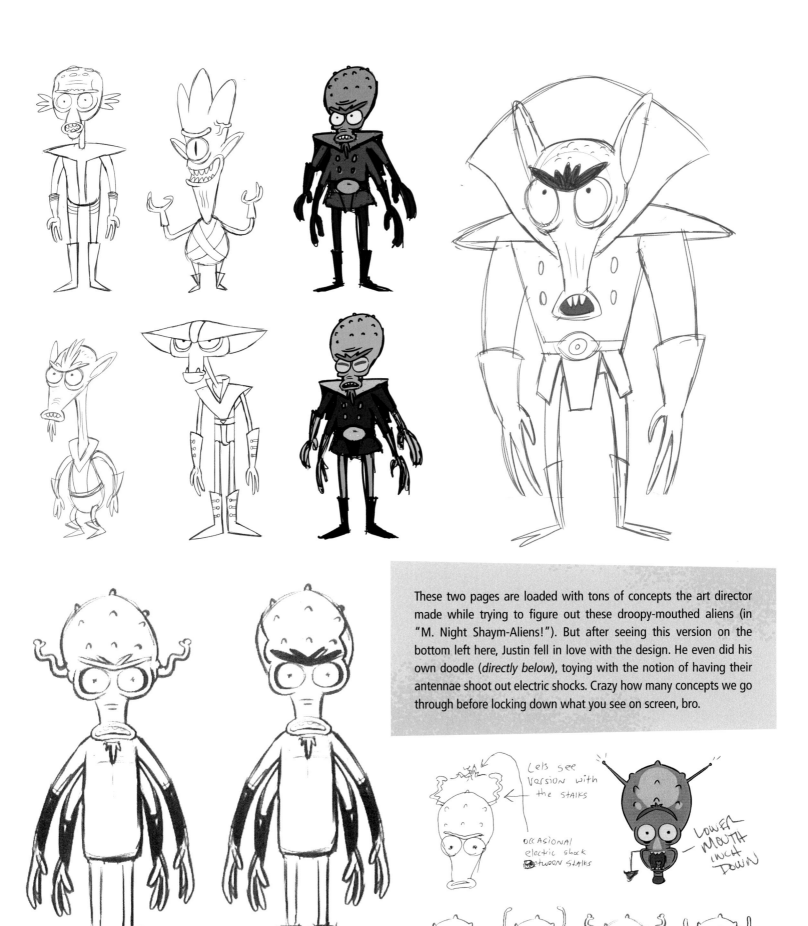

These two pages are loaded with tons of concepts the art director made while trying to figure out these droopy-mouthed aliens (in "M. Night Shaym-Aliens!"). But after seeing this version on the bottom left here, Justin fell in love with the design. He even did his own doodle (*directly below*), toying with the notion of having their antennae shoot out electric shocks. Crazy how many concepts we go through before locking down what you see on screen, bro.

Let's see version with the stalks

OCCASIONAL electric shock BETWEEN STALKS

LOWER MOUTH INCH DOWN

Mr. Meeseeks

"I'm Mr. Meeseeks! Look at me!!" You can see some very early concepts for these task-loving, existence-hating creatures at the bottom here. But Justin (who also does the voice) wanted to keep Meeseeks super simple, naked, with no clothes—a reoccurring theme in a lot of Justin's characters. Also kinda cool: Pit-Pat from *Mr. Show* was a big inspiration for this character's design. CAAAN DO!

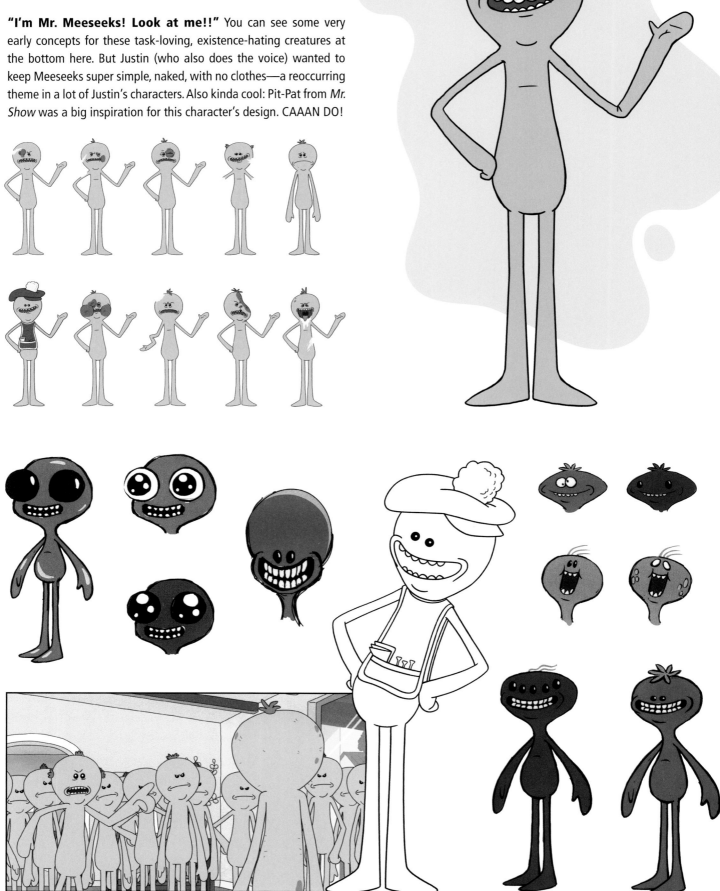

GROMFLOMITES

"They're just robots, Morty! It's okay to shoot them, they're robots!" These bug-eyed minions are not just an enemy of Rick, they also suck at the loyalty teat of the Galactic Federation. Design-wise, there's two types of Gromflomites: the grunts, who are winged, less evolved worker bugs (*directly below*), and the leading upper class, who are a little more evolved, more bipedal, and don't have wings.

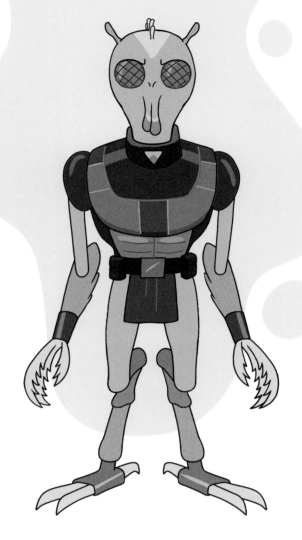

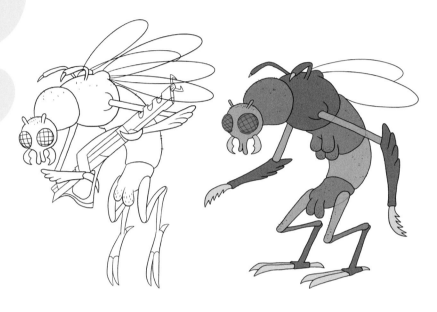

KROMBOPULOS MICHAEL

"Oh boy, here I go killing again!" Now don't be fooled: Krombopulos Michael (voiced by Andy Daly) might look like an upper-class Gromflomite, but he's actually a rogue assassin working against the Federation. He also buys illegal guns from Rick with cold, hard flerbos.

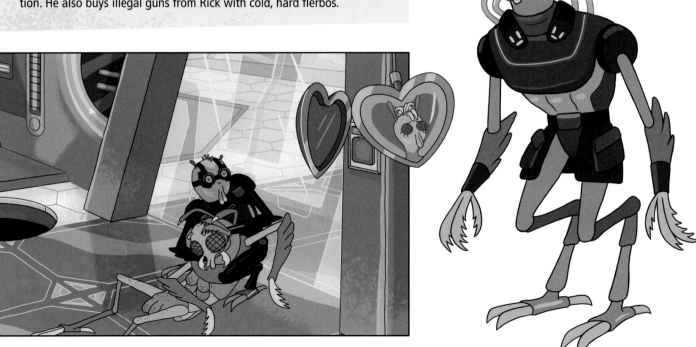

Giants

So, kinda obvious if you look at it—but the main giant was actually designed after Harmon. That wasn't always the case though. The first concept is actually in the bottom left, but once the art director drew that red line version in the middle, they were like, yep, done. The other Giant World people (in "Meeseeks and Destroy") were designed to look kinda like midwestern Americans.

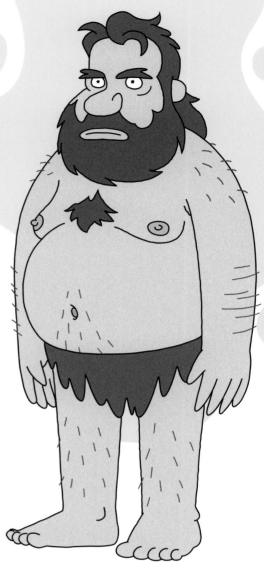

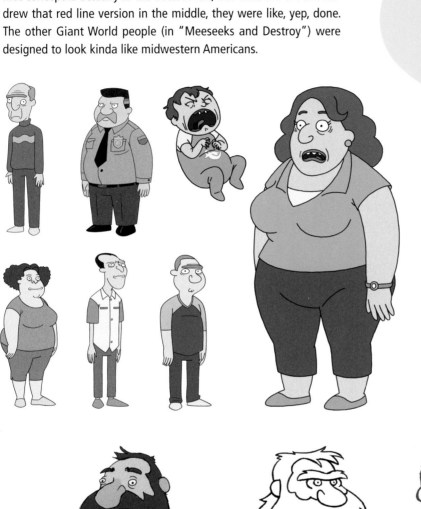

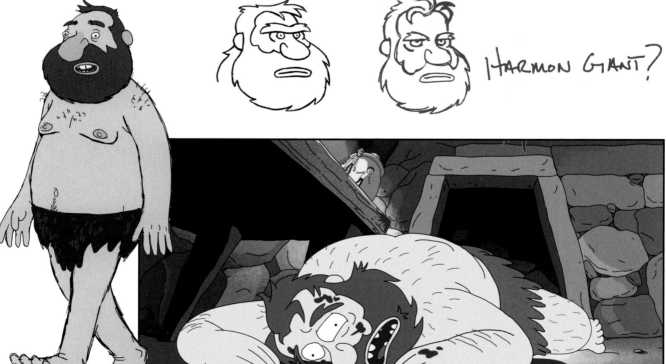

HARMON GIANT?

Stair Goblins

"Oh, wow, Rick! Look, there's little staircase-shaped people in here. A-all kinds of crazy characters!" All these shmeckle-loving creatures from the Thirsty Step—Slippery Stair, Mr. Booby Buyer—this was just Justin goofing around and having fun (*more about that on page 178*). You can see some early concepts for Slippery Stair below, as well as some drawings of weird bar aliens in the middle. The final designs for the bar creatures are at the bottom. Prettttty sure that alien with the ring-toy cones on his head (*top row*) was our first sphincter-eye character. Super proud of that.

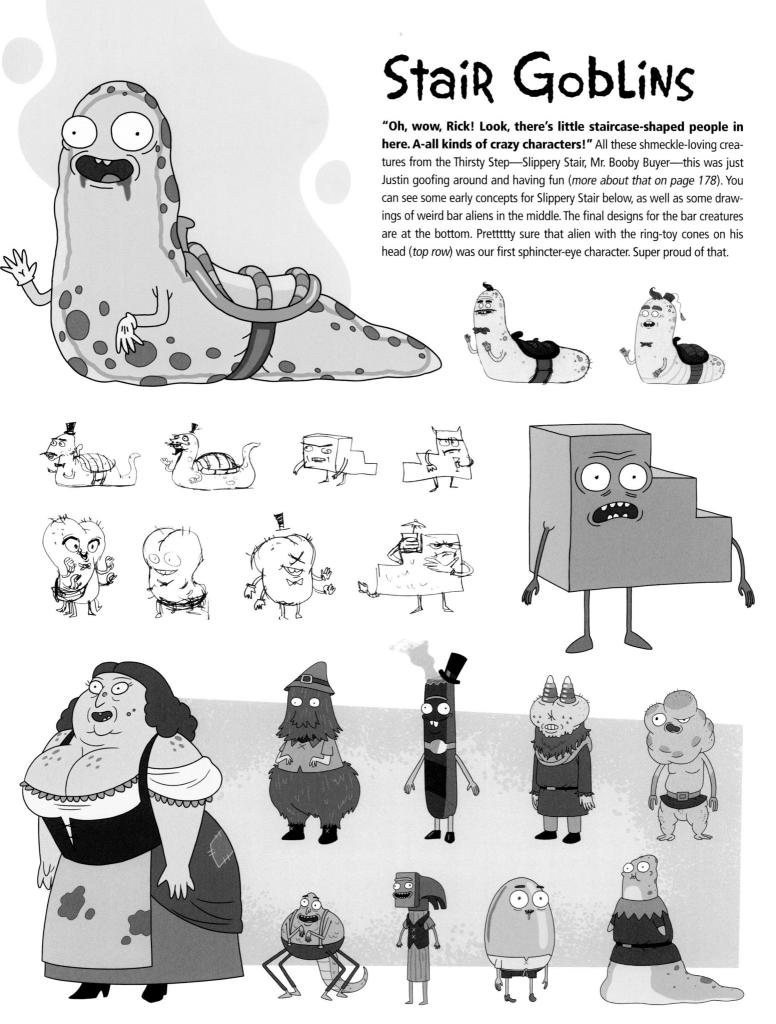

Mantises

After Rick infected the world with his love potion "antidote" (in "Rick Potion #9"), he created this weird race of mantis mutants that really wanted to make love to Morty (and then eat his head). The art below is us taking stock characters we already had and converting them into mantises. Carlos Ortega (the lead character designer) really nailed the mantis transformation—he was the first one to really bring that home.

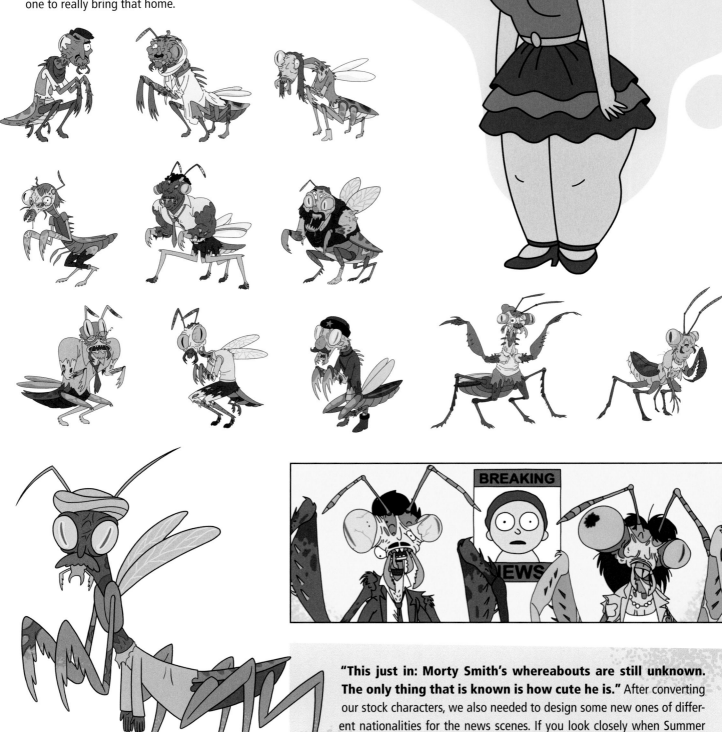

"This just in: Morty Smith's whereabouts are still unknown. The only thing that is known is how cute he is." After converting our stock characters, we also needed to design some new ones of different nationalities for the news scenes. If you look closely when Summer flips the channels, you can see some Middle Eastern mantises rioting and making out with an effigy of Morty.

CRONENBERGS

"Boy, Morty, I really Cronenberged the world up, didn't I?"
These monsters (from "Rick Potion #9") were really fun to design. When giving art direction for this, James McDermott told the artists to basically come up with three things that have nothing to do with each other, then melt them together into a character: "What would an old lady mixed with a cat and a bicycle look like?" At the bottom there, you can see the key frames for one of our stock characters transforming into a Cronenberg monster (done by character designer Zach Bellissimo).

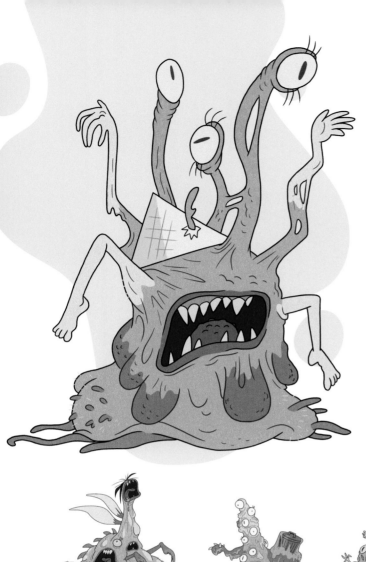

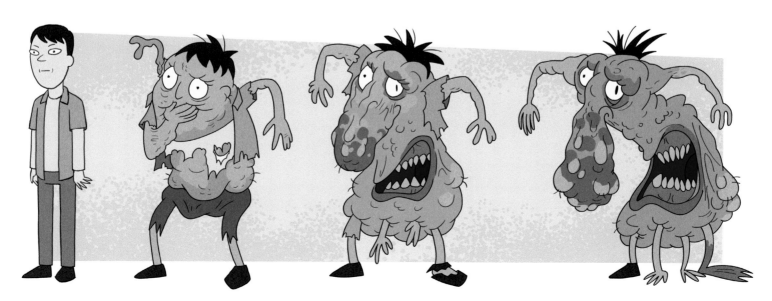

GAZORPIANS

"I am Mar-Sha, ruler of Gazorpazorp. I am here if you need to talk." Rick and Summer meet these two castes of aliens in "Raising Gazorpazorp"—you know, after Morty conceived a Gazorpian child with a sex robot? The females below are the ruling class, prospering in an underground utopia led by Mar-Sha (voiced by *Farscape* actress Claudia Black). And the males . . . Well, as Rick so delicately puts it, the males just fight with each other over fake pussy with sticks and rocks all day long.

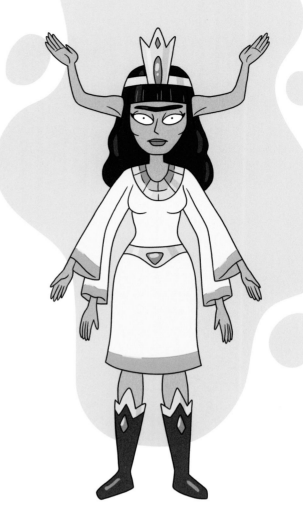

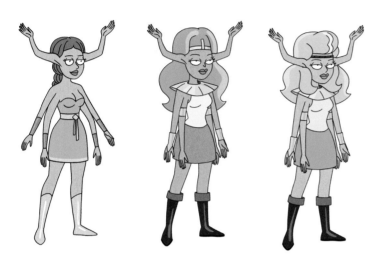

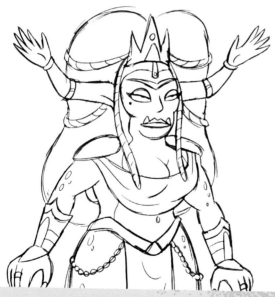

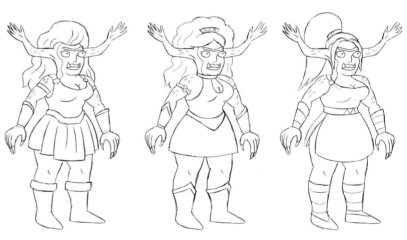

Okay, so early designs for the female Gazorpians went back and forth quite a bit. At first, they started all husky and hulkish, like their male counterparts (*on the right page*), but Justin pushed away from this—he wanted a mislead. You know, for their look to be unexpected. So the art team infused the final designs with a warrior vibe while still hanging on to femininity.

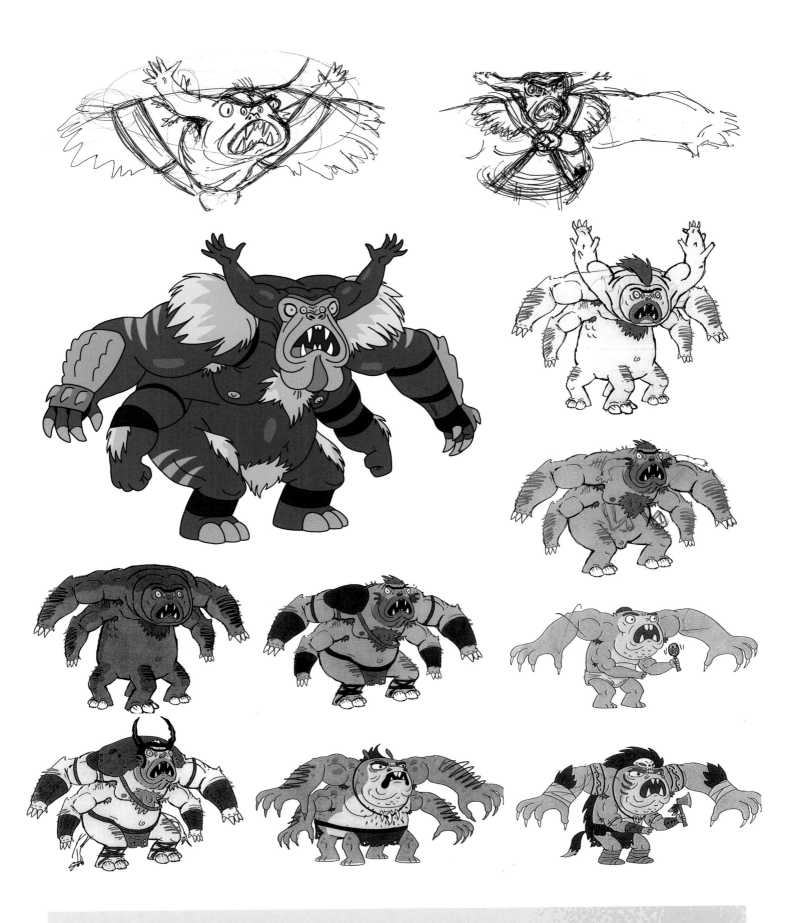

DROPPIN' LOADS! These are all super early concepts for the male Gazorpians. Almost always, multiple people on the art team would take stabs at designs: James McDermott did some initial concepts, the pencil sketches above are Steven Chunn, and the final drawing is Carlos Ortega. Once we had that final design for the males locked down, we were able to design Morty Jr. (*page 69*).

Chair People

"Yeah, I'd like to order one large phone with extra phones, please."
Chair Man #2: "Cell phone. No, no, no, no: rotary. And pay phone on half." The writers came up with this sequence while trying to figure out how to have fun with a foot chase that went through various dimensions. Instead of doing three random worlds, they decided to really dial in and cycle through three very specific concepts: chairs, pizzas, and phones.

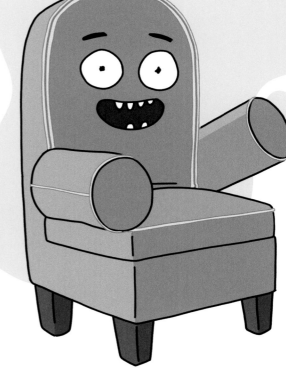

CHAIR SITTING ON MAN TALKING ON PIZZA PHONE

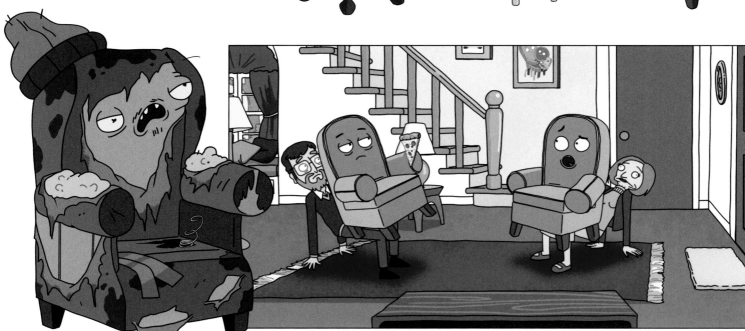

Pizza People

"Yeah, I'd like to order one large person with extra people, please."
Pizza Man #2: "White people. No, no, no: black people. And Hispanic on half." Whenever a new script came in like this—especially ones with dimensions on top of dimensions—the art director would have all kinds of questions about the new characters and locations. He'd then meet with Justin, who'd clarify things with crude drawings on the whiteboard—like the Pizza Person below, and the little chair guy at the top of the previous page.

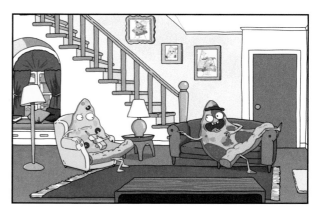

Phone People

"Yes, I'd like to order one large sofa chair with extra chair, please."
Phone Man #2: "High chair. No, no, no, no: recliner. And wheelchair on half." This was the middle world in the infamous Furniture World chase sequence (from "Close Rick-counters of the Rick Kind")—they use pizza as chairs, use people as phones, and eat chairs as food. Kinda cool: when browsing interdimensional cable channels in "Rixty Minutes," Rick flips by a Phone People version of Michael Jackson's *Thriller* dance (*page 155*). So yeah . . . infinite timelines, infinite possibilities.

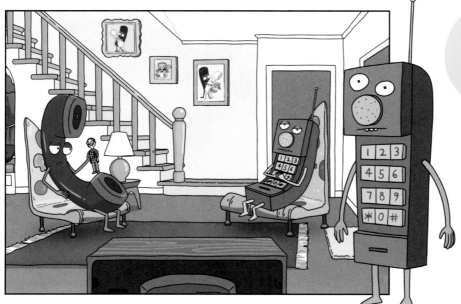

Plutonians

One of the benefits of Jerry being an idiot is that we got to meet these weird aliens in "Something Ricked This Way Comes." You can see some early Plutonian concept sketches at the bottom. Although these early designs didn't work, the one thing Justin loved from them was the pupils being crosses. Two notable Plutonians here: King Flippy Nips (*middle*, voiced by Rich Fulcher) and his scientist son Scroopy Noopers (in the white shirt, voiced by Nolan North). Unfortunately, Scroopy now lives in Plutanamo Bay.

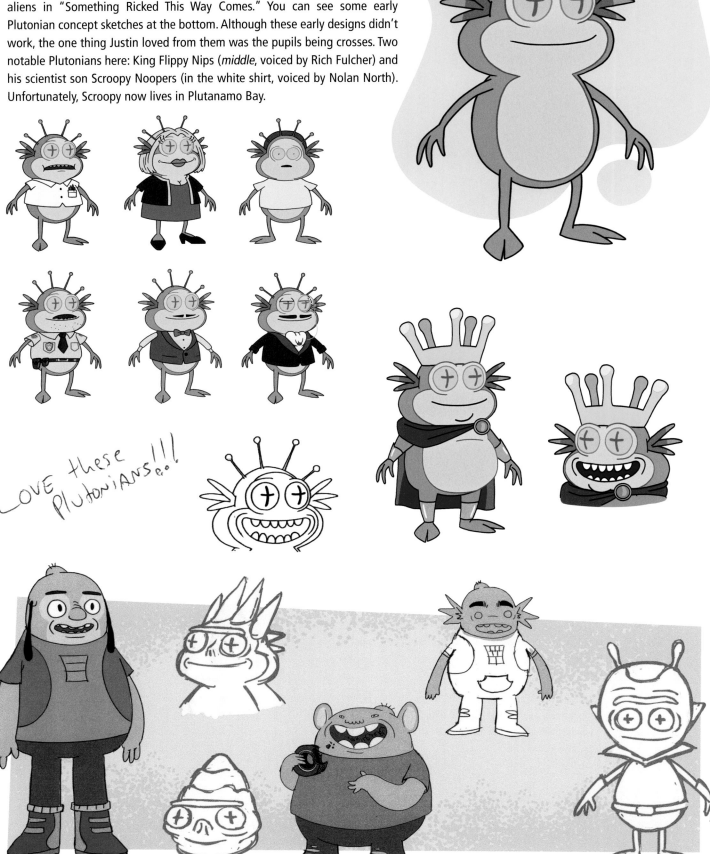

Love these PLUTONIANS!!! eol

GEaR PeoPLE

"Calling me Gearhead is like calling a Chinese person Asia Face!" The design on the left for Gearhead (a.k.a. Revolio Clockberg Jr.) was actually inspired by Roboto from *He-Man*. Justin still has the Roboto toy in his office (he's got soooo many epic, old-school toys) and showed it to the art director as a reference. Basically saying, let's make Gearhead kinda like this—but pudgier, less muscular, and *way* less cool.

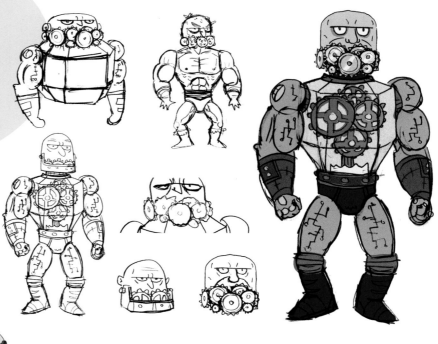

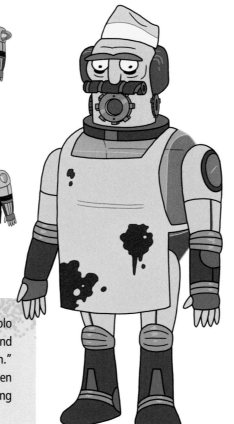

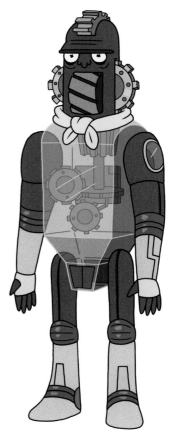

Although Gearhead (voiced by Scott Chernoff) debuted solo in "Ricksy Business," our art team got to expand on that and design a whole gear society in season 2's "Mortynight Run." Bonus gear fact: the designs and mouth charts for this alien race were a real pain in the ass because of all the interacting gears and moving parts.

Neighbors, Aliens, Mutants, and More ° 95

Unity's Hosts

Creating this hive-mind race for "Auto Erotic Assimilation" was tricky. In a perfect world, we would have designed yet another entirely new human species with almost no reuse. But instead we came up with a solution where we reused a ton of stock characters but turned their skin color blue, added three bulbs to their head, and gave them alien markings. That was a huge fix, especially since there's massive crowd shots in this episode. Also pretty cool: Unity was voiced by Christina Hendricks.

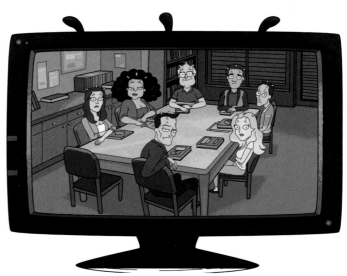

"I'm not looking for judgment, just a yes or no: Can you assimilate a giraffe?" In addition to all the kinky sex stuff and the assimilation via mouth vomit, this episode was a first for the writers in terms of exploring Rick's past romantic relationships. Ryan Ridley (the writer of this episode) loved the idea of Rick running into his ex—and not just that she's an old flame, but that she's become more successful and self-actualized than Rick. Also a first: exploring the complex racial tensions between flat and cone-nippled aliens.

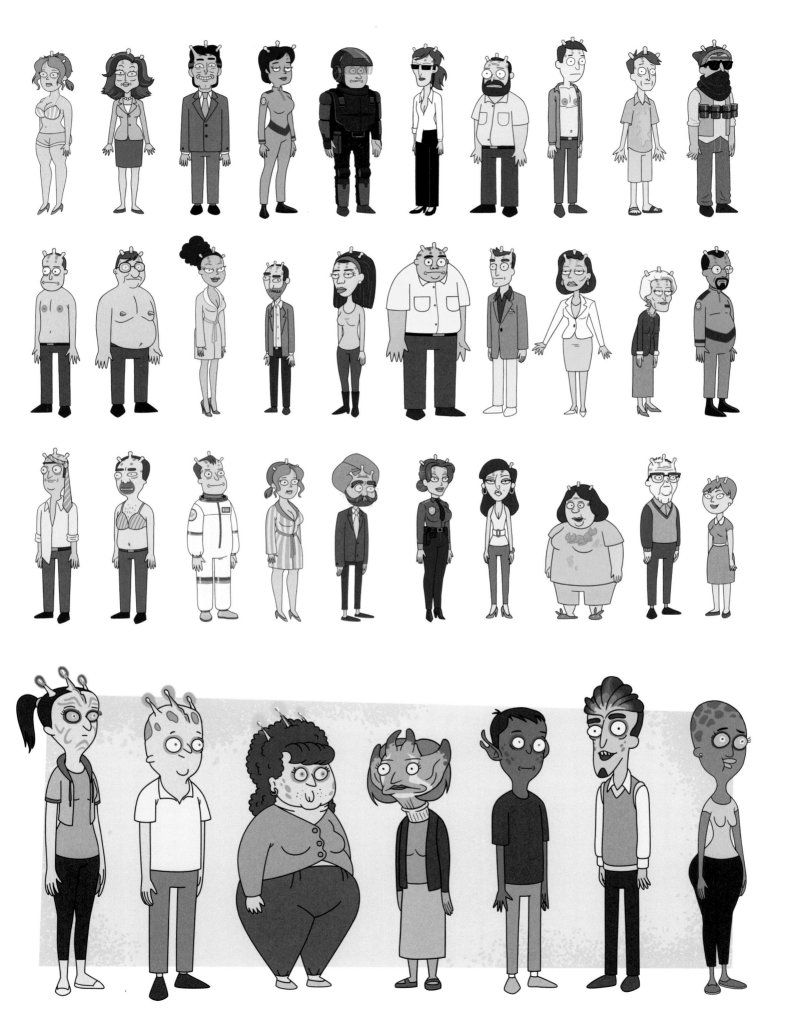

Memory Parasites

Man, this episode had *so many* fun new characters, but it killed the design team and was super challenging for the artists. At first, the art director did all these concepts using real microscopic parasites as an inspiration—they were bulkier and terrifying. But Justin was really specific about wanting the parasites to have a beef jerky–style body—kinda like a Slim Jim—really making the texture ribbed, wrinkly, and disgusting. That gave the cue for design. After that, they added a really scary face to it, along with a kinda folded foreskin over the top.

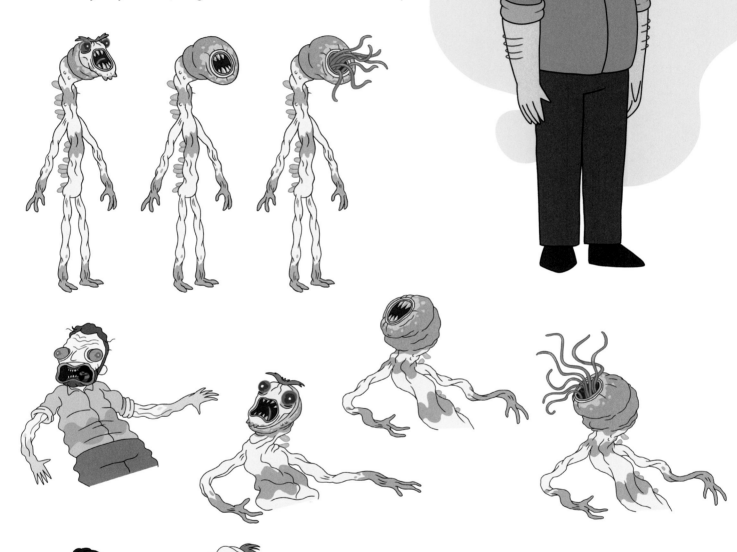

Transformations

These parasite transformations—like Uncle Steve's in the middle here—were a major challenge for animation. Bardel had to traditionally hand animate each of them, and then transfer it into Harmony (the animation software used to make the show). They broke it down into about twenty-eight different transformations, which then got reused throughout the episode. But there were a few that were so specific, they only got used once. Bardel absolutely crushed it.

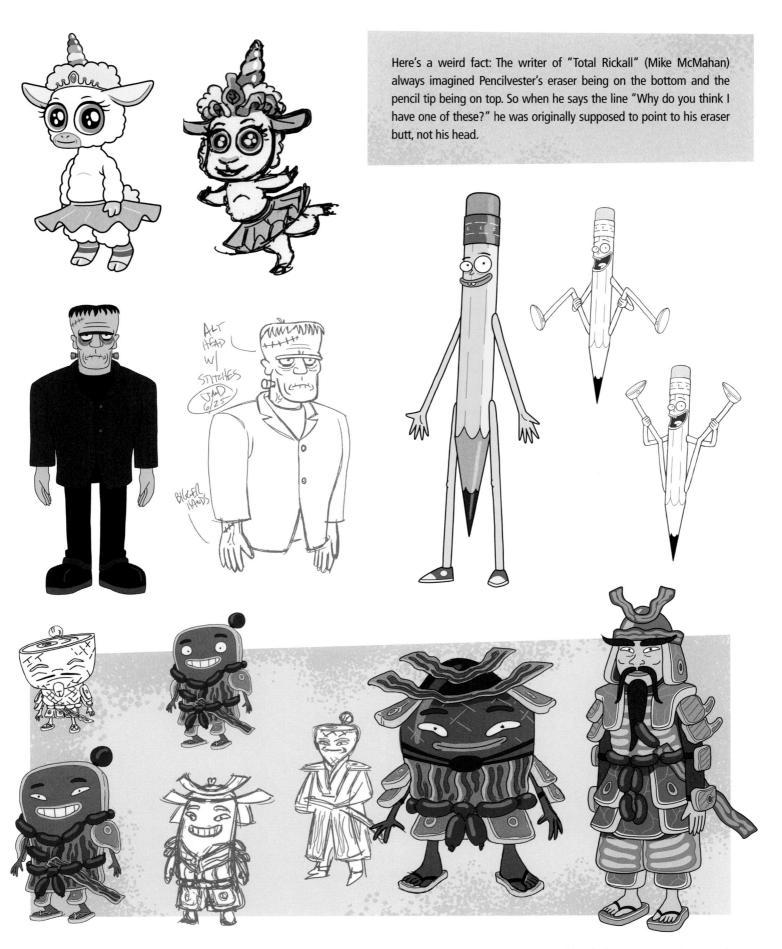

Up top, you've got some near-final concept art for Frankenstein's Monster and the magic ballerina-lamb Tinkles. (Who is just amazing, BTW.) And as you can see on the bottom here, early designs for Hamurai were very cartoony and ham-centric. But Harmon wanted it to look more realistic—like he was an actual samurai with armor that's made entirely of pork products.

"Everybody stop remembering! These parasites are like bedbugs and every flashback is another mattress!" Tons of awesome characters here: Ghost in a Jar, Mr. Beauregard, Photography Raptor, Reverse Giraffe, Amish Cyborg, Big Duck, Mrs. Refrigerator, and of course, Jerry's secret lover, Sleepy Gary (voiced by Matt Walsh). Also worth noting: that lumberjack (*second row from the bottom*) is modeled after our IT guy, Nick.

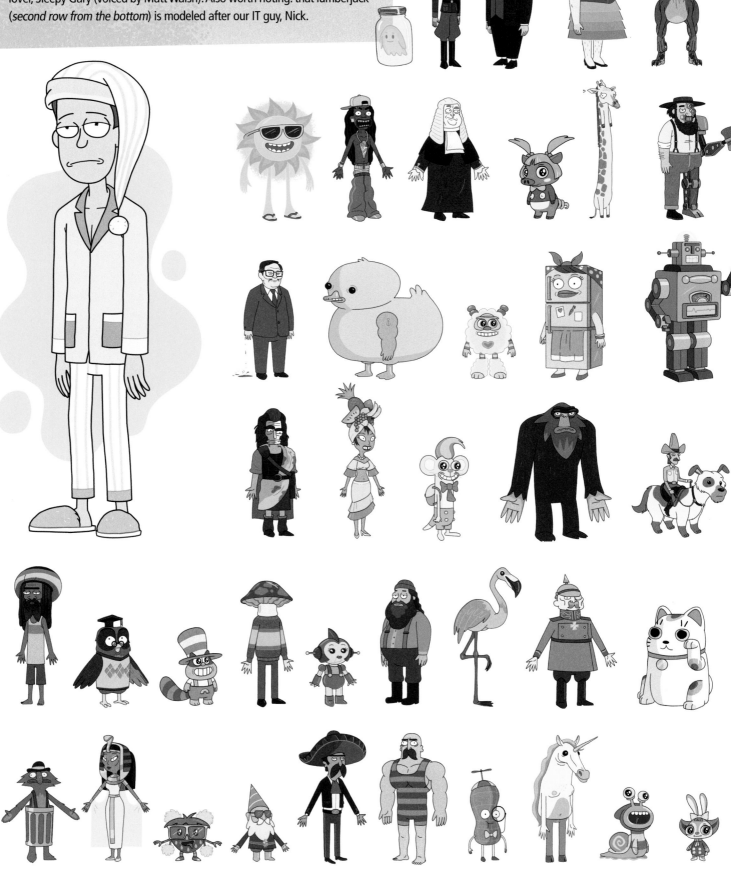

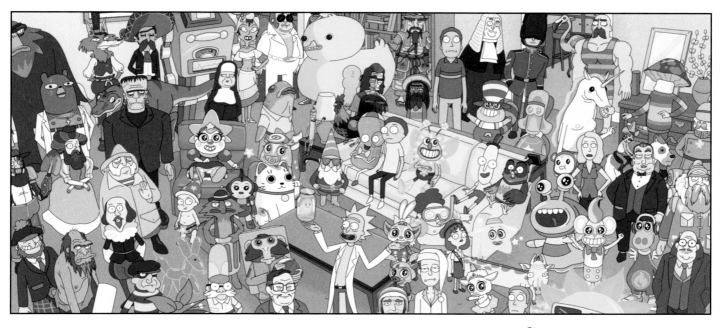

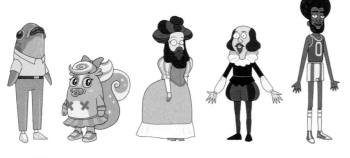

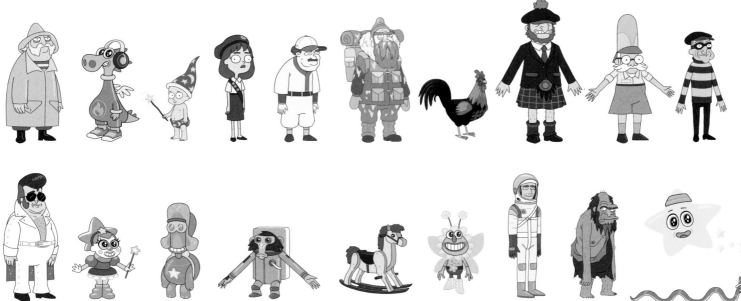

Parasite Storyboards

Before sending this episode to Bardel, the storyboards needed to be really freakin' clear, especially since we were dealing with dozens of new characters on screen together and they were all moving about from shot to shot. The director (Juan Meza-Leon) and the board artists did an amazing job making sure everything was numbered and marked so when Bardel got it to animate, it was a lot easier to manage.

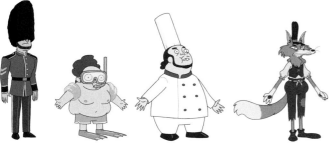

MicRoverse

Okay, so this is what the writers notoriously call a "thing in a thing in a thing" episode. After it went out to production, the art director had to reread the script three times, trying to understand: wait, whose world are we in now? But it was a super cool challenge, design-wise. Not only did the art team create an entire race of characters and environments for the Microverse world; they then went down a level and created a new Miniverse race, then went one world deeper with the Teenyverse, the Tree People, and that badass wooden mech suit (*on the right page, bro*).

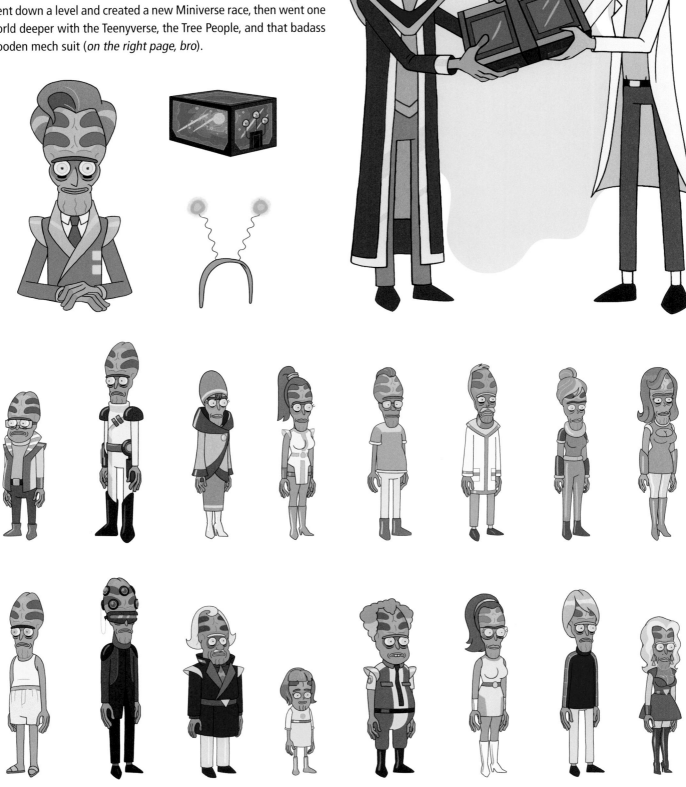

Zeep Xanflorp

"Eek barba dirkle, somebody's gonna get laid in college."
Everyone on the crew was *super* excited to have Stephen Colbert do the voice for Zeep. And wanna know something crazy? Zeep's look actually came from rejected Cromulon head designs (*page 105*). Once they chose that, it informed the design for the rest of this alien race very quickly.

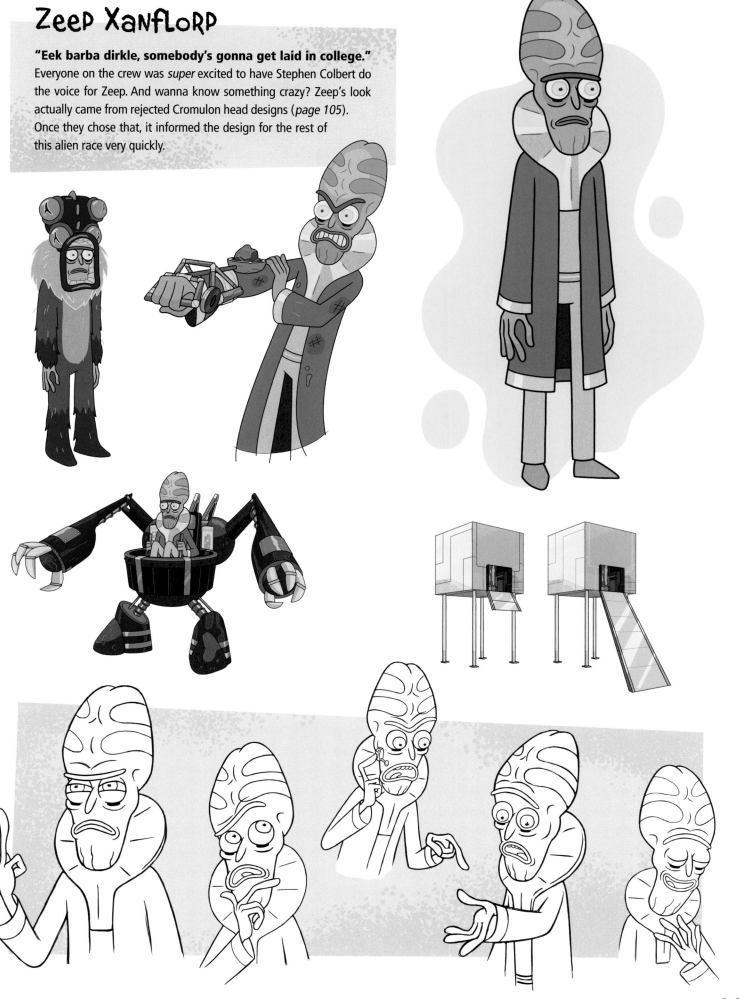

Miniverse

Just in case your mind is spinning, here's the world breakdown: Rick created the Microverse that Zeep lives in, Zeep created the Miniverse that Kyle lives in, and Kyle created the Teenyverse that the Tree People live in. Even though Kyle (*right*, voiced by Nathan Fielder) had the simplest design out of everyone, he's actually the one that took the longest to land on. Check out the early drawings of Kyle sprinkled throughout the Sketches section (*pages 212–215*). There's so many iterations of this dude. But much like Mr. Meeseeks, Justin wanted to keep him clean, white, and super simple.

Teenyverse

When trying to figure out the design for the different worlds, the art team tackled Kyle's Teenyverse first because it was the most basic—okay, we're in a primitive time, there's Tree People here, they eat every third baby because they think it makes fruit grow bigger. From there, they took on the Microverse and Miniverse worlds (*which you can read about on pages 196–197*).

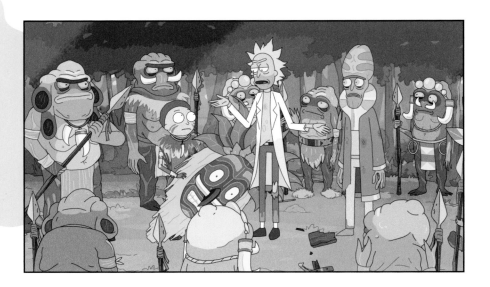

CROMULONS

"SHOW ME WHAT YOU GOT!!" Oh man, remember these guys? The giant, floating heads from "Get Schwifty" that feed on the talent of less evolved life forms? The initial thought for design was to go for more of a deity look, kinda like Easter Island heads. But Justin wanted the Cromulons to look bored, waiting for the perfect tune—and also a little bit more like Patrick Stewart from *Star Trek: The Next Generation*. You can see some alternate designs ("alts") below that didn't make the cut. "DISQUALIFIED!"

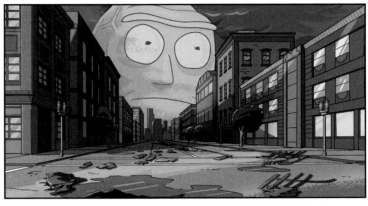

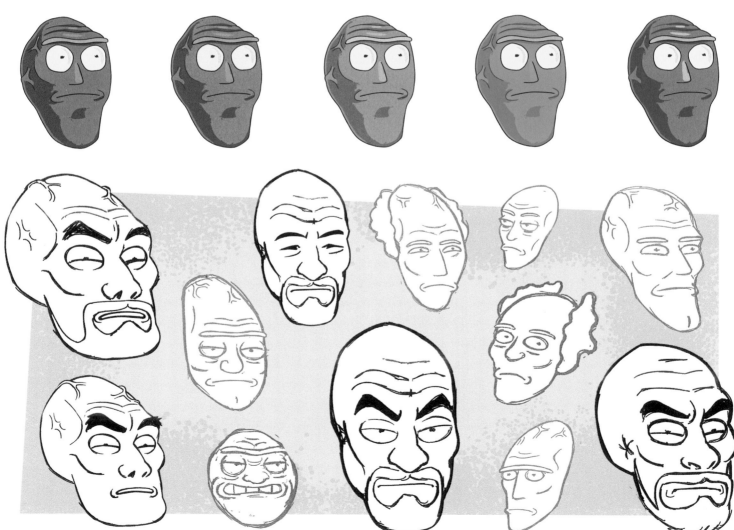

PuRge PeopLe

"I-i-it's a Purge Planet. They're peaceful, and then, you know, they just purge." Fun fact: The writers wrote this script in a very short time, having never watched a single Purge movie. They just assumed . . . and then turned out to be pretty close. As for character design, there's some early hand-drawn sketches for the Lighthouse Keeper below. Arthrisha (voiced by Chelsea Kane) was much tougher to figure out—we went through lots of iterations of her. But once it went out to production, Justin really liked what Erica Hayes did in her storyboard panels, so we ended up designing Arthrisha more off her take.

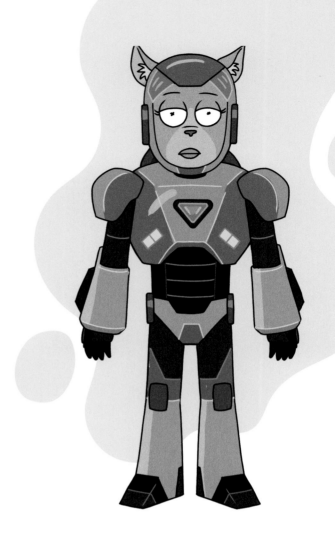

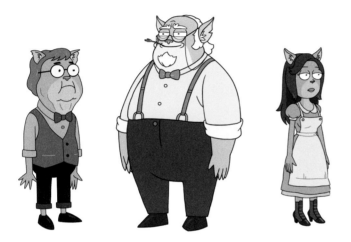

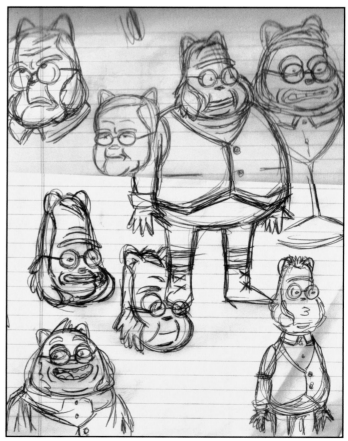

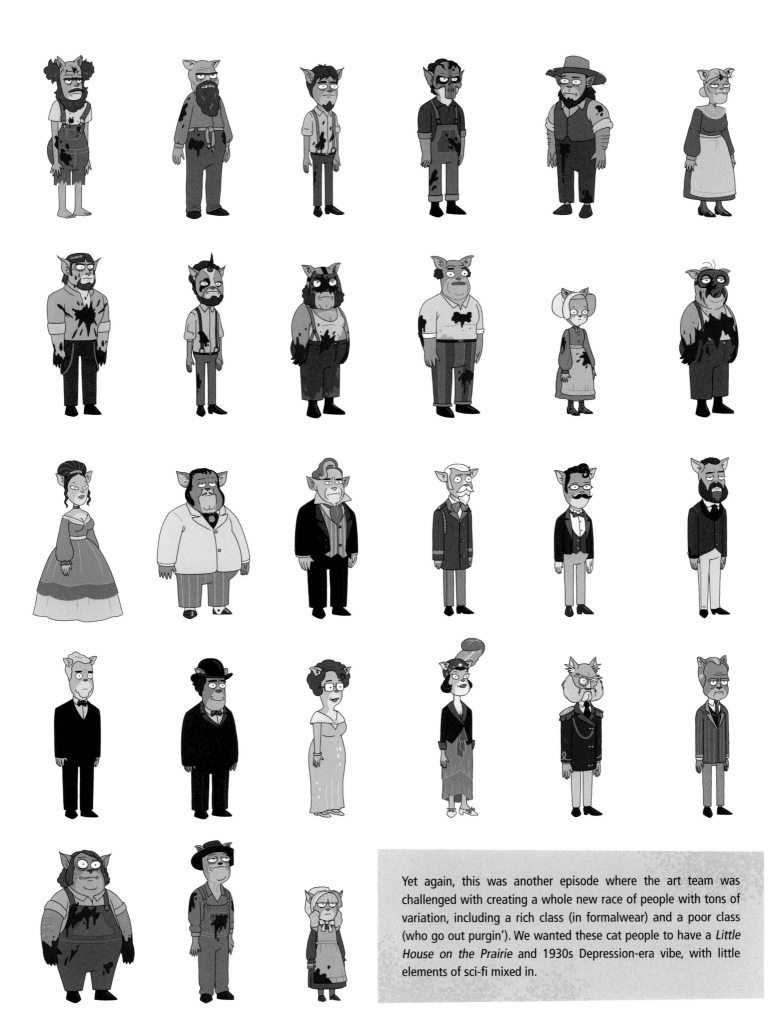

Yet again, this was another episode where the art team was challenged with creating a whole new race of people with tons of variation, including a rich class (in formalwear) and a poor class (who go out purgin'). We wanted these cat people to have a *Little House on the Prairie* and 1930s Depression-era vibe, with little elements of sci-fi mixed in.

BALL FONDLERS

Dan and Justin thought it was super funny these interdimensional TV stars (first seen in "Rixty Minutes") were called Ball Fondlers, but never actually fondled each other's balls. As for design, the original thought was to give them a *Teenage Mutant Ninja Turtles* crime-fighter vibe, but we eventually scrapped that and switched to a bizarro *A-Team* look. Also—probably not a surprise, but Justin designed that weird-looking bean dude.

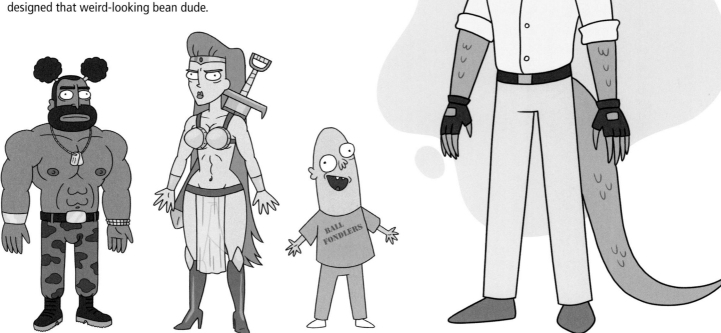

FaRt

"My kind has no use for names. I communicate through what you call Jessica's feet. No. Telepathy." Although technically nameless, this ethereal gas cloud (voiced by Jemaine Clement) was originally called "Koof" in the script. Production-wise, he was extra tricky because we wanted him to be *constantly* animating. Bardel did an amazing job with the animation cycles on this guy. Also amazing—that trippy David Bowie-esque song sequence for "Goodbye Moonmen", which our in-house artist Caroline Foley animated almost entirely herself. I mean, Fart probably deserves a bigger section in this book—but Morty vaporized him with an anti-matter gun. So, yeah . . . doesn't really matter.

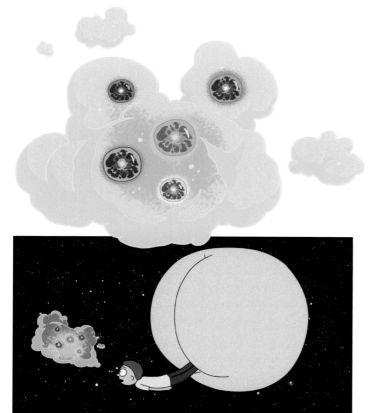

Politicians

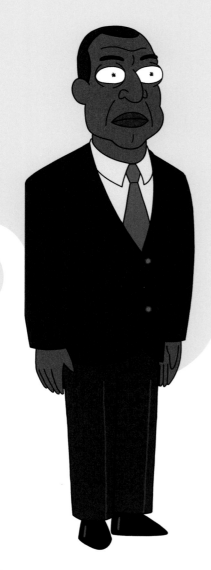

"I LOVE THIS MAN!!" The whole idea for Rick and the president was really an homage to *Doctor Who*—Dan just liked the idea that every once in a while, the president could recruit Rick for a specific mission (like the prime minister did with *Doctor Who*). Art-wise, you can see some alts below that helped get us closer to the final designs for "Get Schwifty." Oh, and the writers definitely geeked out during the recording sessions: The president was voiced by Keith David, and General Nathan was voiced by Kurtwood Smith—both of whom starred in iconic '80s sci-fi movies that heavily influenced the writers and the show.

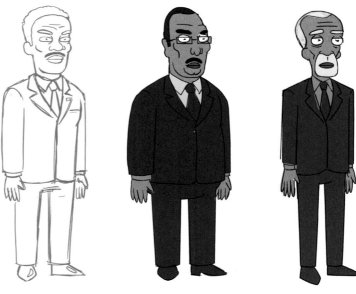

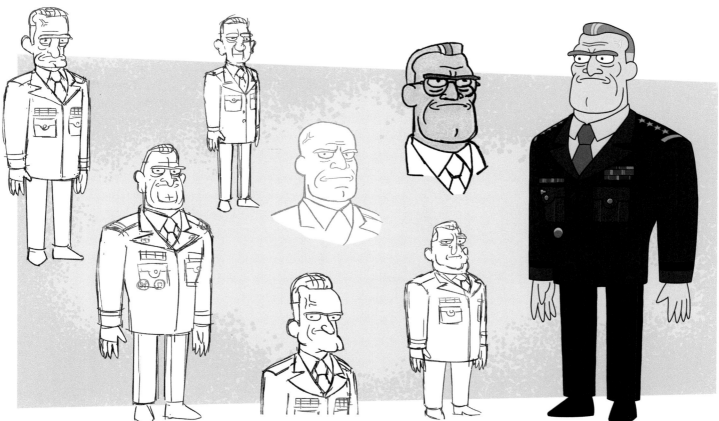

Scary Terry

"You can run, but you can't hide, bitch!" Although Scary Terry (voiced by Jess Harnell) might just look like some legally safe knockoff of an '80s horror character with miniature swords for fingers instead of knives, he's a lot more complex than that. One: he's a family man (father to Scary Brandon, husband to Scary Melissa). And two: he suffers from the same stressful no-pants-at-school nightmares as everyone else. Thankfully, Rick and Morty incepted themselves into his dreams (in "Lawnmower Dog") to help him chill the F out: "Hey, yo, Scary-T. Don't even trip about your pants, dawg. Here's a pair on us, fool!"

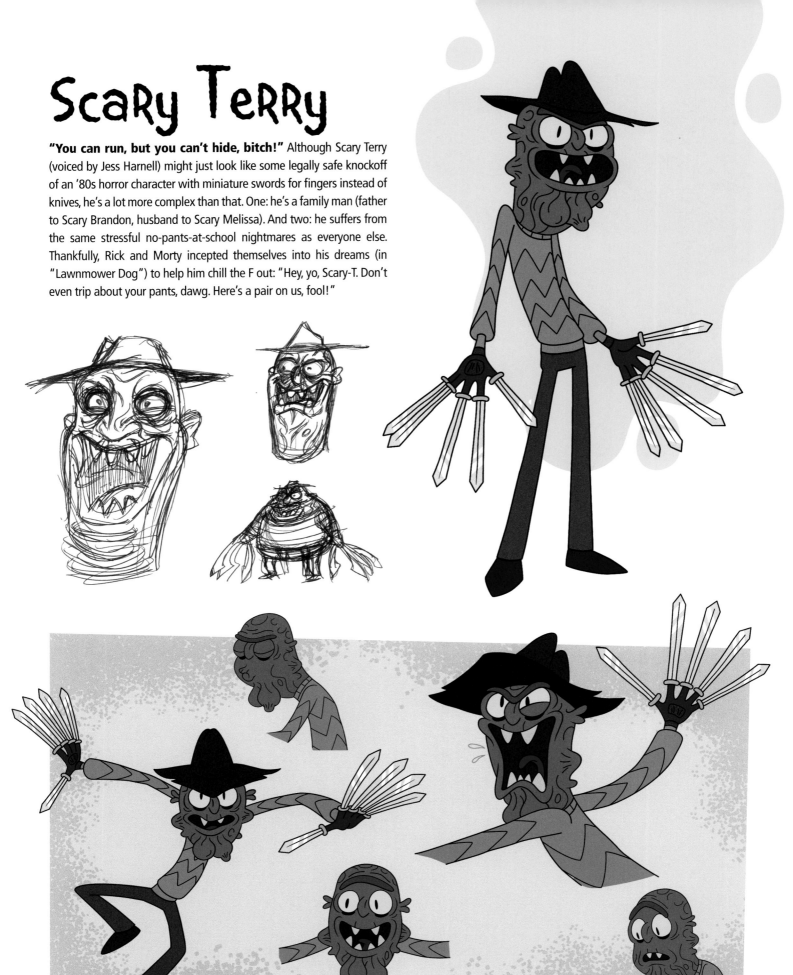

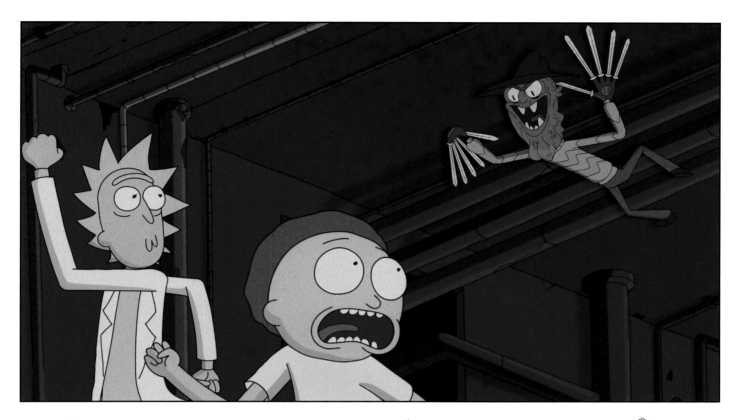

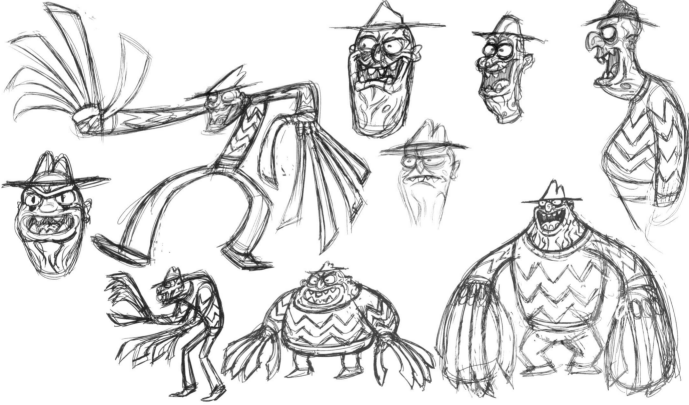

These are early, earrrrlllllyyy pencil sketches by art director James McDermott, literally done during the first week of production on the series. In fact, Justin never even saw these drawings until now—this was all McDermott messing around in his sketchbook, figuring out the character. But once he added Scary Terry's "chinsticles," he really tapped into the look of the show and nailed this infamous final design, bitch.

Body Explorers

In the beginning of season 1, the writers had this big list of classic sci-fi tropes and technology: multiple dimensions, teleportation, etc. And one of the big ones was—okay, we have to do a shrink episode. It's totally sci-fi, there's tons of '80s movie references. In fact, this was originally gonna be a zombie movie combined with an *Innerspace* kinda thing, but then it slowly became *Jurassic Park* mixed with *Innerspace*. Check out the final designs here for Poncho, Annie, and of course, Dr. Xenon Bloom (voiced by John Oliver)—all of whom lived inside the body of a homeless guy named Reuben.

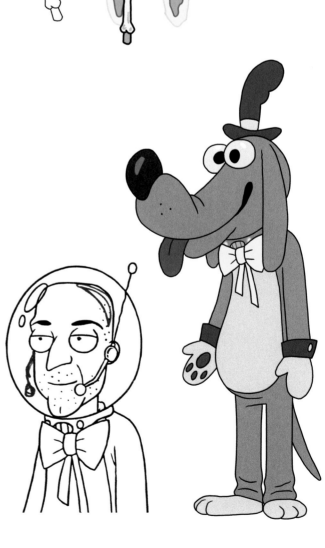

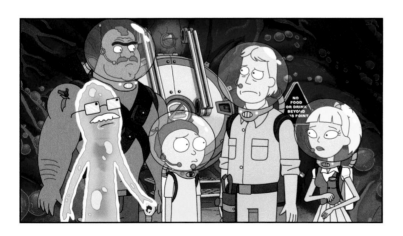

You're probably wondering: what's with the drawing of this dude on the right? That's the character *inside* Dippity Doo's mascot suit. We designed him to look like Rob Schrab, who also did the voice for Dippity Doo. You can catch a super quick glimpse of him in "Anatomy Park" when the mascot head comes off.

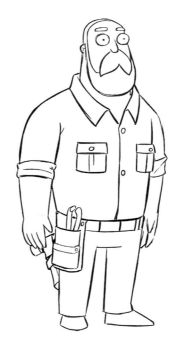

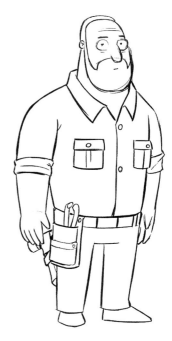

Up top are a handful of original design alts for Roger (voiced by Jess Harnell). But Justin wanted him to look more like a normal dude; he thought it looked too cliché to have a big, burly repairman—hence the change in Roger's final design. You can also see key poses below for when Dippity Doo is being coughed out of the homeless guy's lungs at such a speed that it literally rips his face off.

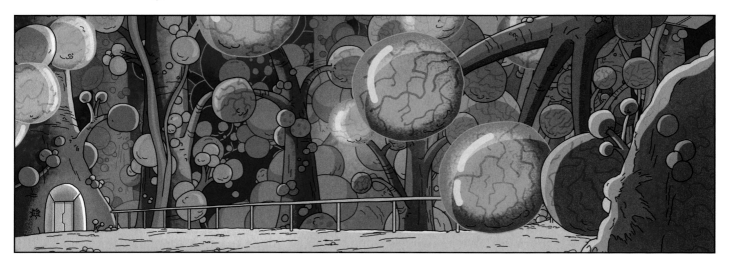

Pop-Tart People

"Why would a Pop-Tart want to live inside a toaster, Rick? I mean, t-that would be like the scariest place for them to live."
Just one of the crazy creatures the Zigerions (*pages 82–83*) put into their incompetent Earth simulation. This bit originated during Dan's pass on the script, with him adding the line about the Pop-Tart living in the toaster. The artists then added the later version of the tortured Pop-Tart during the chase sequence. Teamwork!

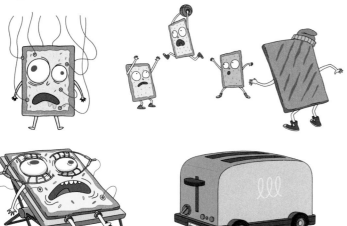

Garblovians

Okay, so everyone around the office calls these guys "Garble" aliens. And they're pretty freakin' bizarre, even for us—they explode into goo, cannibalize each other's slime, and continually scream "AGA BLAGH BLAGHH!" Even though they technically debuted in season 2, the design for these dudes was floating around forever—that blue, toothy head was a concept the art director originally made for the Gazorpians (*pages 90–91*). It didn't work for them, but it was awesome, so we held on to it . . . finally showcasing them on the Jerryboree asteroid (in "Mortynight Run"). Since then, these weird googas have appeared a bunch, like in "Interdimensional Cable 2" (*below*) and the couch gag from the crossover with *The Simpsons*.

MR. Jelly Bean

The design for this infamous bean creature who assaulted Morty in the Thirsty Step (in "Meeseeks and Destroy") is actually based on a character called Crumply Crumplestein, a child-murdering kids' show host featured in Justin's Channel 101 short *Unbelievable Tales*. Justin made that to shock people, to see the audience cover their eyes—which, ironically, is the same creative energy that made *Doc and Mharti*. As for Mr. Jelly Bean (voiced by Tom Kenny), let's remember him more for the idea he represented than for the jelly bean he actually was.

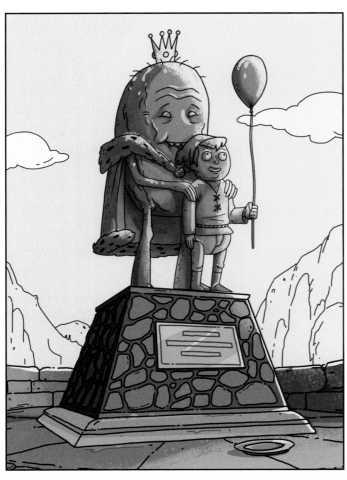

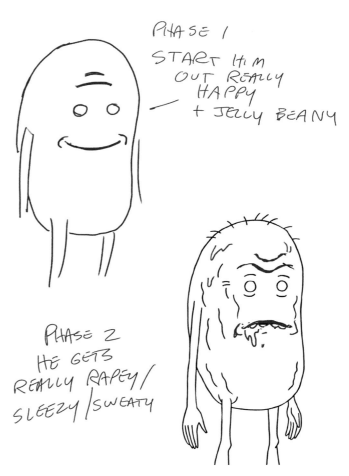

PHASE 1
START HIM OUT REALLY HAPPY + JELLY BEANY

PHASE 2 HE GETS REALLY RAPEY/ SLEEZY/SWEATY

MR. Needful

"I'm the devil, biyotch! What WHAT!" When designing Mr. Needful (voiced by Alfred Molina), we really wanted him to be slender and mirror Rick in his proportions. The goal was that Rick was meeting his match—meeting his first real nemesis. We also added a Vincent Price kinda vibe to him. You can see a bunch of early iterations below (from "Something Ricked This Way Comes"), with the red line drawing getting it a lot closer to the final.

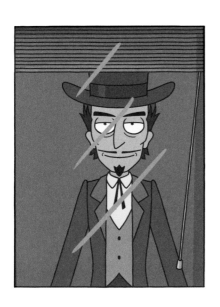

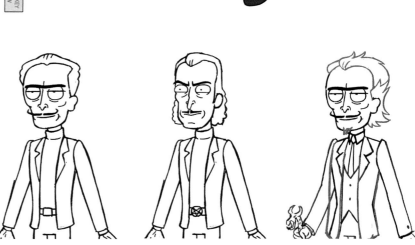

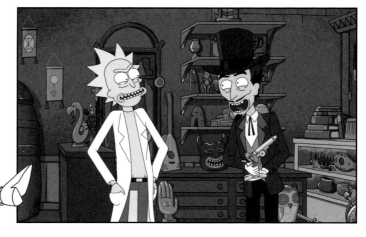

Abrodolph Lincoler

"Prepare to be emancipated from your own inferior genes!!" The early concepts for this conflicted maniac (from "Ricksy Business") had him looking way too much like Abraham Lincoln. As you can see in Justin's notes below, he wanted Lincoler (voiced by Maurice LaMarche) to look more Hitler-ish, but without the swastika. The design team then added a cool bounty hunter outfit. Kind of ridiculous—the writers have also pitched ideas about "Adolham Hitcoln" . . . Lincoler's possible other half.

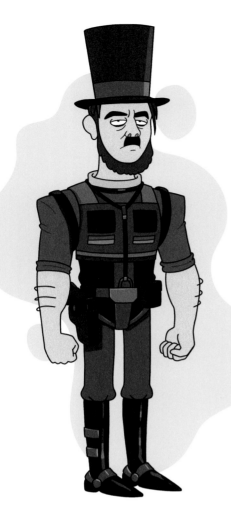

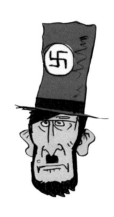

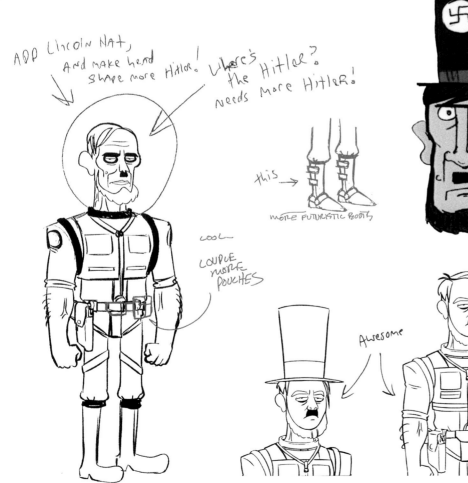

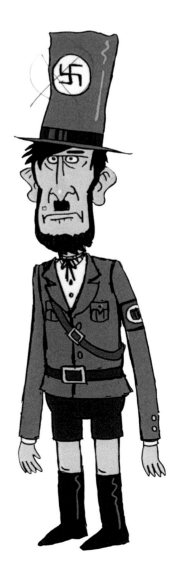

Rick's Friends

While breaking the story for the season 1 finale ("Ricksy Business"), the writers talked about doing an episode where all of Rick's nemeses came back—you know, people like Abrodolph Lincoler (*page 117*). But instead of Rick fighting them in a big showdown, the writers decided to have it be more like an '80s house party movie. Below is an almost-final design for Slow Mobius, as well as some early designs for Scropon. But enough about that—let's get wriggedy wriggedy WRECKED, son!

this is cool

maybe Loose Bett?

I'm ok with this Body And Clock size

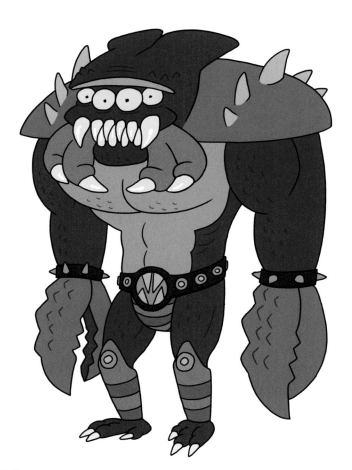

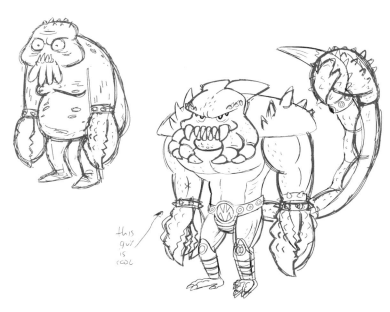

this guy is cool

"Red Line" Drawings

Okay, so these red line drawings here (and throughout the book) are worth noting. They're drawn over the initial art to make corrections or tweaks to the designs—basically saying "let's add that" or "let's try it more like this." Pretty much all the red lines in this book were done by the art director, James McDermott.

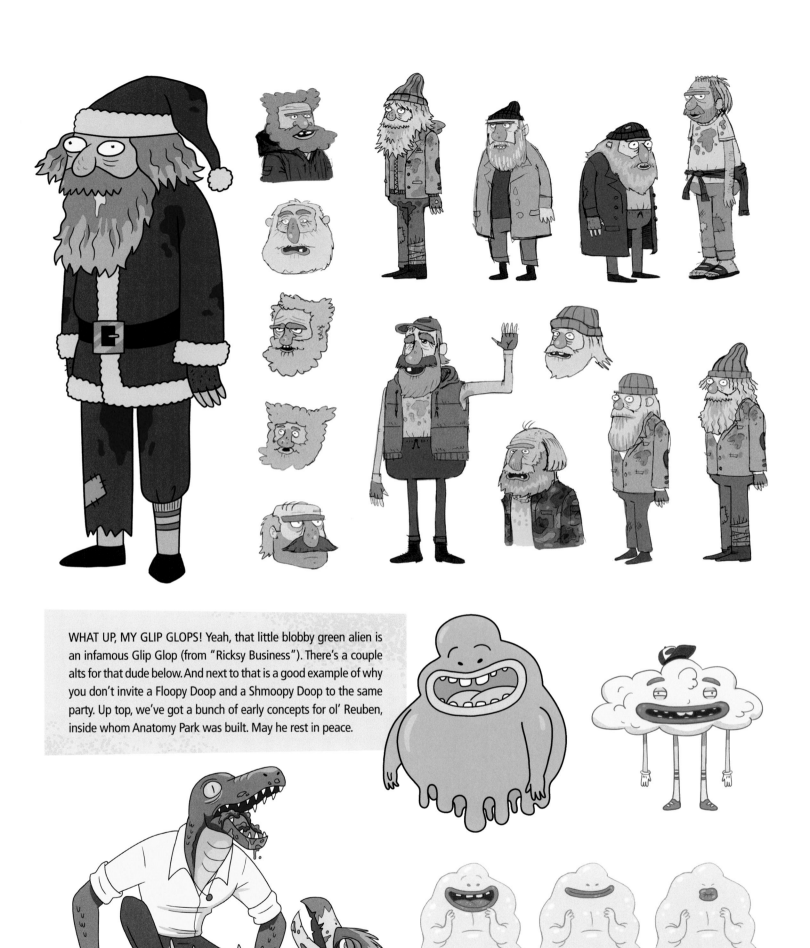

WHAT UP, MY GLIP GLOPS! Yeah, that little blobby green alien is an infamous Glip Glop (from "Ricksy Business"). There's a couple alts for that dude below. And next to that is a good example of why you don't invite a Floopy Doop and a Shmoopy Doop to the same party. Up top, we've got a bunch of early concepts for ol' Reuben, inside whom Anatomy Park was built. May he rest in peace.

COURIER FLAP

"It's a Courier Flap. It's like the intergalactic version of UPS, but less off-putting." When designing this mucus-y alien from "The Wedding Squanchers," the art director loved the whole idea of Courier Flap looking like a floating testicle, but then having these flaps that you had to stick your hand into. It just seemed really weird, so he went with it.

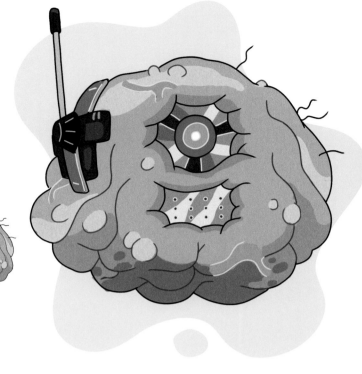

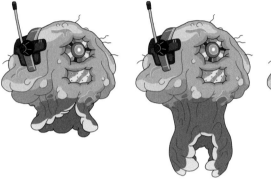

Lucy

"Draw me, Jerry." On the writing side, the basic idea was to make Lucy (voiced by Alejandra Gollas) this cheesy *Titanic* character, then intertwine that with a Robert De Niro in *Cape Fear* kinda intensity. Hence the homage to *Cape Fear* in her death scene. There's some early concepts below, with notes that helped push her closer to the final design.

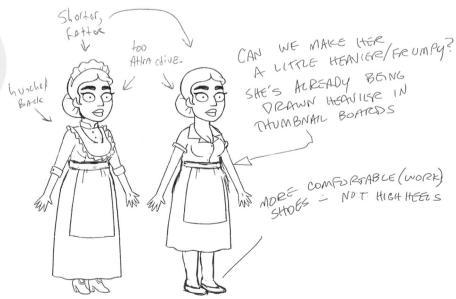

Shorter, fatter

too attractive.

hunched back

CAN WE MAKE HER A LITTLE HEAVIER/FRUMPY? SHE'S ALREADY BEING DRAWN HEAVIER IN THUMBNAIL BOARDS

MORE COMFORTABLE (WORK) SHOES - NOT HIGH HEELS

ShLeeMyPants

Just your average time-traveling, fourth-dimensional testicle monster. As far as design goes, Shleemy's mouth chart (in "A Rickle in Time") was one of the toughest things to figure out. He's a very *Little Shop of Horrors* type character with a really big, unconventional mouth—and because it had all these angles, it made it really tough to sound out every "ooh" and "ahh." There's a couple mouth poses in the center strip below; you can imagine how hard that would be to animate. Tag-team bonus (literally): Keegan-Michael Key voiced Shleemypants, and in the tag, Jordan Peele voiced his testicle monster friend who helped beat up Einstein.

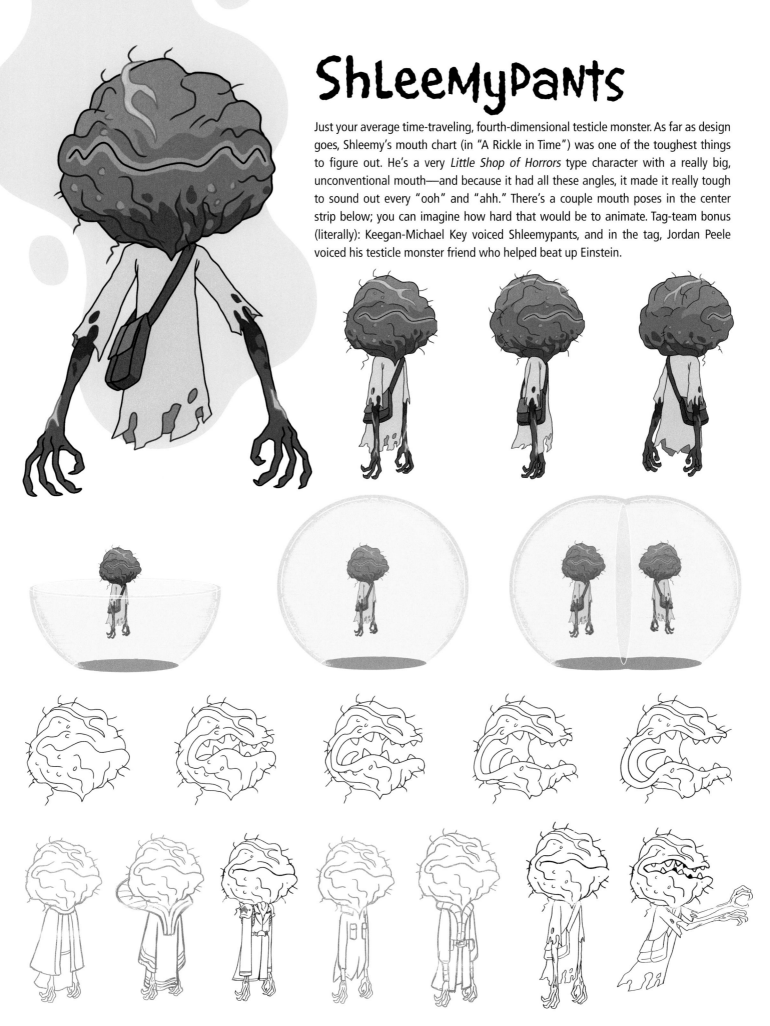

Albert Einstein

"I _will_ mess with time!" The goal with Einstein (in "A Rickle in Time") was to make him look exactly like Rick from behind so that when Shleemypants found him, there'd be a mislead. You can see a bunch of earlier versions (_below_) that looked a lot more realistic, but Justin wanted him to look as Rick-ish as possible . . . while still being identifiable as Einstein.

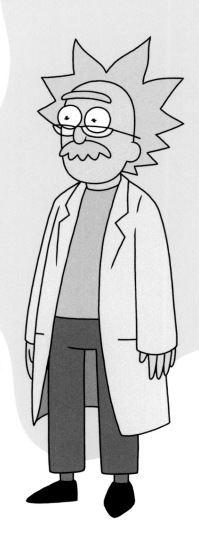

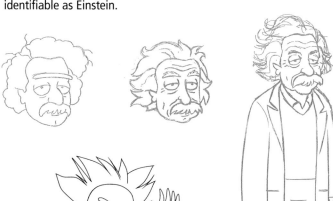

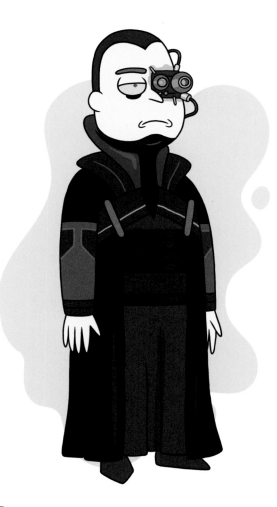

Beta Seven

Beta Seven's look (in "Auto Erotic Assimilation") was based largely on the Borg from _Star Trek_ with little hints of Patton Oswalt (who did the voice) mixed in—almost as if Patton Oswalt had been assimilated into Unity's collective. Also kinda obvious, but he's clearly jealous of Unity's down-'n'-dirty relationship with Rick. He wanted that hive mind sex, dawg!

Hunter

This melting goo boy was infamously used by Rick's ship as a deterrent to keep Summer safe in "The Ricks Must Be Crazy." The art team loved this bit, but some said this is one of the most fucked up things they've ever had to draw. Which, you know, really says a lot.

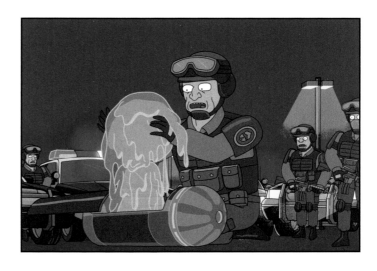

Blim Blam

"First of all, hello. My name is Blim Blam the Korblok. Second of all, cards on the table, I'm a murderer that eats babies, and I came to this planet to eat babies." Originally, that blue pattern on his nose was designed to be a series of little mouths that would talk in unison. But it wound up being too difficult to track, so we killed it and just had the red bulbs on the bottom act like mandibles. Oh yeah, also worth noting, this googa from "Auto Erotic Assimilation" has what you might call . . . space AIDS.

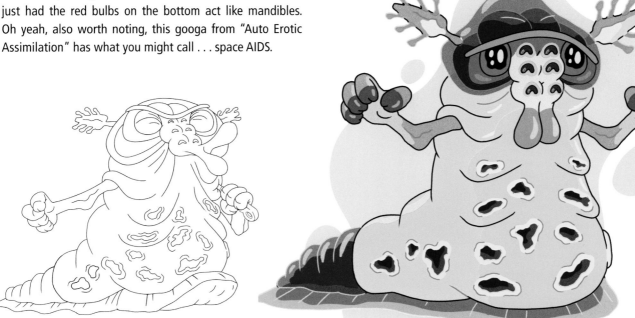

Ice-T and Crew

Sure, you know him as a rapper here on Earth, but Ice-T's story begins at the dawn of time in the faraway realm of Alphabetrium. We had a bunch of initial designs for Ice-T, then Wes Archer (director of "Get Schwifty") went in and did a pass on his face and brought it more on model—more into the look of our show. Below, you can see the key frames of his transformation from regular human to an alien block of ice (voiced by Harmon, BTW). "I care now. You made me care more!"

ICE-T will return in

ICE-T AND THE RISE OF THE NUMBERICONS

"I love you, son. I should've never turned you to ice."
Pictured here are the heavy hitters: Sulfur-P, Hydrogen-F, Magnesium-J, and of course Ice-T's father, Helium-Q. Justin cites this as a great example of the show doing what it does best: the writers laughing their asses off about the dumbest concept ever—the idea that Ice-T is from another planet of alphabet-shaped characters made of different properties—and that actually making it all the way through production, into the final product.

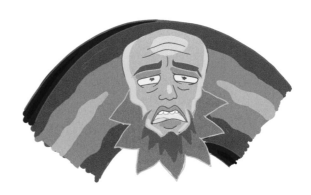

Therapy Retreat

"I booked you for a two-day intensive at Nuptia Four, the galaxy's most successful couples counseling institute. They could save the marriage of a dog and a bar of dark chocolate." To the right here is Glaxo Slimslom (voiced by Jim Rash), the mythologue creator that took on the impossible task of trying to repair Beth and Jerry's marriage. This guy's design was hard to figure out. He had these big expressions—as you can see below—so he really needed to have enough facial space and room to act when shit hit the fan. To accomplish this, the art team went with a big, nacho-chip-shaped head.

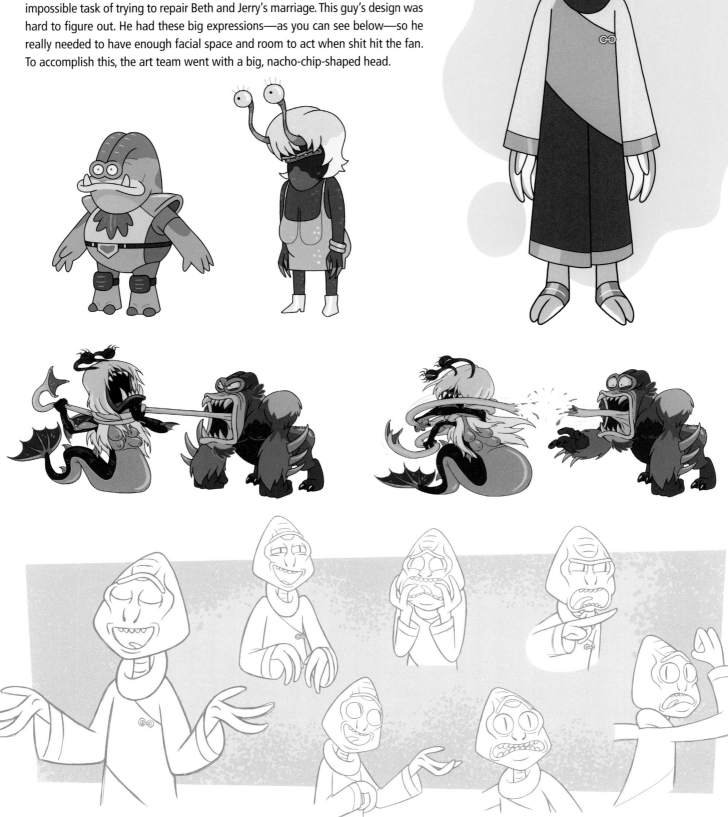

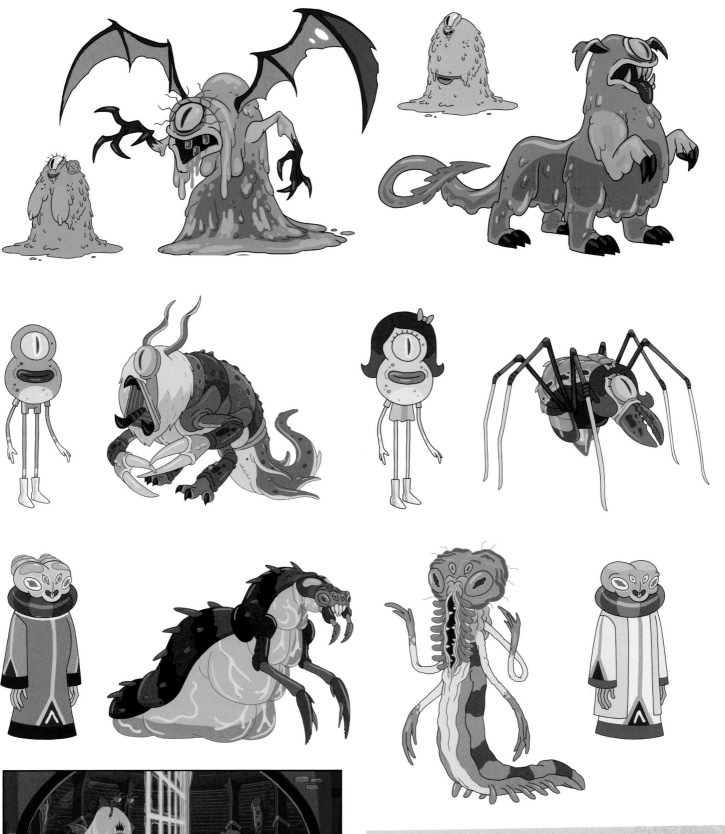

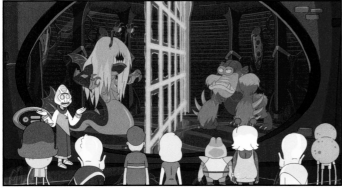

It's crazy how varied and badass these alien designs were in "Big Trouble in Little Sanchez." By the second season, the artists really understood the insane chemistry these creatures needed. Sometimes the first thing that would come in to the art director would be perfect.

Nuptians

"Oh, dear god, no. THEY'RE CODEPENDENT!" It's always our goal when visiting a new alien setting—in this case, alien couples therapy—to create a whole new species that basically runs the place. We don't reuse some preexisting alien. The first step with this is always to come up with a proto design, which in this case was Glaxo Slimslom (*page 126*). Then we come up with a subset of similar-looking aliens to fill out the race, like those you see below. That's one of the reasons the show is so expensive to make, but it's well worth it.

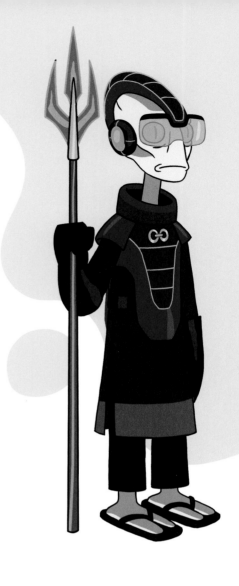

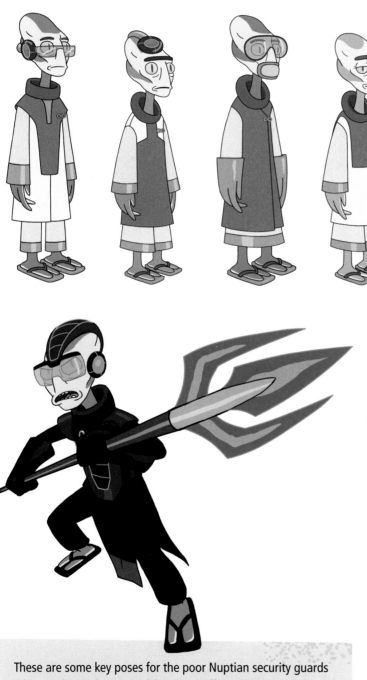

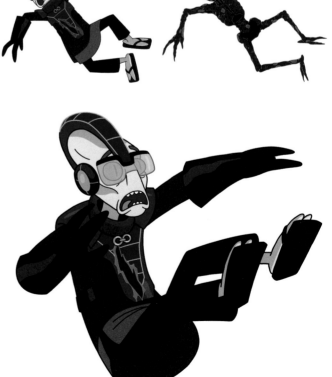

These are some key poses for the poor Nuptian security guards who tried to take on Beth's pissed-off mythologue and got freakin' worked. Key poses, bro. You should know what those are by now. (*If not, check out page 30.*)

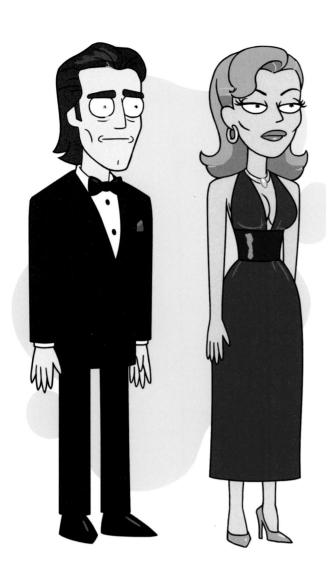

The Gutermans

"So, your teenage daughter's marrying a bird man. You guys 'down' with that?" Ahh, Tammy's parents. You might remember these two from Bird-person's mate-melding ceremony in "The Wedding Squanchers"—you know, before they turned into murderous robot people. This duo is actually one of those little Easter eggs in the show—from time to time, we try to get cool actors from prominent sci-fi shows, bring them in, and cast them in a story line together. We did that here with actors from *Battlestar Galactica*: Pat Guterman is voiced by James Callis and Donna Guterman is voiced by Tricia Helfer—who play Dr. Gaius Baltar and the humanoid Cylon Number Six, respectively. We also kinda designed the characters after the actors who played them, and kindaaaa borrowed their last name from writer/producer Dan Guterman.

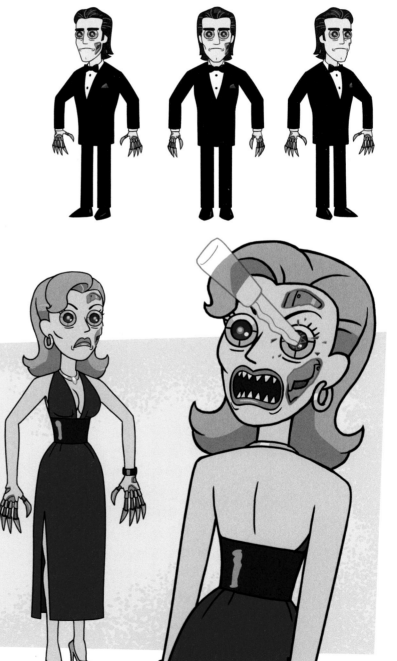

St. Gloopy Noops

Okay, so this was a pretty intense challenge for our art team. St. Gloopy Noops (in "Interdimensional Cable 2") was this giant floating space station hospital—a little bit like Deep Space Nine—so it's a cross section of all different races of aliens. Rather than having the artists create one specific race, and then variations on that, we had to create a ton of *different* alien races. There's some reuse, but not much—the majority are original designs. Like Dr. Glip Glop (*right*), who dies thirty seconds into the episode.

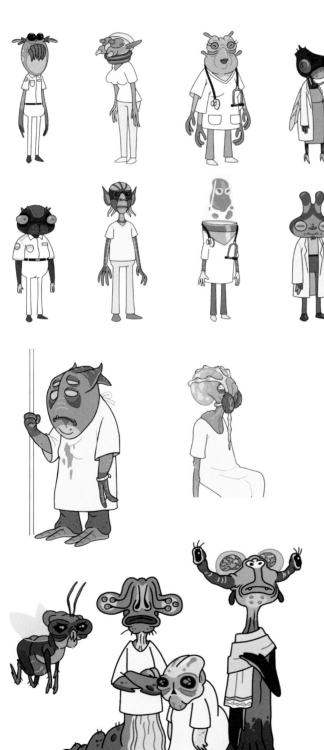

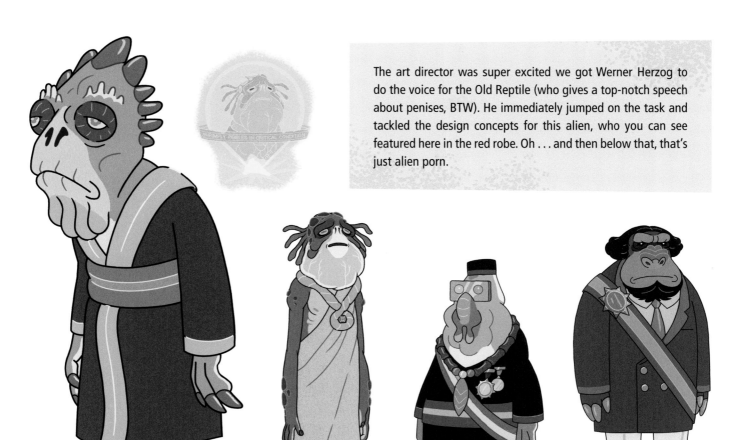

The art director was super excited we got Werner Herzog to do the voice for the Old Reptile (who gives a top-notch speech about penises, BTW). He immediately jumped on the task and tackled the design concepts for this alien, who you can see featured here in the red robe. Oh . . . and then below that, that's just alien porn.

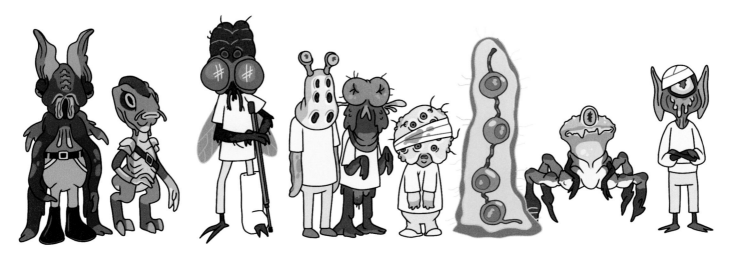

Human Extras

Look at all these wacky characters, you know, just hanging around in the background of shots, waiting in lines, standing in crowds. And the crazy thing is, none of these people are special—they're all just an insignificant smear on the central finite curve, happening infinite times across infinite realities. But still . . . you gotta love that mailman. "MY MAN!"

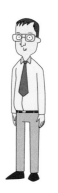
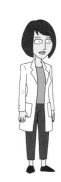

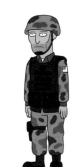

Alien Extras

One thing that helped guide the art director early on was this: the creators really liked the idea of a '70s version of the future. You know, there's this element of cheese to it—people were trying to be so high concept in the '70s, but now we look back on it and it's just silly and weird. So even if you're designing the creepiest, scariest alien ever, there still has to be an element of sarcasm—something needs to be weird and funny about it.

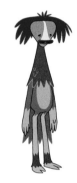
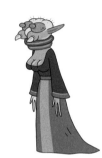

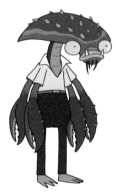
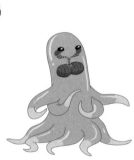

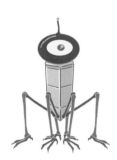

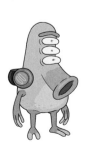
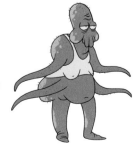

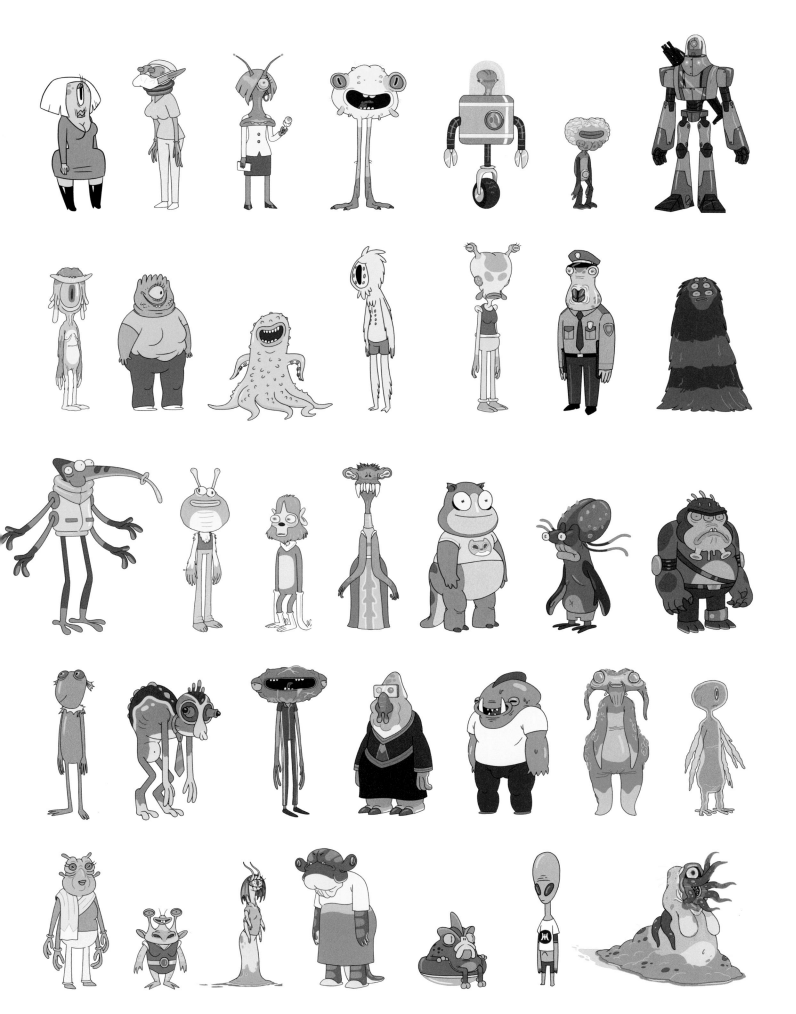

CHAPTER THREE

TECHNOLOGY

Rick's Ship

"What—what do you (BURP) think of this flying vehicle, Morty?" Okay, so the ship design actually came about *after* the initial animatic for the pilot, when we were working on a series of short clips to prove we could give Rick and Morty greater range. The basic design (done by Bryan Newton) was loosely modeled after a UFO, like Rick built it a long time ago just to screw with people. Justin wanted it to look haphazard, but another big inspiration was Spaceman Spiff from *Calvin and Hobbes*. In the bottom left, you can see the final design from the pilot—the only episode where it has that dumpy sail on the back.

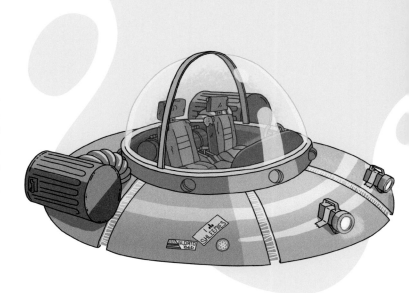

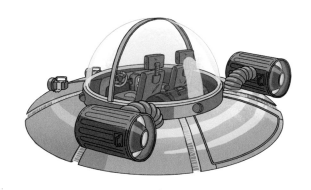

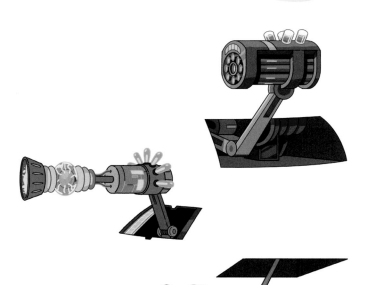

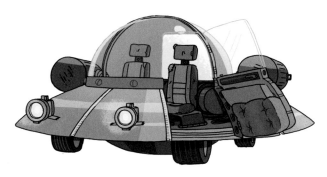

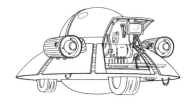

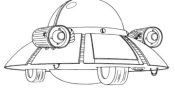

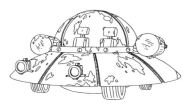

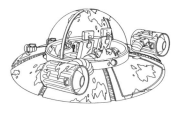

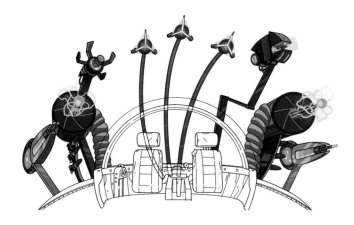

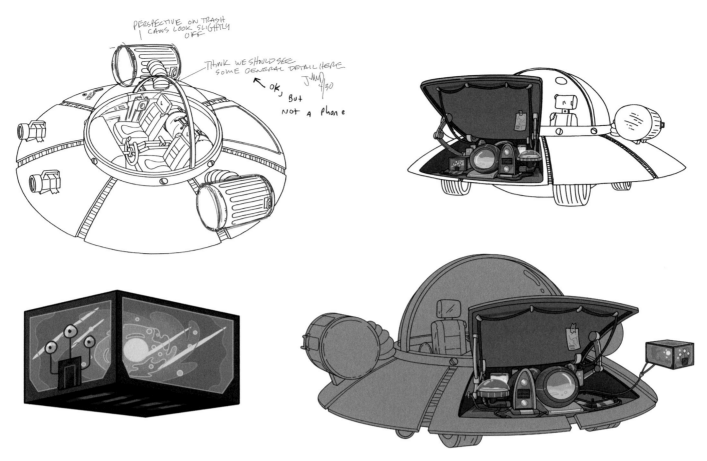

Microverse Battery

Up top, you've got some pics of Rick's planet-infused car battery from "The Ricks Must Be Crazy." On both the writing and art sides, this was a great example of us expanding the ship—what it's capable of, what's inside of it. It's really just a ship episode on both sides of the story. On the A side, we're going inside Rick's battery to see the whole world he's created for slavery—errr, power. And on the B side, we have the ship doing everything to "keep Summer safe" . . . including brokering a peace agreement between the giant spiders and the government.

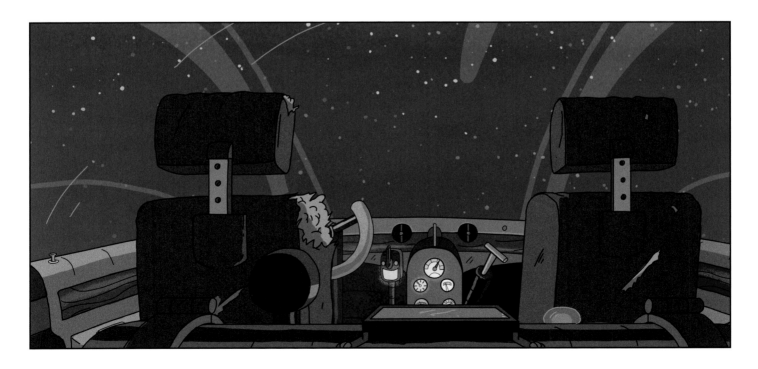

Ships and Vehicles

Damn, dawg, look at all these ships! You can see early concept designs below for the Zigerion ship (in "M. Night Shaym-Aliens!"), which drew inspiration from the new *Battlestar Galactica*. But some of the most impressive vehicles we've done are for the Gromflomites. They have a whole fleet, with a mother ship and all these smaller fighter ships—some of which have these cool, insectoid-looking shapes. Check out that one on the right page (*top*) that looks like a beetle. They all have Gromflomite design elements that tie them together (like the black-and-red color scheme), so you know they're from the same alien race.

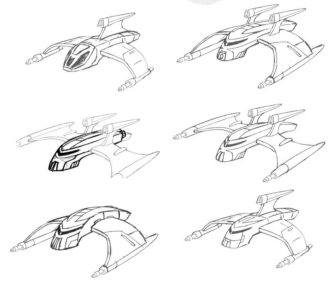

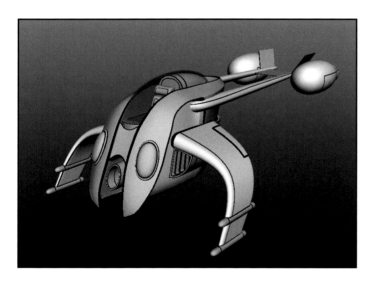

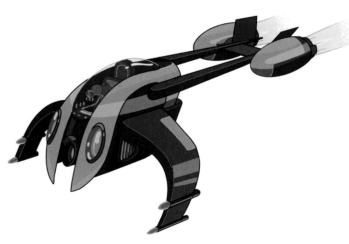

3D Modeling

For a lot of the featured ships and vehicles—especially if they're in a chase sequence or moving around a lot—we take the final design and give it to our 3D modeler. By having a 3D version of the ship, it's a lot easier for the artists at Bardel to see all the different angles and trace back the animation. The final product is still made in 2D in Harmony, but underneath it, we use the 3D as a helpful tool to show all the different perspectives.

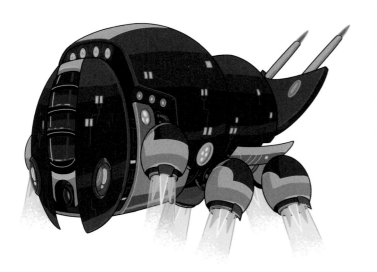

For the second episode of season 2 ("Mortynight Run"), our prop designer Brent Noll did concepts for, like, a hundred vehicles. Just pages and pages of really cool vehicle and ship designs. And we finalized maybe forty of them, which is pretty amazing. You can see a bunch of the final designs that made it here.

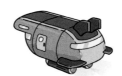
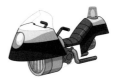

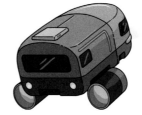
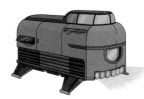

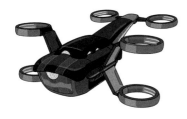
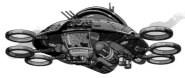
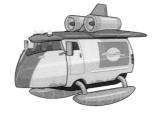
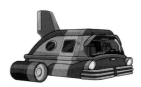

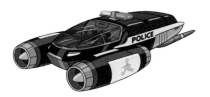

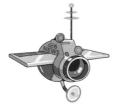
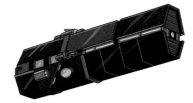

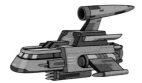
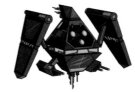
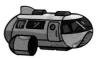

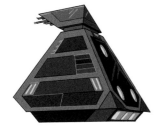
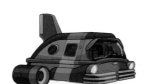

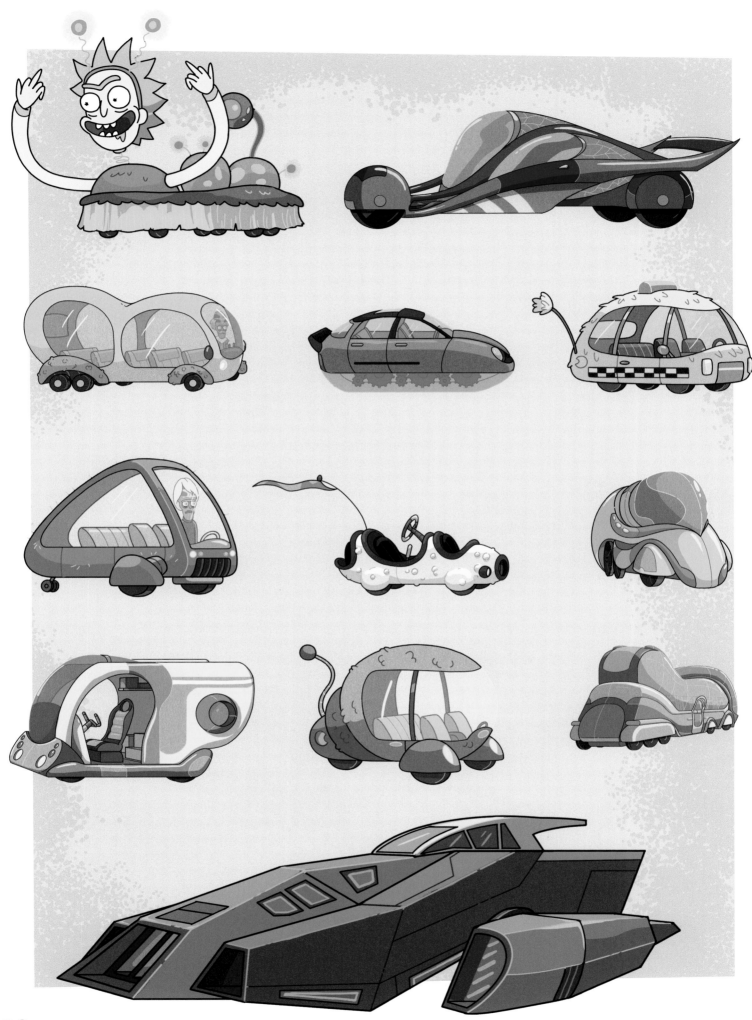

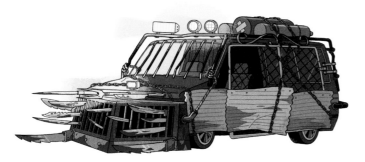

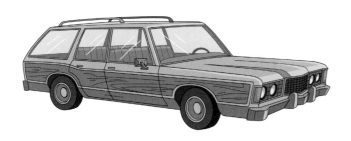

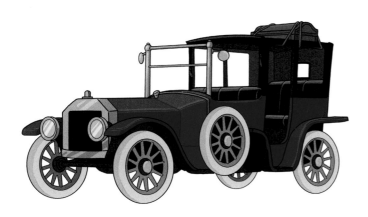

On the left, that's mostly all vehicles from Rick's Microverse (in "The Ricks Must Be Crazy"). Cool thing with this world: the artists wanted everything to have texture to it, so a lot of elements—like those weird cars in the middle—kinda looked like a shaggy dog. And then over here, hoo boy, this is just a random smattering of vehicles from across the show. We've got the toaster car up there, Jerry's station wagon, and even the old-timey car from the *Titanic 2* (*bottom left*)—which Jerry was forced to get inside of at gunpoint.

WEAPONS

Just your average stockpile of freeze rays, anti-matter guns, and neutrino bombs, you know, in case shit goes ham. Rick's laser gun (*to the right*) is one of the few weapons we've shown quite a bit, but for the most part, whenever there's a new alien race (or world), we like to start with a brand new concept and give them their own custom tech. It's crazy, though: we have so many weapons designed at this point, we could probably reuse them for the rest of the show and still have a ton to pick from. But that won't happen, bro—it's not how we roll!

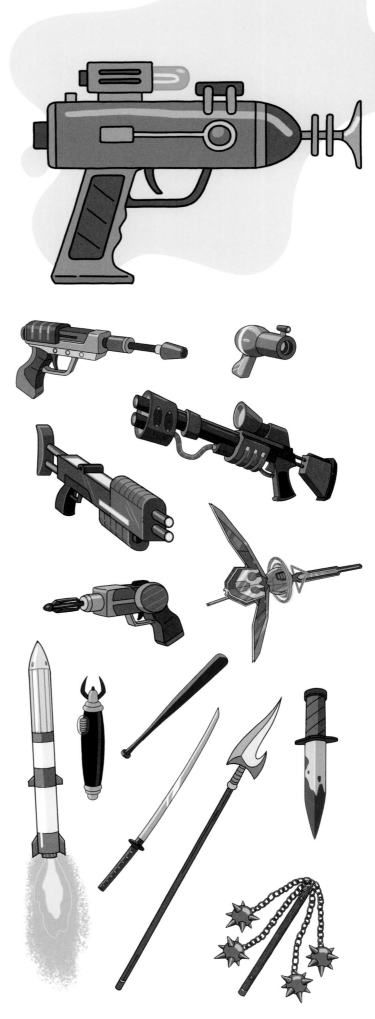

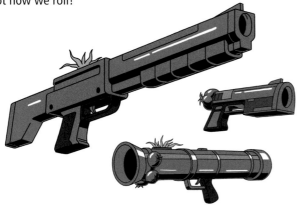

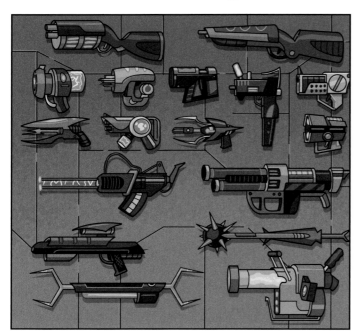

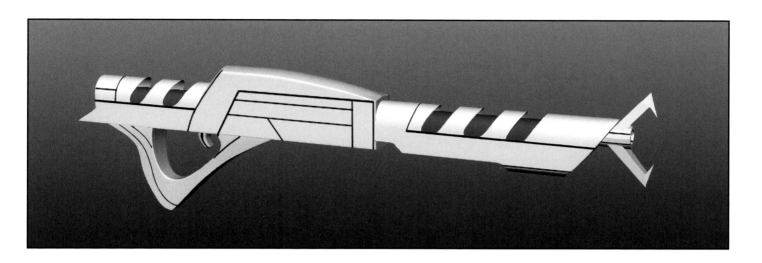

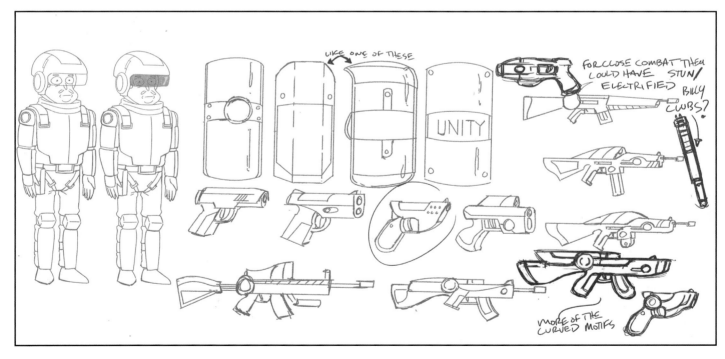

LIKE ONE OF THESE

UNITY

FOR CLOSE COMBAT THEY COULD HAVE STUN/ ELECTRIFIED BILLY CLUBS?

MORE OF THE CURVED MOTIFS

You might recognize that bad boy up top as the main gun used by the Gromflomite grunts (*page 85*). The rest of the page is all concepts and weapon pitches for the police force on Unity's world (*pages 96–97*)—these sketches are like the artists saying, "Hey, what kind of guns should they have on this planet?" This is us narrowing it down to basically two types of weapons: a handgun and a big AK-type gun.

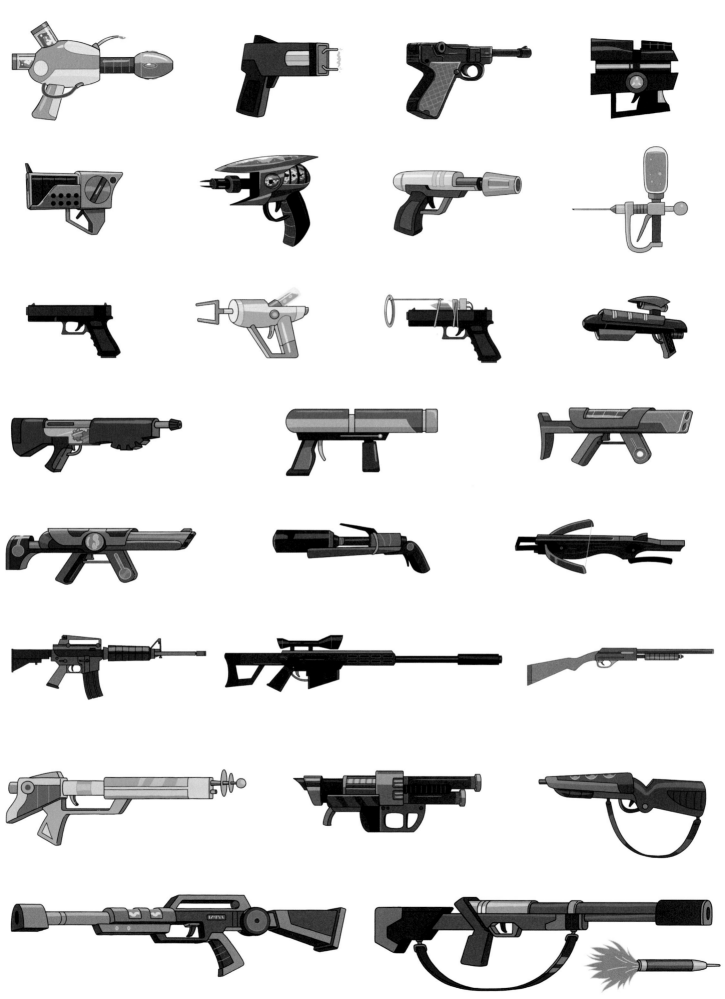

The Art of Rick and Morty

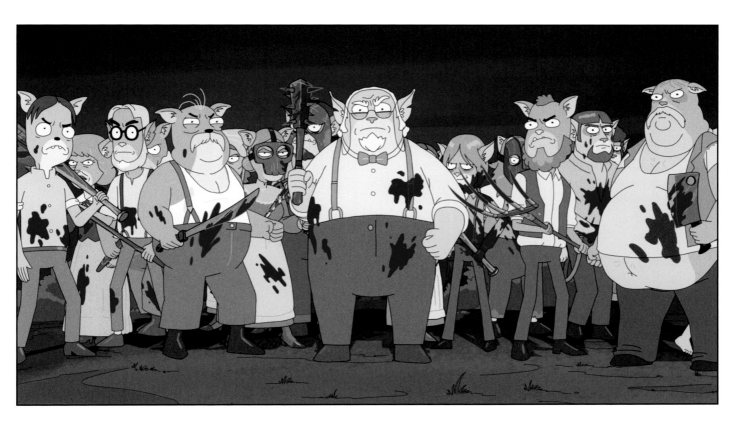

The Purge

We went in a different sci-fi direction for "Look Who's Purging Now," using old-school 1800s farming weapons instead of high-tech gadgets. Fun fact: this was actually the last episode written for season 2. "The Wedding Squanchers" was never intended to be a cliffhanger; it was originally meant to be a two-parter that finished out the season. But after a few drafts, the writers scrapped it, rearranged the episode order, and wrote this Purge episode in record time.

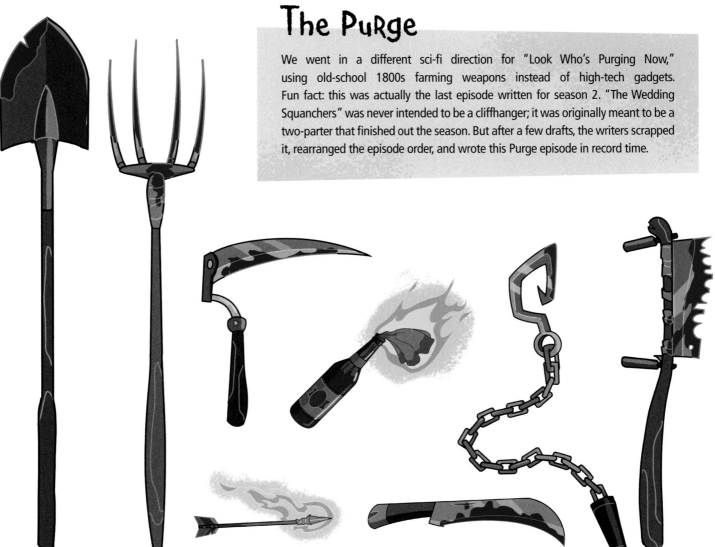

Gadgets

So obviously out of all the crazy sci-fi shit Rick's invented, the most important is his portal gun. But it wasn't always intended to be special—originally, the portal gun was just one of many cool sci-fi concepts the writers were gonna jam into the show. But after "Rick Potion #9"—where Rick and Morty bail out and go to a new dimension—the writers quickly realized how significant the ability to hop realities would be. Interestingly enough, that episode was actually written third, but we moved it to midseason for air. It felt cooler to completely reset everything after you've lived with the characters for a bit.

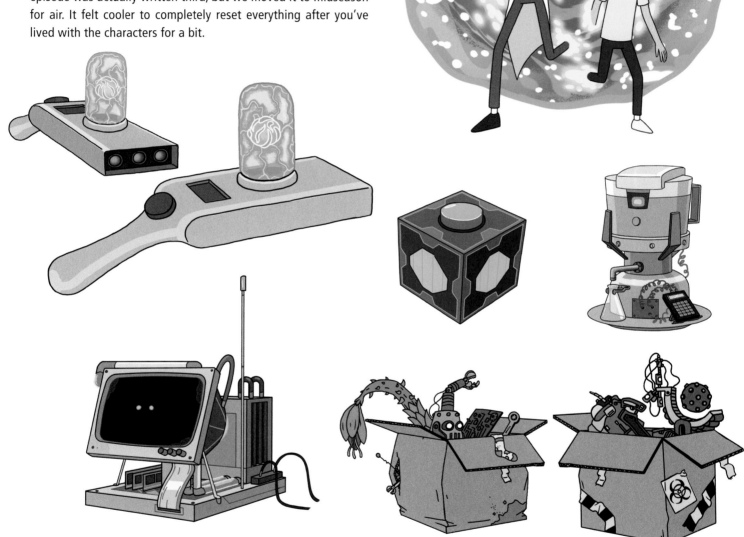

Rick's Tech

Kinda cool factoid: the art team generally tries to keep Rick's inventions in the gray color tone—like he built them from random objects and garbage lying around the garage. This way, when he's combating a new alien googa, it really contrasts with that dude's tech. Probably the best examples of this are Rick's portal gun and his flying car.

"What is my purpose?" You pass butter. Couple more classic bits of Rick tech here—the butter robot (from "Something Ricked This Way Comes"), the holographic map (from "Raising Gazorpazorp"), and the massive shrink ray (from "Anatomy Park"). Little tip with that last one: hold your breath until the process is over or your lungs *will* collapse.

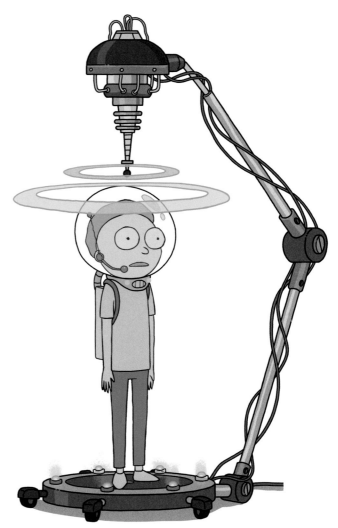

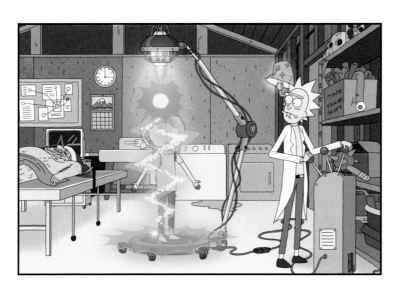

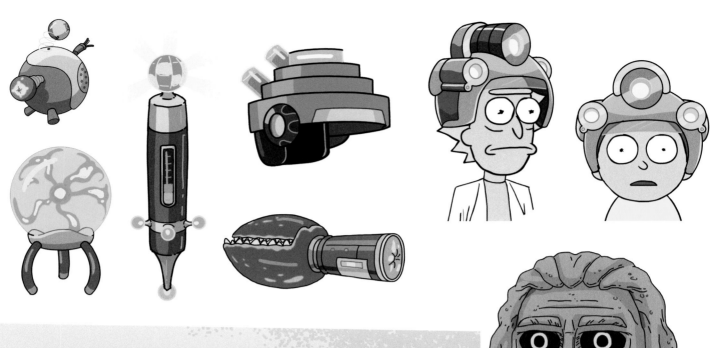

Man, whole grab bag of stuff here. Up top on the right page, that's Rick's dream inceptor, the interior design for Evil Morty's eye patch, and the backpack used to bail on the Cronenberg dimension. Below that are some props from "Lawnmower Dog"—muzzles for humans, the cognition amplifier helmet, and of course, the infamous mech suit (*check out early designs for that on pages 80–81*). And don't forget this page, broh: we got the mythologue-generating helmet (*top center*), the Roy gaming headset (*top right*), and a bunch of concepts for the sex robot Gwendolyn. Her design is kinda inspired by Chrome, a hypersexualized female robot from the short-lived HBO show *Perversions of Science*.

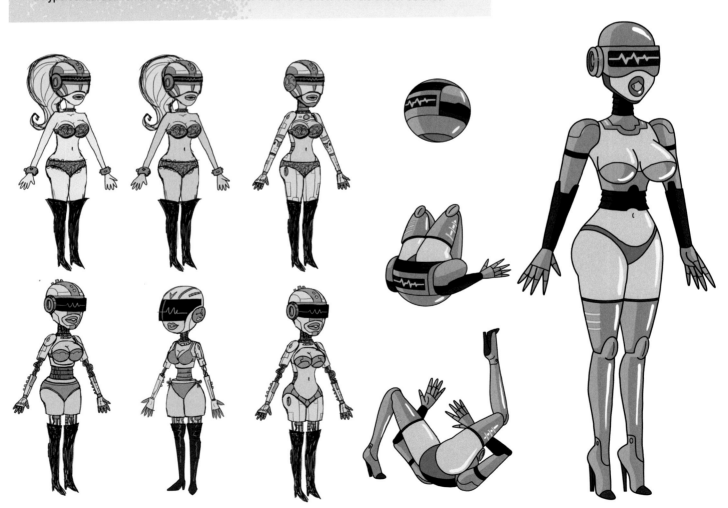

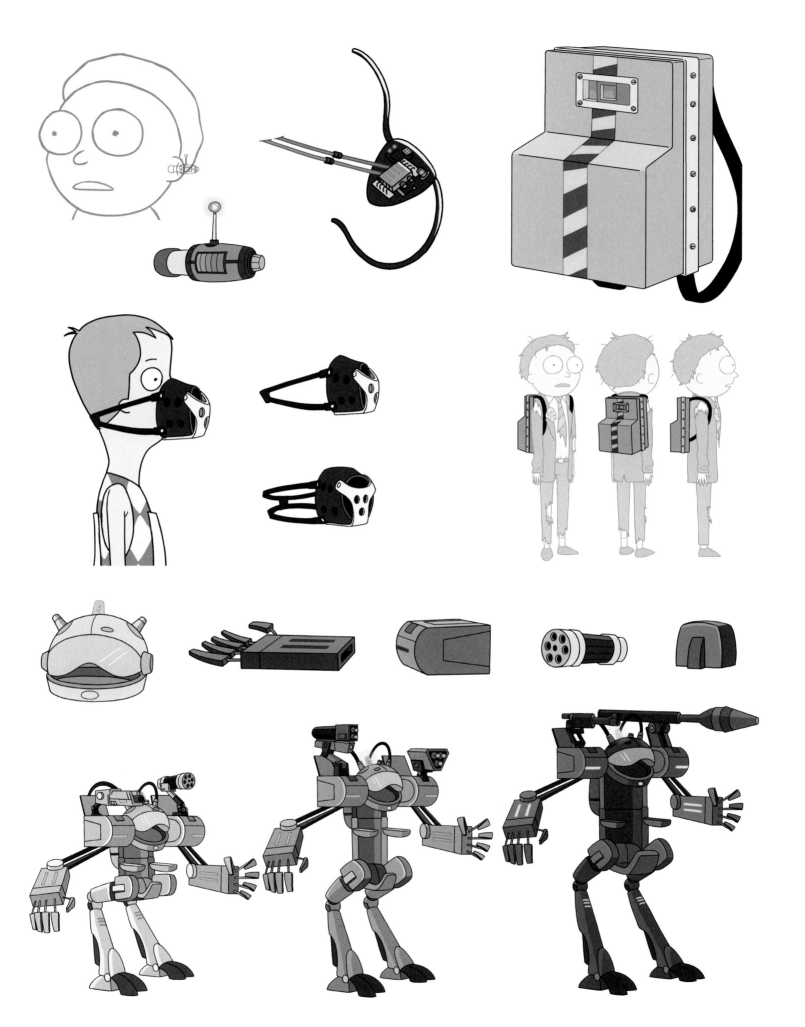

Interdimensional Cable

"I'm Ants in My Eyes Johnson, everything's black, I can't see a thing!" The production flow for these episodes is absolutely freaking nuts—especially since most sketches aren't scripted. At the recording, the writers sit in the control room pitching ideas to Justin, who riffs dialog and improvises in the booth while getting drunk. After that, it goes to the dialog editor, who cuts together a cohesive sketch from that improvised insanity. Then our kick-ass artists painstakingly design and draw what they think Justin is talking about in his ramblings, bringing every detail to life. Lastly, those sketches get paired up with a really good "A story" that's actually scripted by the writers.

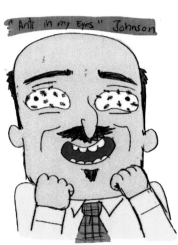

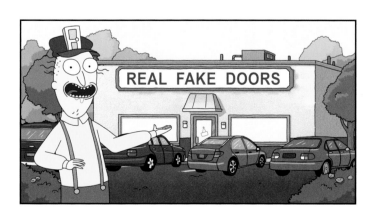

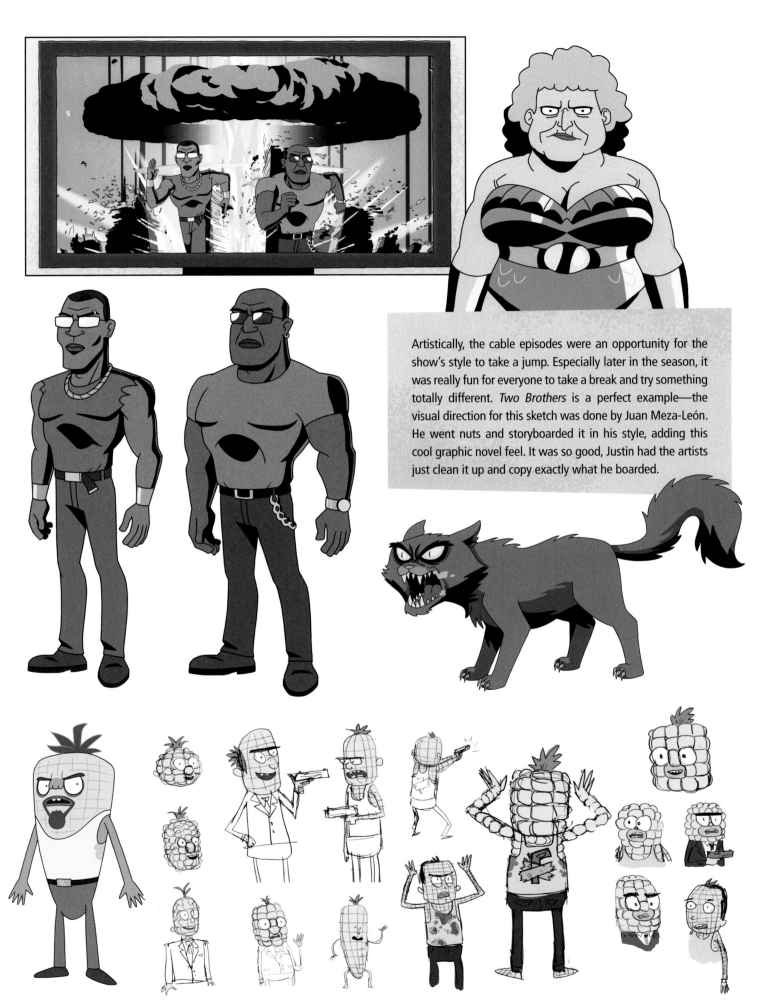

Artistically, the cable episodes were an opportunity for the show's style to take a jump. Especially later in the season, it was really fun for everyone to take a break and try something totally different. *Two Brothers* is a perfect example—the visual direction for this sketch was done by Juan Meza-León. He went nuts and storyboarded it in his style, adding this cool graphic novel feel. It was so good, Justin had the artists just clean it up and copy exactly what he boarded.

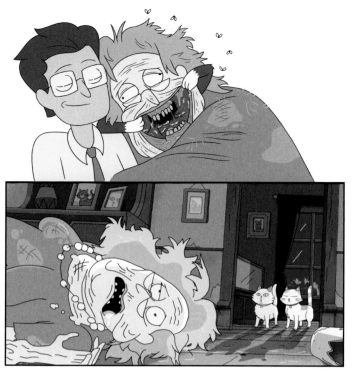

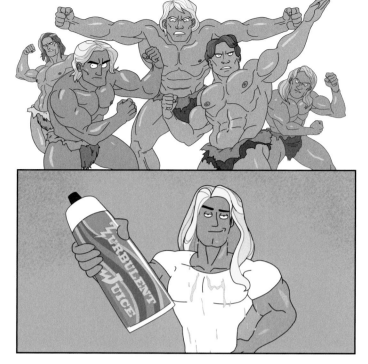

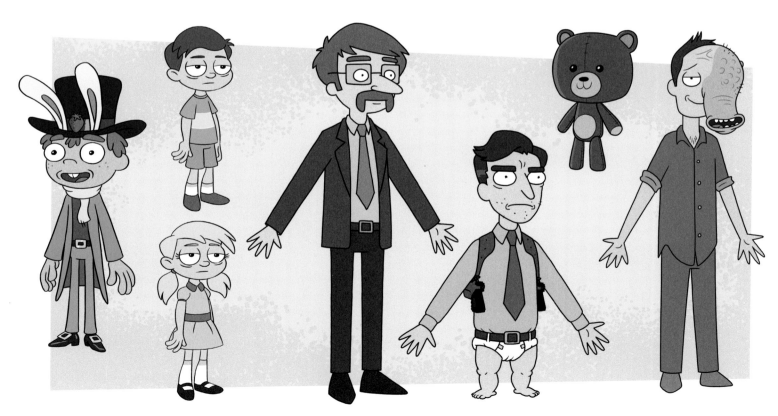

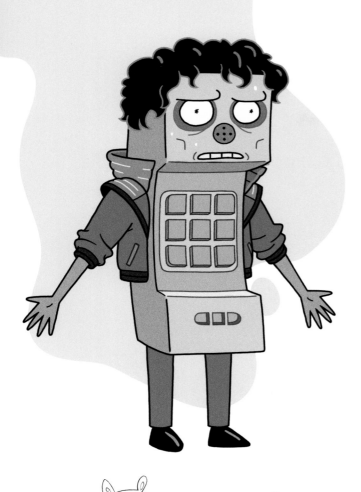

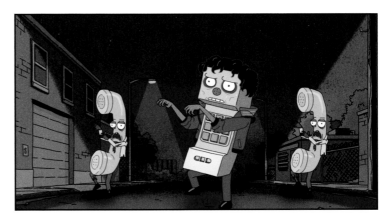

So many cable classics on these pages—to the left, there's the Strawberry Smiggles leprechaun, Detective Baby Legs, and the dead cat lady from *Weekend at Dead Cat Lady's House II*. And over here, we got the infamous Hamsters That Live in Butts. After that got pitched, the writers had a million questions: Do the butts look like little apartments inside? Can the hamsters leave the butts and walk around on their own?? So that just became the joke. The writers had the family ask all the same questions being asked in the writers' room.

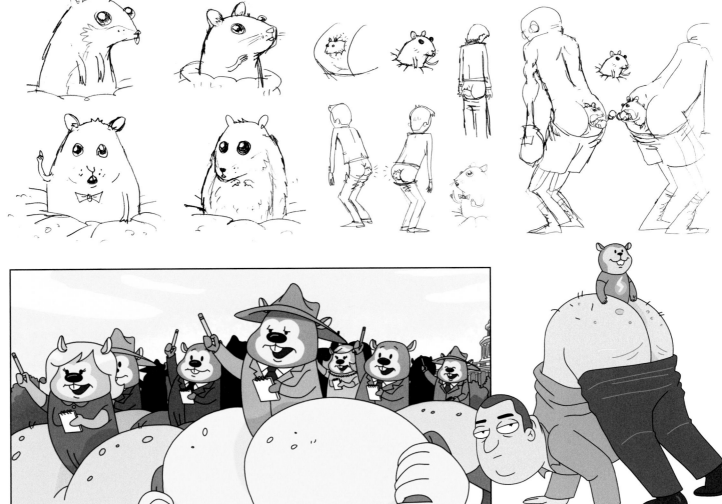

"Yes! Look through my eyeholes!" With the sequel "Interdimensional Cable 2: Tempting Fate," we kept the same insane, drunkenly-improvised process as the first episode (*page 152*). That's how we wound up with gems like the Eyehole lovers, Butthole Ice Cream, and the beloved Plumbus, which everyone should have in their home (seriously). On the bottom there—that's Phillip Jacobs, host of *Personal Space*, showing off the key frames of how seriously he takes personal space.

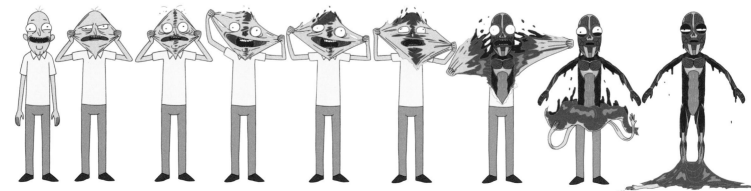

"This JANuary. It's time to Michael down your Vincents!" Just like the first cable episode, the artists were encouraged to go crazy with storyboards, design, staging, and execution. You know, really bring their own creative energy into the process. Juan Meza-León again infused his cool stylization into the Jan Michael Vincent sketch, similar to what he did with *Two Brothers* (*page 153*). Couple more favorites below: Stealy, the big-headed Lil' Bits man, and the Siamese twins/simultaneous-TV hosts Michael Thomson and Pichael Thompson.

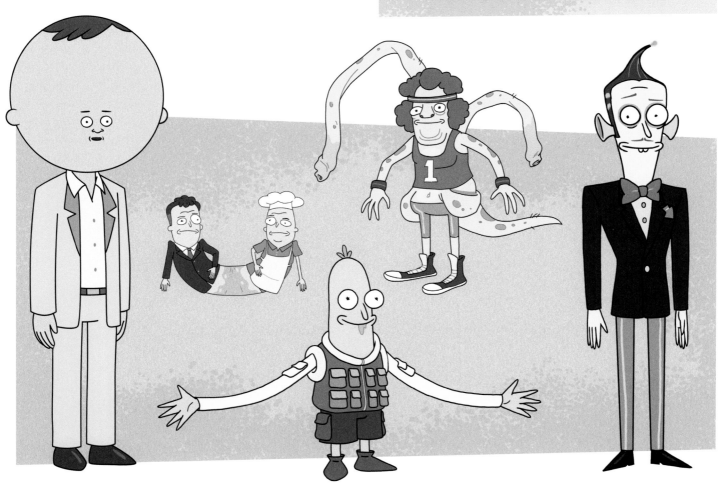

CHAPTER FOUR

ENVIRONMENTS

The Smith House

When it came to designing the Smith House, Justin and Dan wanted it to have a stereotypically primetime vibe—a real suburban-family kinda feel—and then have it go nuts from there. This was all on purpose. Especially before the show aired, they thought if it had a really grounded point of entry for people, they could sort of Trojan horse all this crazy sci-fi shit into it. The best-case scenario being that they would snag viewers that weren't necessarily sci-fi fanatics, then have them feel like, oh my god, this tired sci-fi trope is completely original to me.

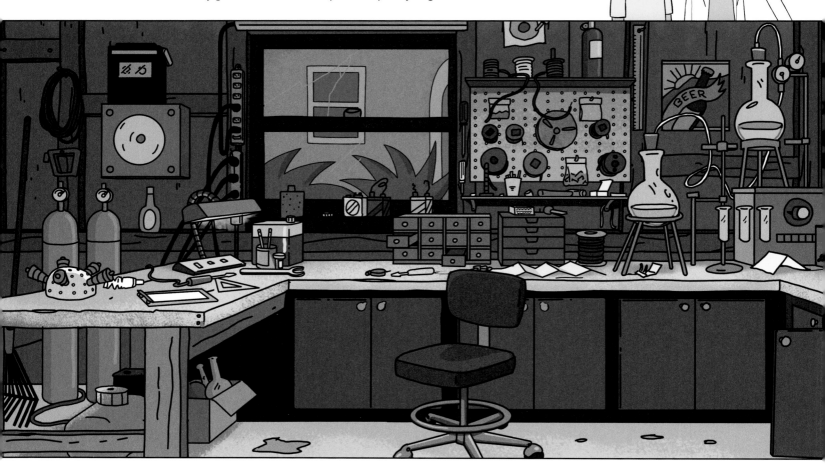

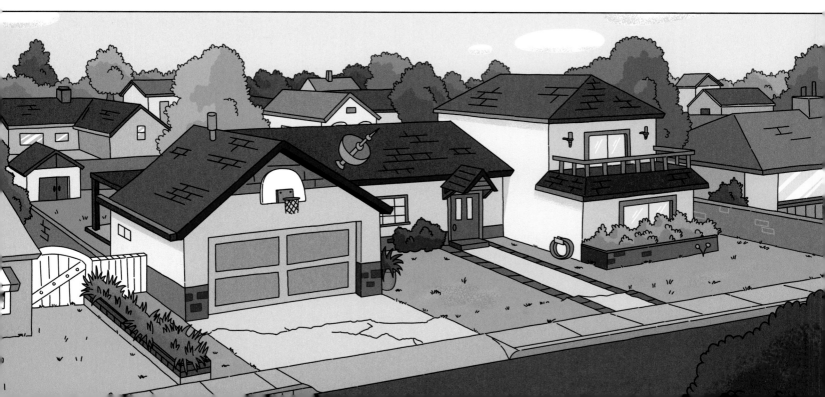

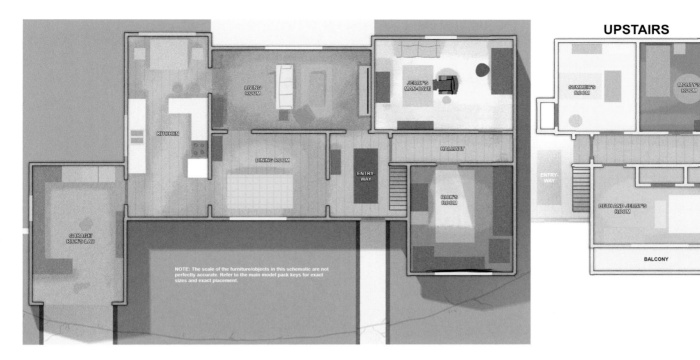

UPSTAIRS

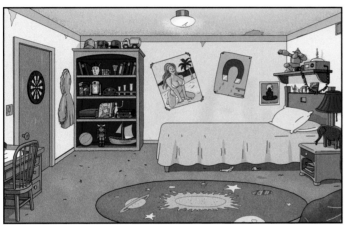

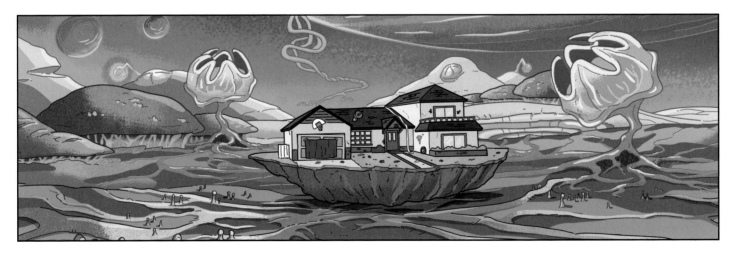

Up top, you can see the house layout from seasons 1 and 2. Interesting thing about this is there's actually no bathrooms, at least design-wise. We didn't realize until late in the game: "Oh shit, there's no toilets." In the middle there's Morty's bedroom, as well as Rick's humble little abode. And can't forget the house floating in an alternate dimension (in "Ricksy Business"). "Hmm, big star in the sky. Oxygen-rich atmosphere. Giant testicle monsters. We'll be fine. Let's party!"

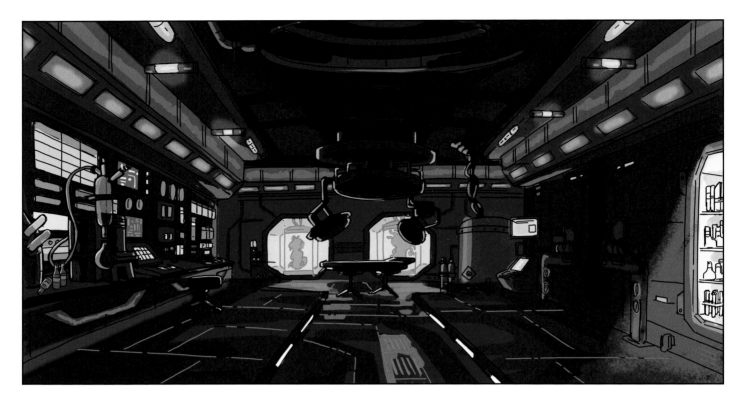

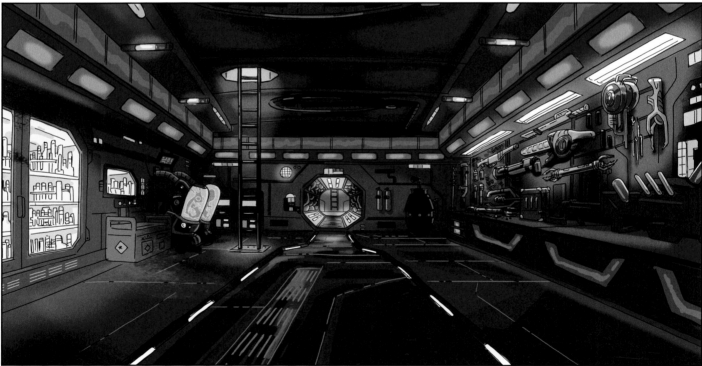

Rick's Sub-basement

After getting the script for "Auto Erotic Assimilation," the art director created this epic look for the sub-basement. (These are his original concepts, BTW.) The thought was: what if this isn't just one little bunker—what if it continued on and had all these different caverns going off it? You know, maybe Rick's built this big mother ship underneath the house? Justin got sooooo excited when he saw this. In fact, it's one of the initial reasons we had the Smiths bail from Earth in the season 2 finale. Originally, there was this apocalyptic threat coming and the whole family was gonna jump in this bunker . . . which then turned into a badass subterranean spaceship. The story changed for that episode, but who knows, that still could be the case. SPOILER ALERT. (OR MAYBE NOT.)

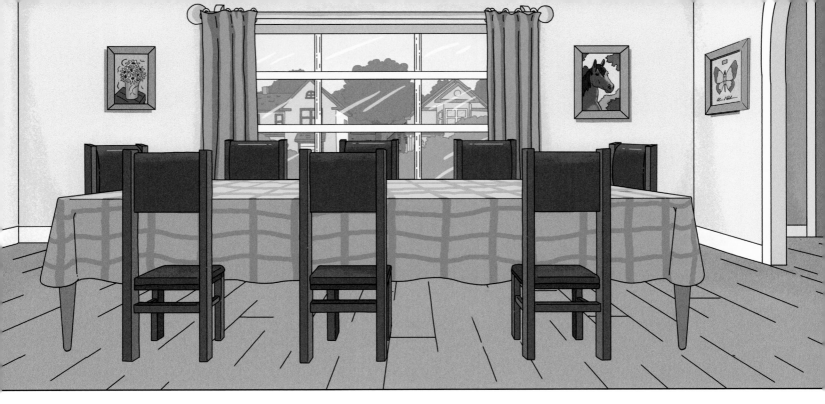
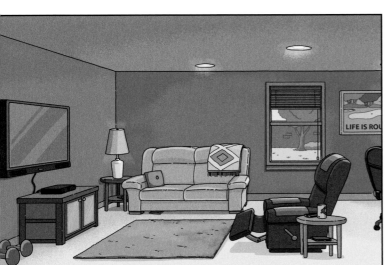
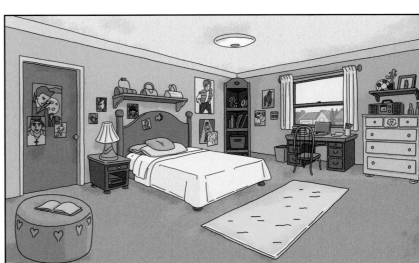

Earth Environments

Again, we really wanted to capture that suburban feel for the town. Whether you're at Harry Herpson High School, Main Street, or St. Equis (Beth's horse hospital, *page 166*), the goal was to give it a really grounded, ordinary vibe. This way, when the artists got a script for a new alien dimension or fantasy world, they could really push it to feel totally opposite of what's familiar. You know, like Greasy Grandma World.

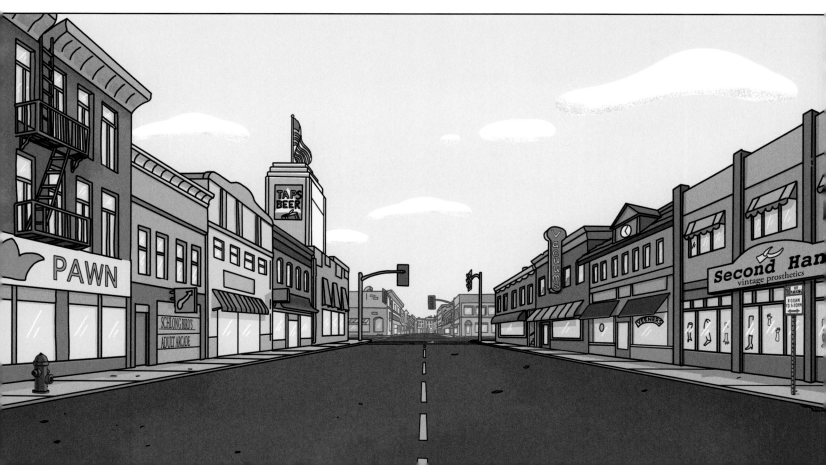

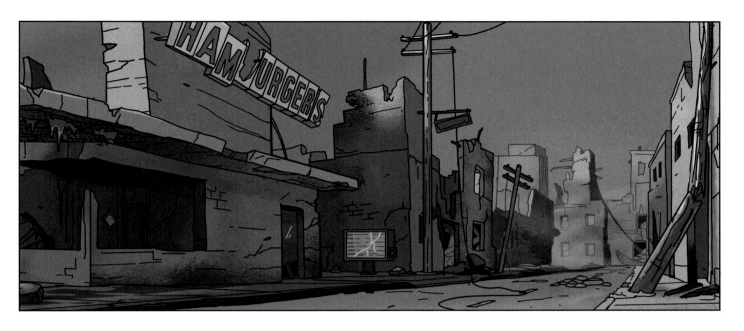

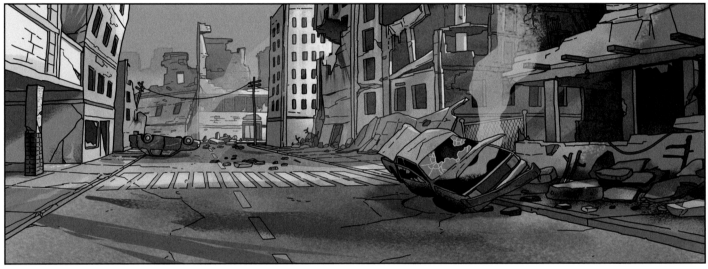

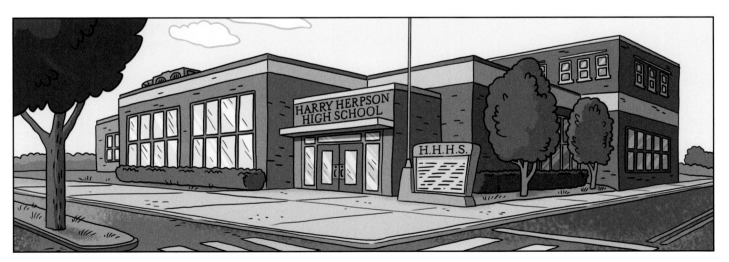

Just some shots of Earth after Rick went and Cronenberged the whole place up. Kinda makes you appreciate how powerful Rick is, you know? Especially when he's not paying attention to what he's doing. And then below, that's Harry Herpson—home to Principal Vagina, Mr. Goldenfold, and occasionally Morty and Summer . . . when they're not out fighting alien googas.

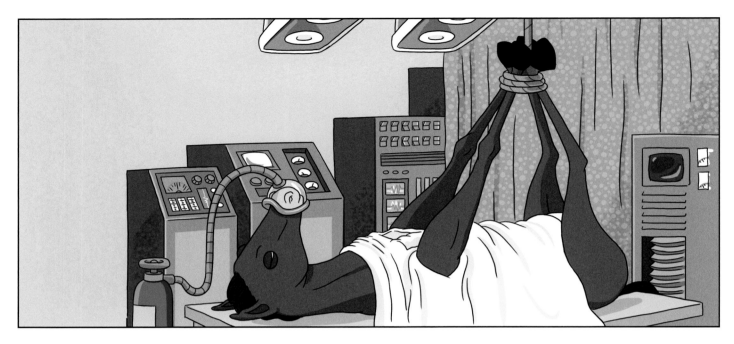

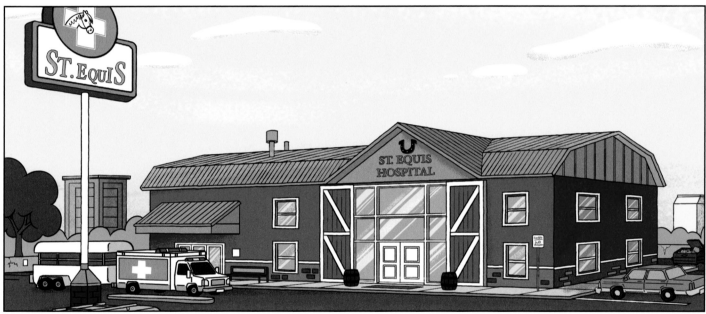

The Art of Rick and Morty

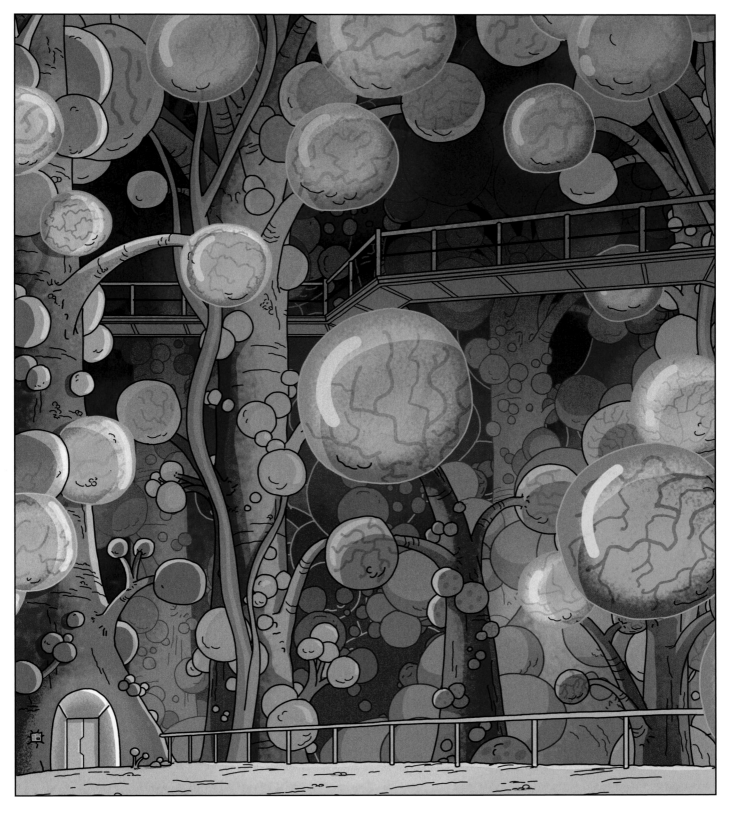

Anatomy Park

Oh man, this lung design for "Anatomy Park" was a tough one to figure out. Early on, the art director did a color concept that looked very different—the alveoli in the lungs were much more raspberry-like and exposed. We eventually scrapped that and went with Andrew DeLange's more membrane-looking, kinda bubbly design (with final color by Hedy Yudaw)—it really transformed the look and made the stalks of the alveoli feel like giant sequoia trees. Not bad for the inside of a homeless guy.

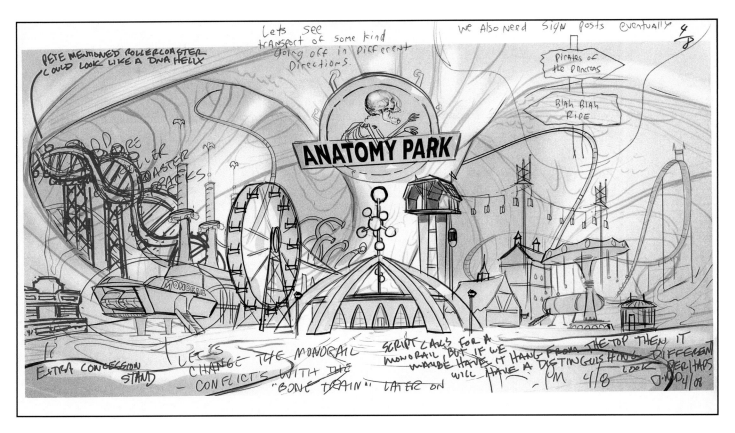

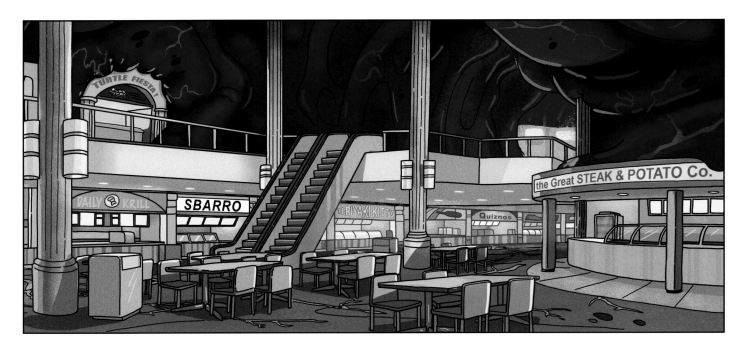

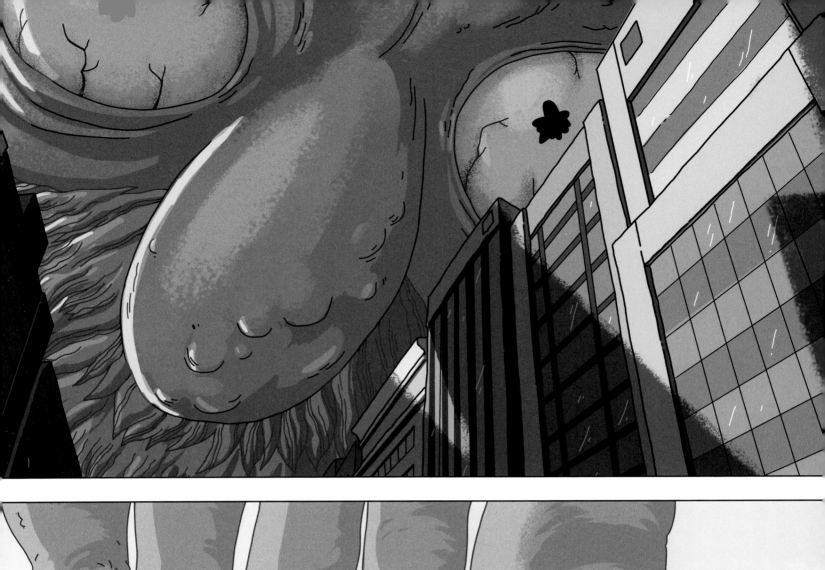

Nothing quite like Reuben's giant, naked body floating over the continental United States. There's his head over New York, feet over Hollywood, and if the old adage is true, one can only wonder what's going down in the Rocky Mountains. The theme park (*left page*) also took some back-and-forth. After the initial designs, the storyboards added things going off in different directions, so the design team had to try to rearrange the different amusement park sections to match what the boards had done.

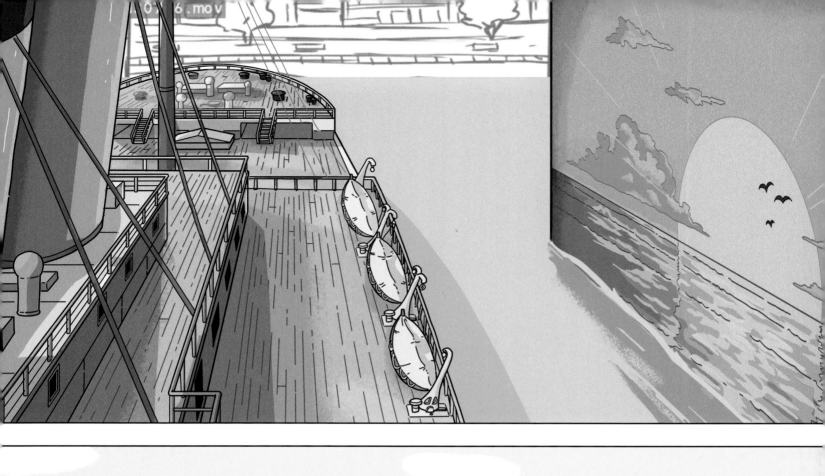

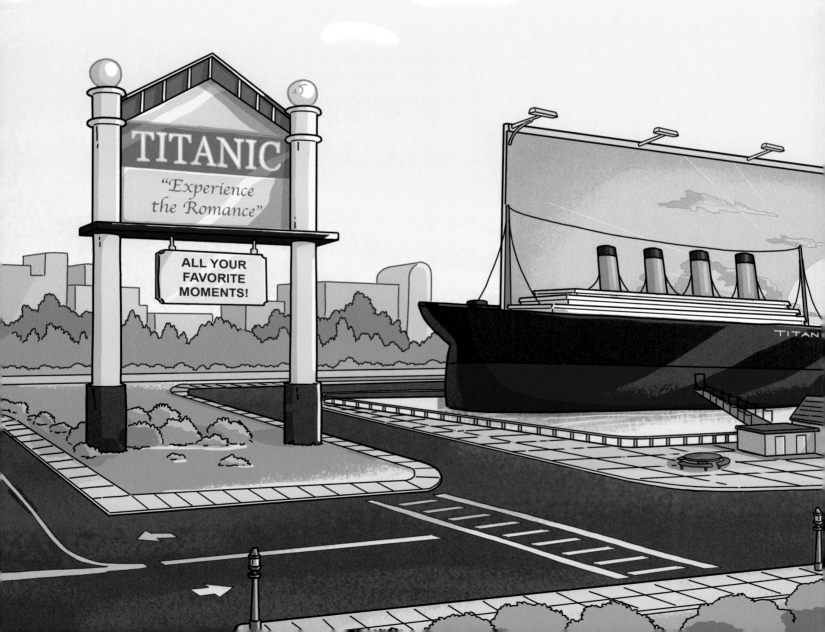

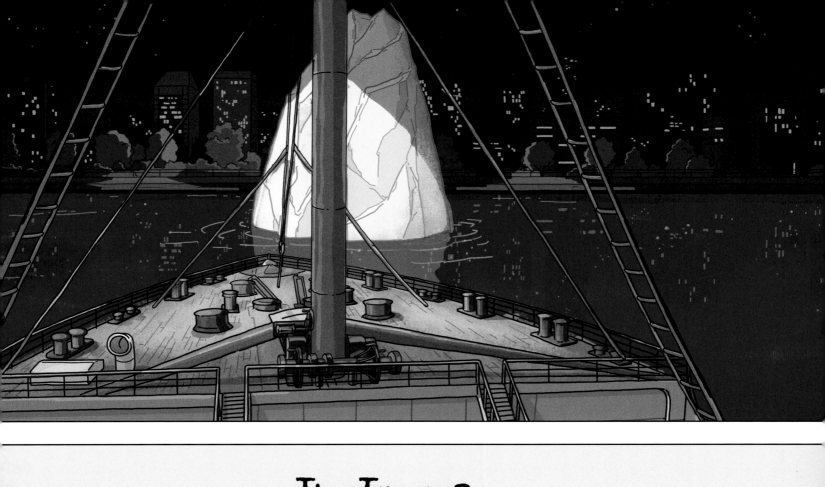

The Titanic 2

"I can assure you the ship will sink as it has a thousand times before. It's UN-unsinkable." For the *Titanic 2* attraction (from "Ricksy Business"), we really tried to make it seem like a mishmash of Medieval Times meets *Titanic* meets a hotel getaway. The initial concept Justin brought to the launch meeting was basically this: There's this big ship on a track, right? Once everyone is onboard, it clicks forward in front of this sunset mural. But then at night it curves around this giant wall, and on the other side is this big mural of the moon. And then . . . the iceberg clicks up from underwater. The ship is supposed to hit it, and it doesn't. It's so stupid, but it really seemed to fit with the kind of thing Jerry would be into.

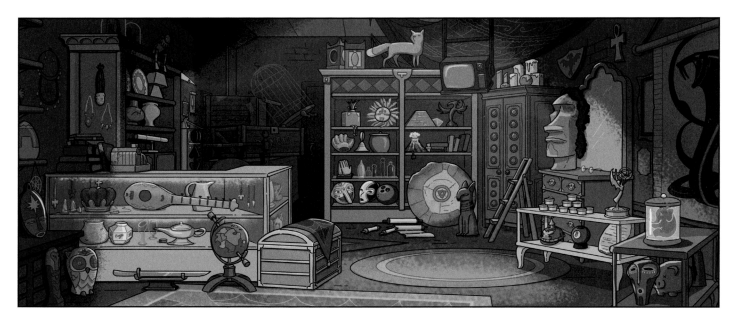

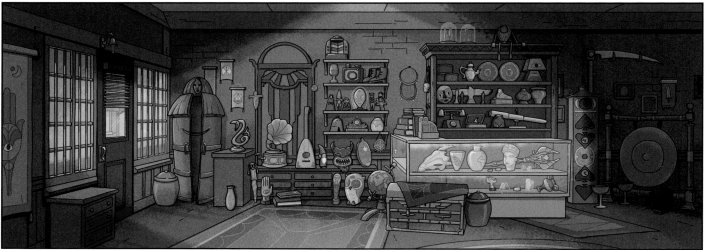

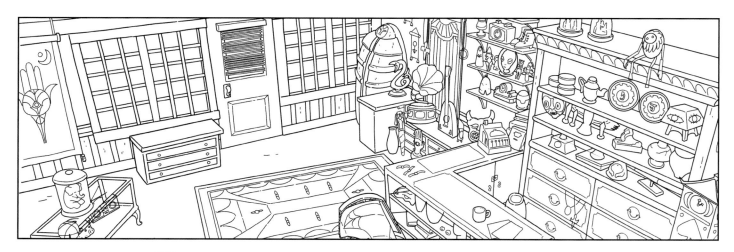

Needful Things Shop

"So, what are you, like, the devil?" The general look for Mr. Needful's shop (in "Something Ricked This Way Comes") was inspired by the antique store in *Friday the 13th: The Series*. The store was filled with so many trinkets and tchotchkes that hooking up all the different angles was a nightmare once we got into production. "My lust! My greed! I deserved this!"

Get Schwifty

"Oh yeeeeeah. You gotta get schwifty. You gotta get schwifty in here!" The initial concept for this Cromulon solar system was done by the art director—he set it up kinda like a Japanese game show centered around a disco ball sun, with all the planets aligned in front of it, acting as contestants, ready to be exterminated. Then below that is the Area 51 stage where Rick and Morty jammed out and showed the Cromulons what they got. Oh yeeaah, take off your pants and your panties. Shit on the floor . . .

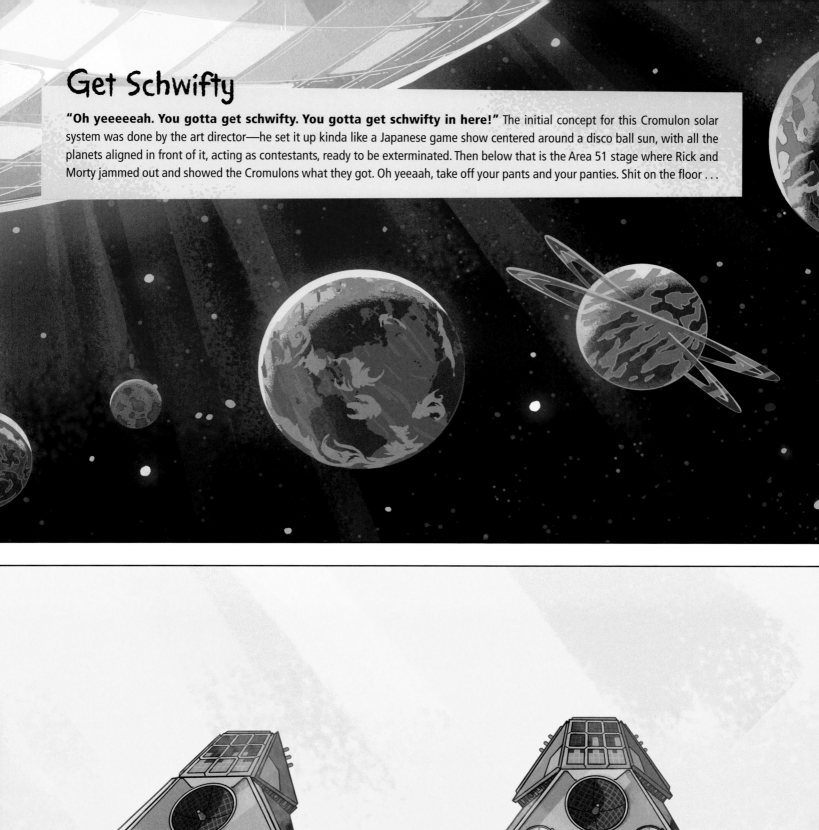

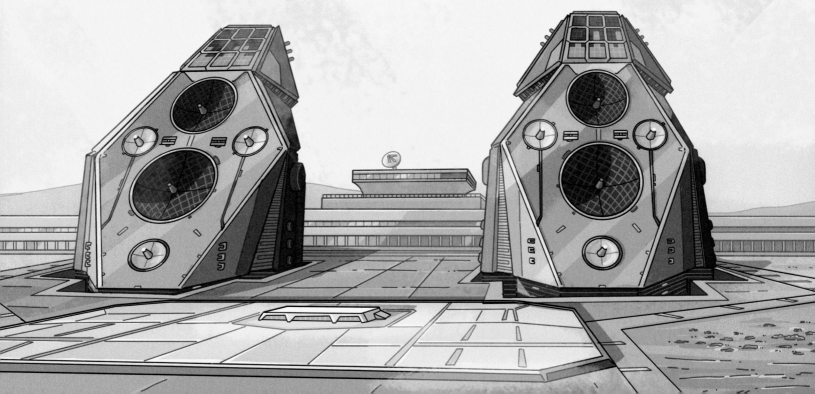

Fantasy Environments

"Oh man, Rick. This- this is pretty weird." The top picture here is the pleasure chamber so shameful that Goldenfold buried it in the dreams of people in his dreams. This was how the writers described it in the script: "We see a *Lord of the Rings* by way of *Eyes Wide Shut* orgy scenario . . . Mrs. Pancakes is dressed up like a bondage queen in the center of it all. She's whipping a wizard." Oh yeah, man. Hardcore stuff. And then with the Scary Terry story (*bottom*, also from "Lawnmower Dog"), we designed the whole world to really look like *Nightmare on Elm Street*—the rundown neighborhood, the derelict boiler room—but then when we got to his house, we thought it'd be funny for it to be super clean and nice and bright. The right page is loaded with early concepts for these locations—as well as a few takes on the lava trap from Goldenfold's dream world.

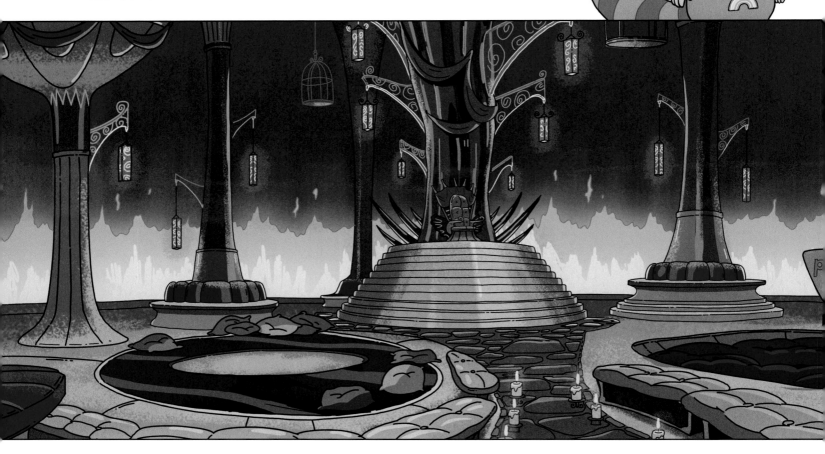

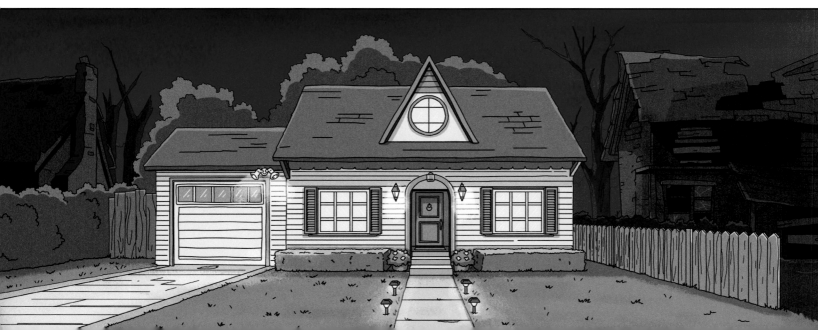

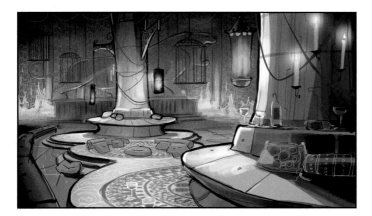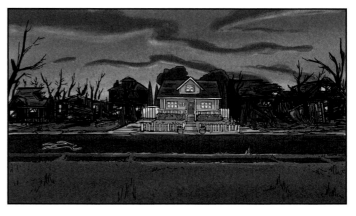

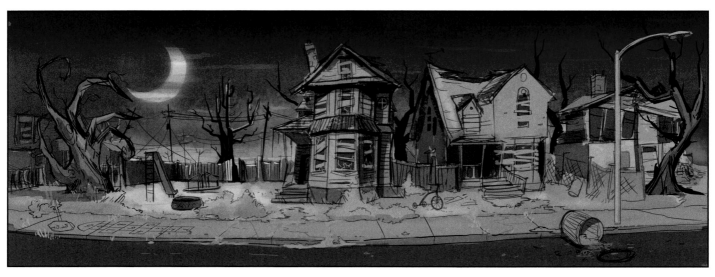

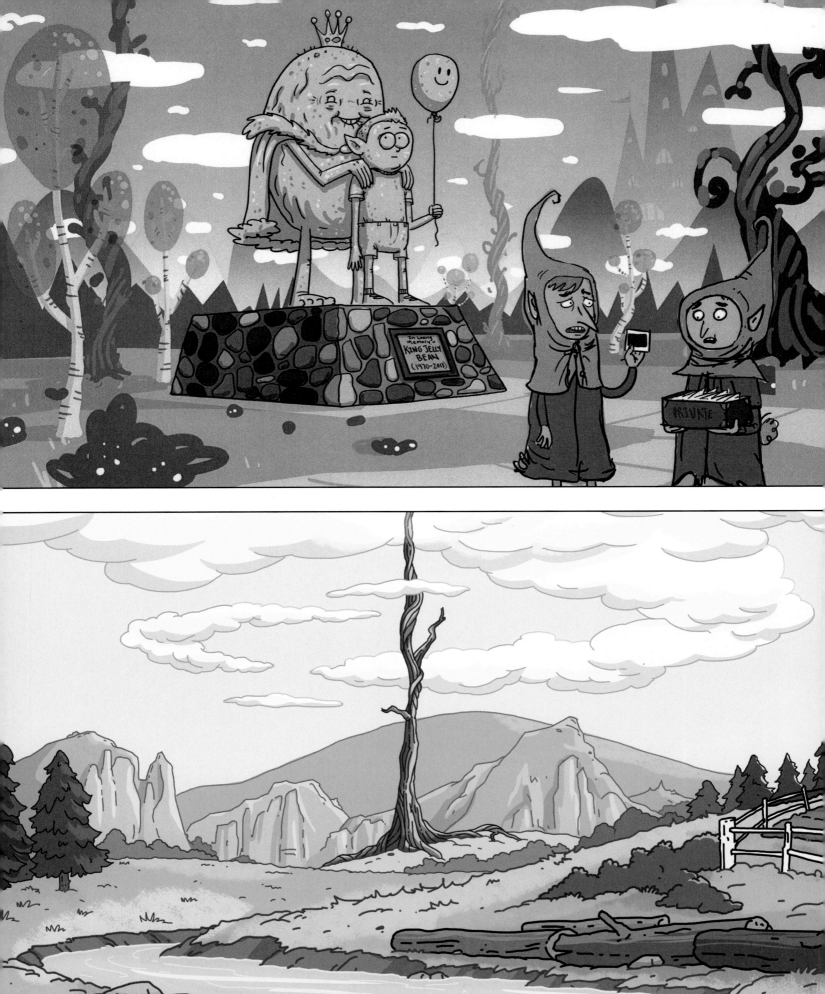

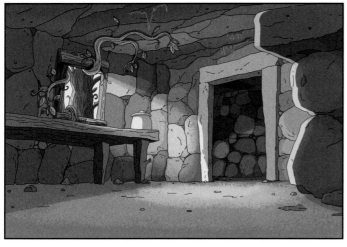

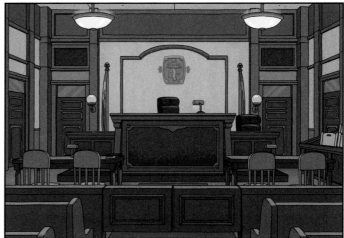

Giant World

In "Meeseeks and Destroy," we circumvented the typical giant story by having Rick and Morty kill the giant, get arrested, win the trial, and then get out—all before the third act of the story. So writing-wise, the big question was: now what the hell do we do with them? Justin was like, "Let's just have them climb down giant steps. They're still in a giant's world, right? Let's have them climb down all these big steps, and then in one of the steps, there's just this bar." So really, the whole idea for the Thirsty Step (and Slippery Stair and all those insane bar characters, *page 87*) came from a lot of people telling Justin, "Yep, sure, we can do that."

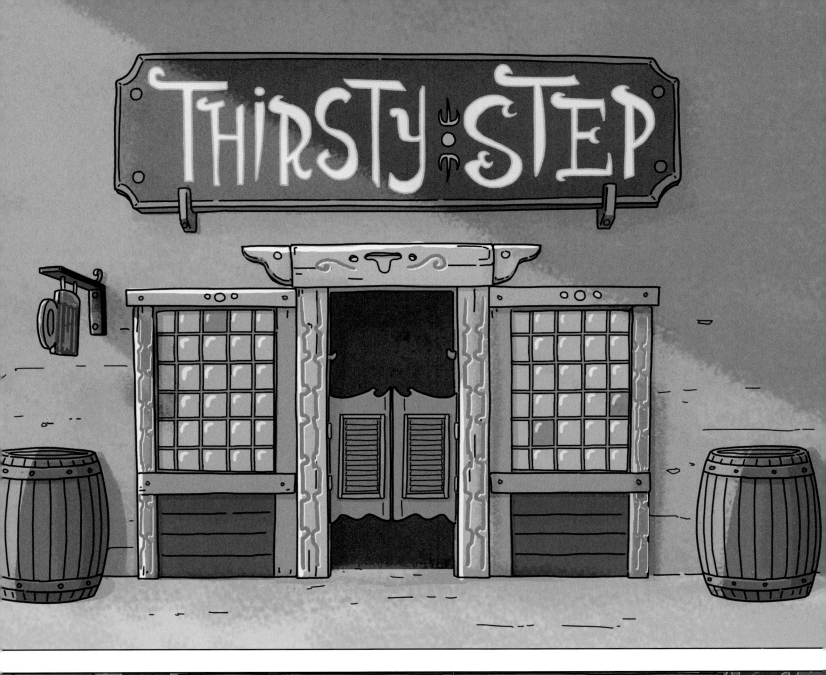

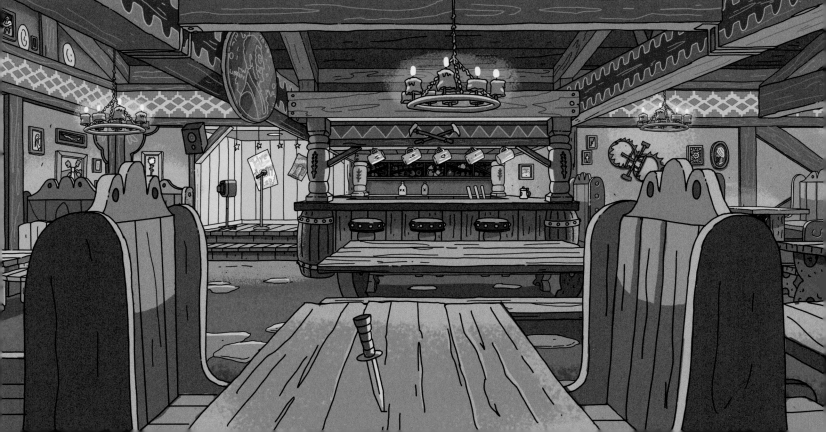

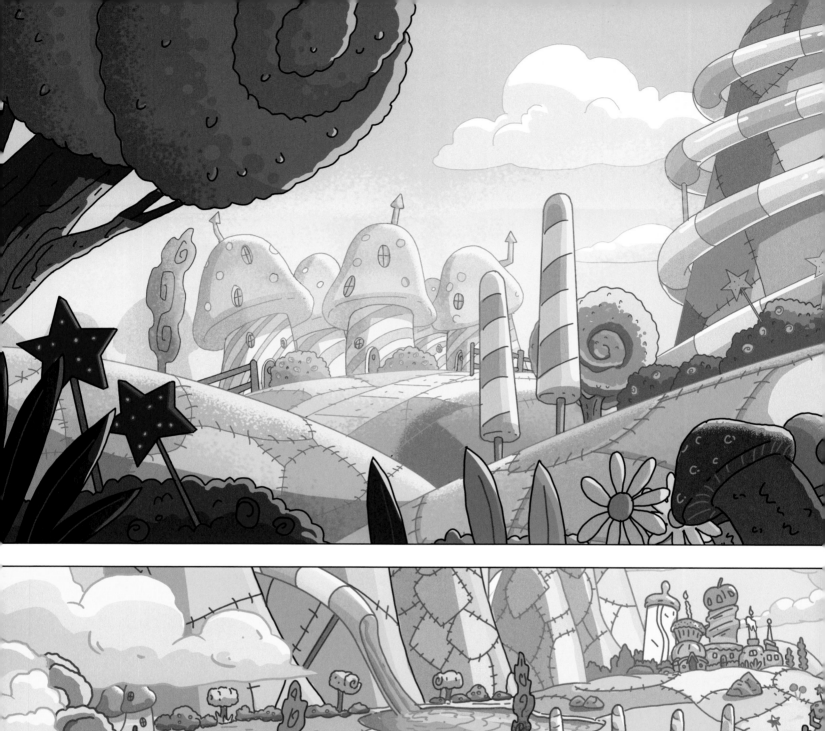
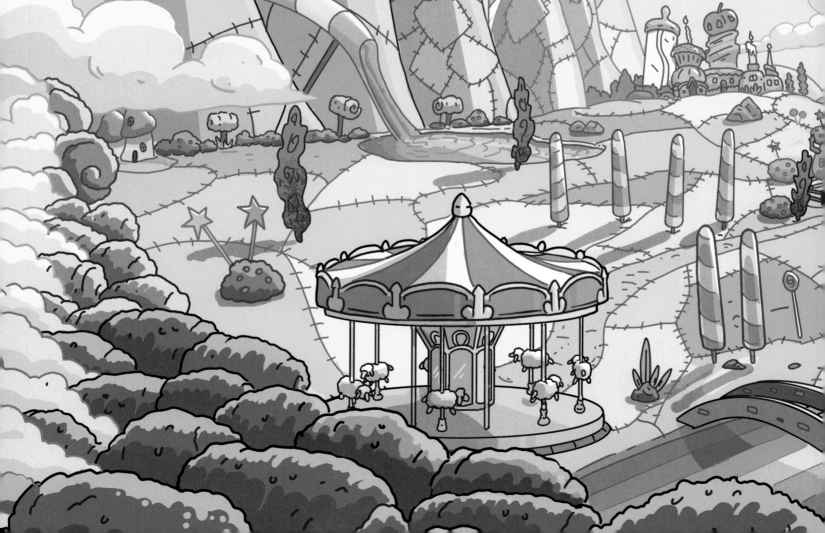

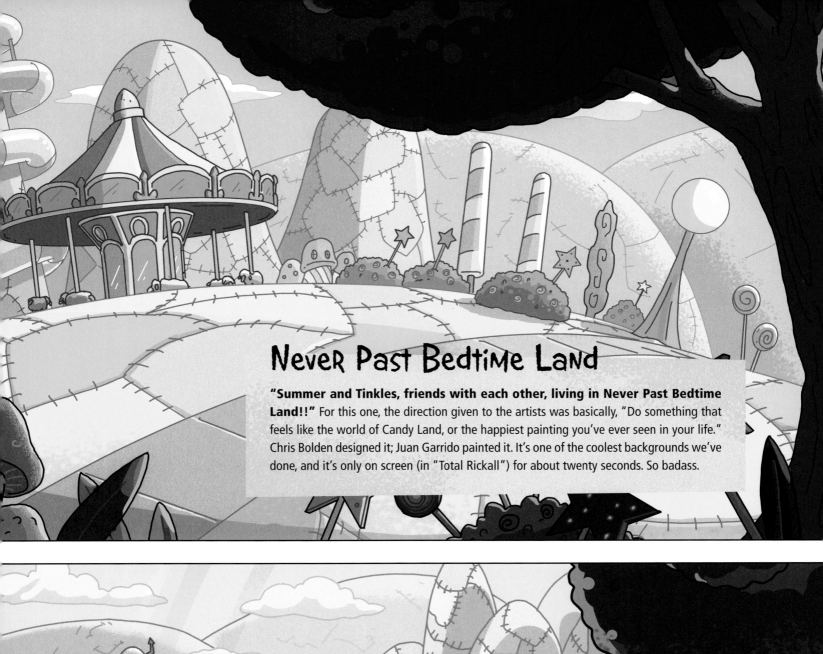

Never Past Bedtime Land

"Summer and Tinkles, friends with each other, living in Never Past Bedtime Land!!" For this one, the direction given to the artists was basically, "Do something that feels like the world of Candy Land, or the happiest painting you've ever seen in your life." Chris Bolden designed it; Juan Garrido painted it. It's one of the coolest backgrounds we've done, and it's only on screen (in "Total Rickall") for about twenty seconds. So badass.

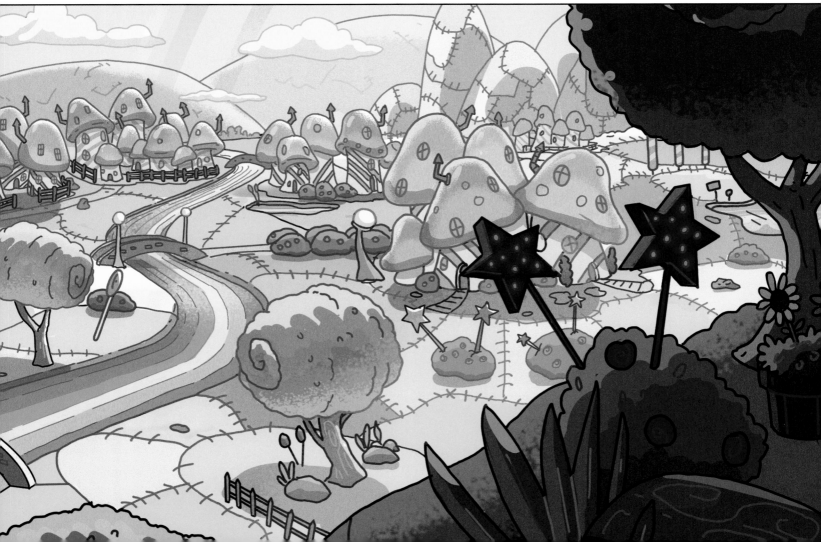

ALIEN ENVIRONMENTS

"Take a deep breath, breathe that- breathe that fresh air in, Morty. You smell that? That's the smell of adventure, Morty." Definitely one of the more iconic backgrounds on the bottom here—that's Dimension 35C, which we saw during Rick and Morty's quest for megaseeds in the pilot. This was designed by Jon Vermilyea—Justin had him just go for it, and he knocked it out of the park. Then Jason Boesch painted in the color and really made it feel fleshy, alien, and visually stunning. And up top here, that's Butt World . . . which is also beautiful in its own way.

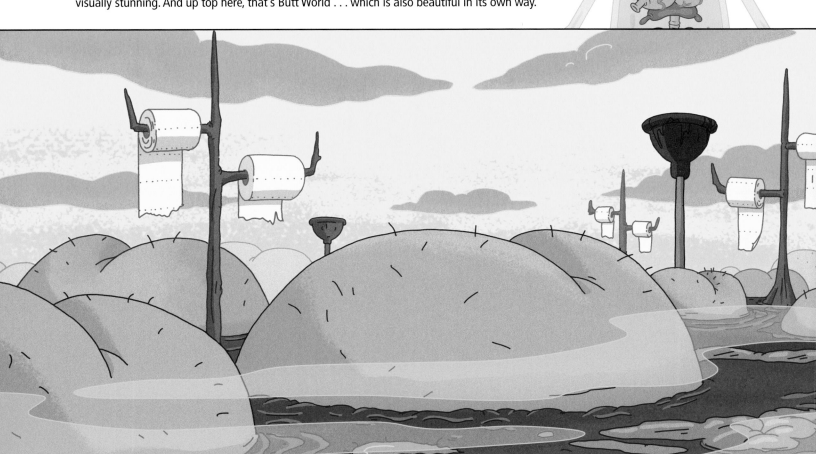

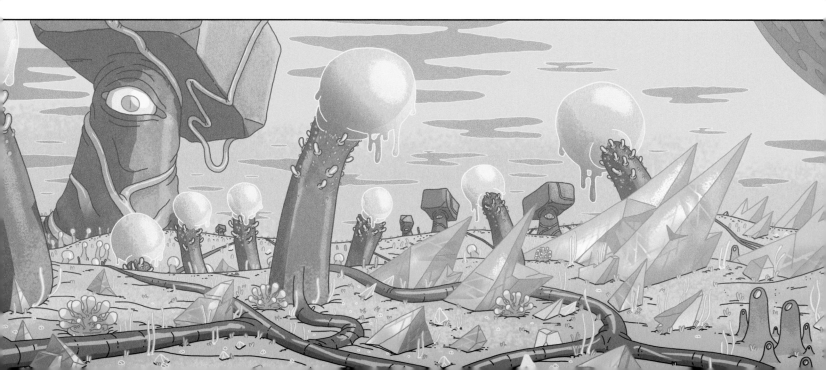

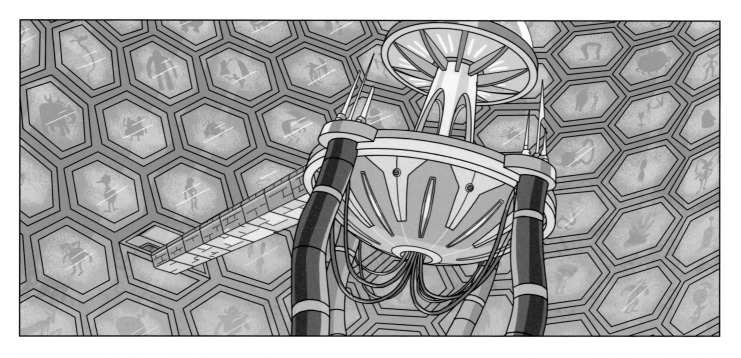

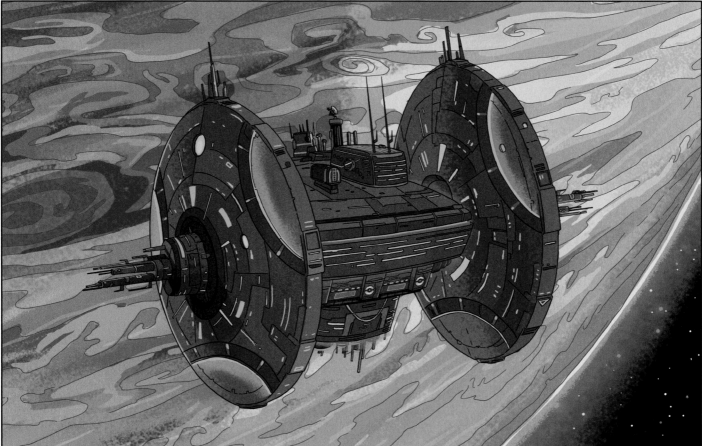

Zigerions

That big, awesome looking dumbbell ship was based on a concept James McDermott did for the exterior of the ship. Jeff Mertz designed the interior for that honeycomb-like hive space (*top*) where Rick and Morty had their gravity-defying chase sequence. Not pictured here: the Zigerions' irrational fear of nudity.

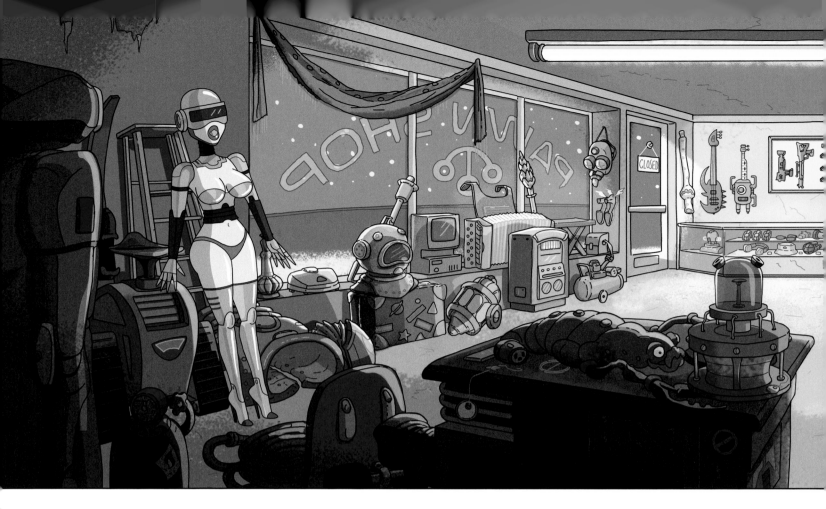

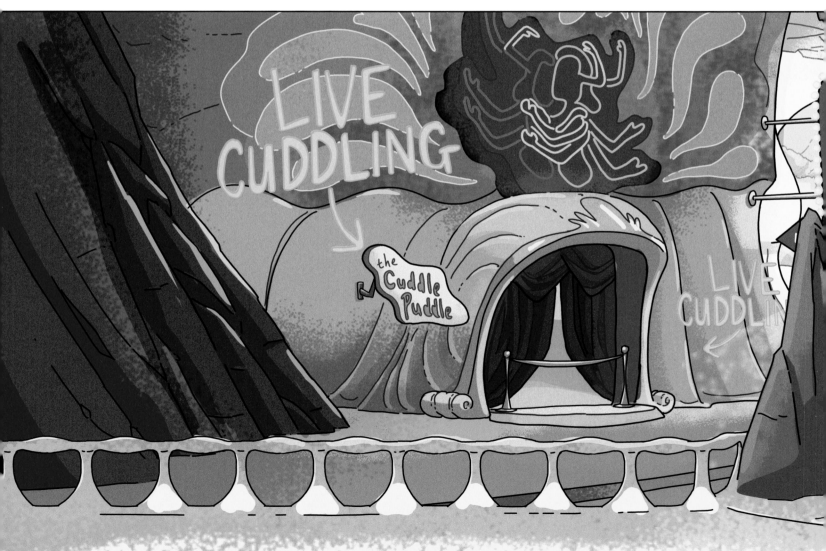

GazorpazorP

The artists used *Logan's Run* as an influence for the design of this underground matriarchal utopia. As for the shop names (like Just a Bite of Yours), these jokes were added in really late. The script was already written and recorded—but we had this whole sequence of Summer and Rick just walking through. So we decided to put visual gags (and loudspeaker announcements) in the background, really milk it for as many laughs as we could. Coming up with these gags, we were trying to think—if you have a utopian female society, what kind of businesses would pop up?

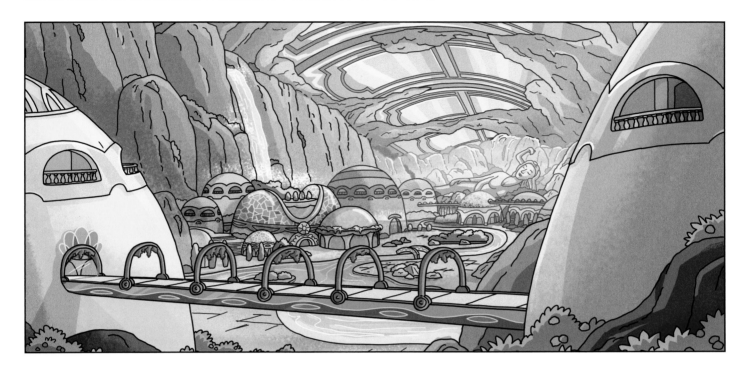

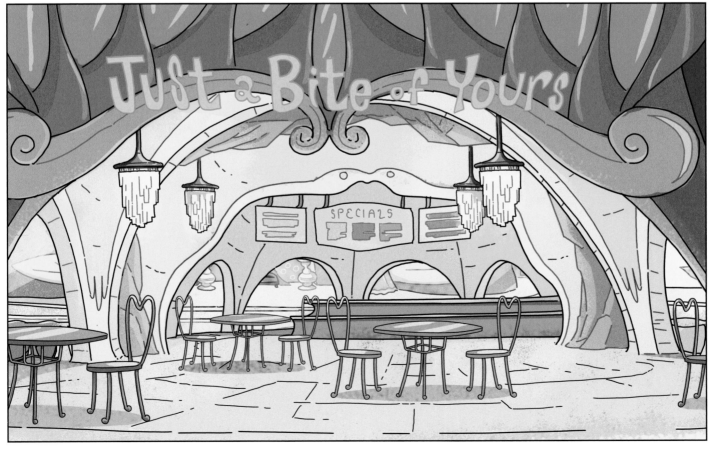

The Citadel of Ricks

"Most timelines have a Rick and most Ricks have a Morty. This place is a real who's who of who's you and me." The writers wanted the Citadel to feel super high tech and futuristic, and wanted the scale of this place to be absolutely rick-diculous. Just massive. With each of those glass pods being its own Rick city, filled with various subsections and towns. So yeah, what we see here (and in "Close Rick-counters of the Rick Kind") is only a small section of a much larger, much more complex Citadel. As for the Council of Ricks' infamous tribunal chambers (*right page, bottom*), the artists gave it this really cool golden color palette—incorporating tall trees, slick *Minority Report*–style screens, and rick-diculously high ceilings. Seriously. Look how rick-diculous.

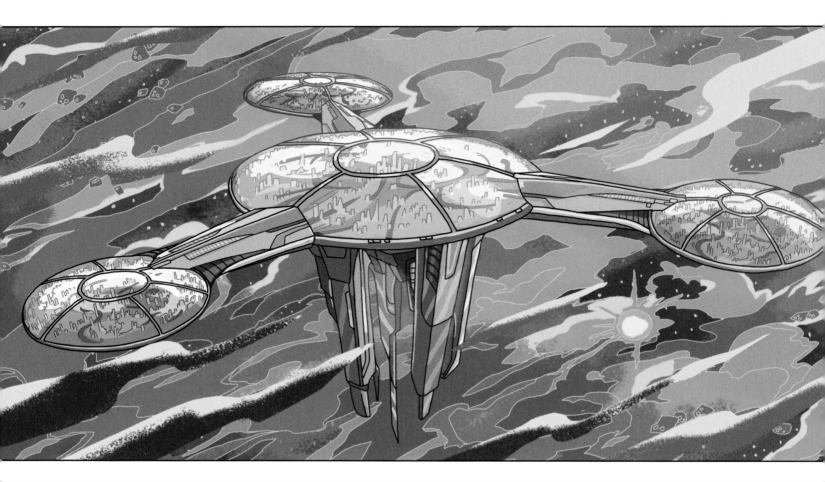

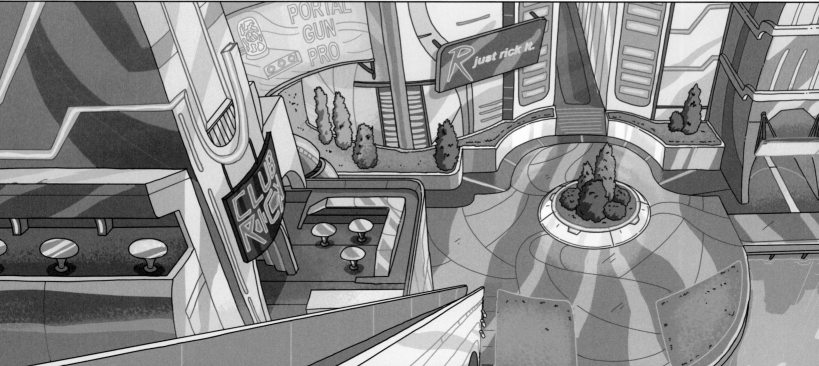

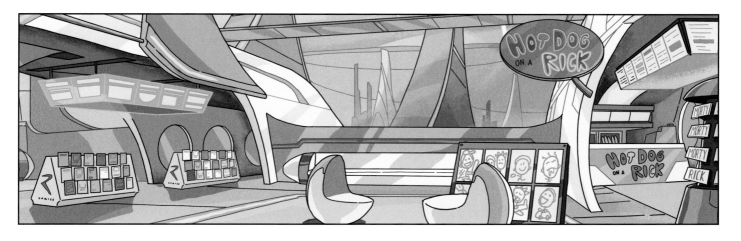

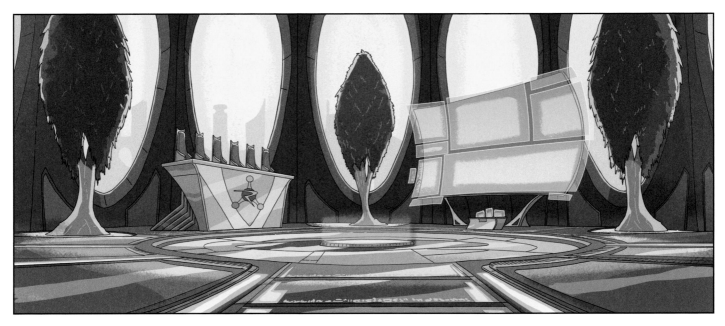

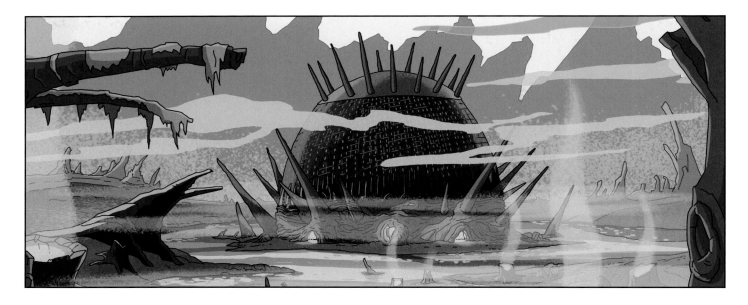

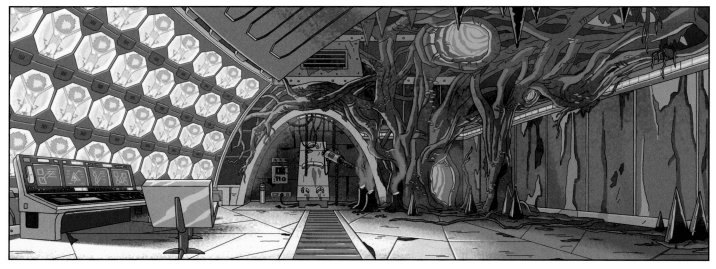

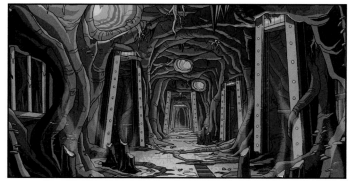

Evil Rick's Base

"One Morty is enough to hide from the bureaucrats, but you get- you get a whole matrix of Mortys and put 'em in agonizing pain—that creates a pattern that can hide even from other Ricks!" The exterior of this madman's lair (*top*) was inspired by Morla, the giant turtle, and the Swamps of Sadness surrounding him in *The NeverEnding Story*. The interior designs (also from "Close Rick-counters of the Rick Kind") were inspired by the cavern system and the large Skeksis opening area in *The Dark Crystal*. As for that matrix of chained-up Mortys . . . I mean, that's just bad craftsmanship. Our Rick could accomplish the same result with, like, five Mortys and a jumper cable.

Pluto

That fancy interior (*bottom*) was used for the Elitist Pluto Party, which Jerry visited as a distinguished guest (in "Something Ricked This Way Comes"). And of course, up top is the exterior of King Flippy Nip's capitol building. You might remember that balcony as the place where Jerry gave a riveting and impassioned speech: "Um. Pluto's a planet."

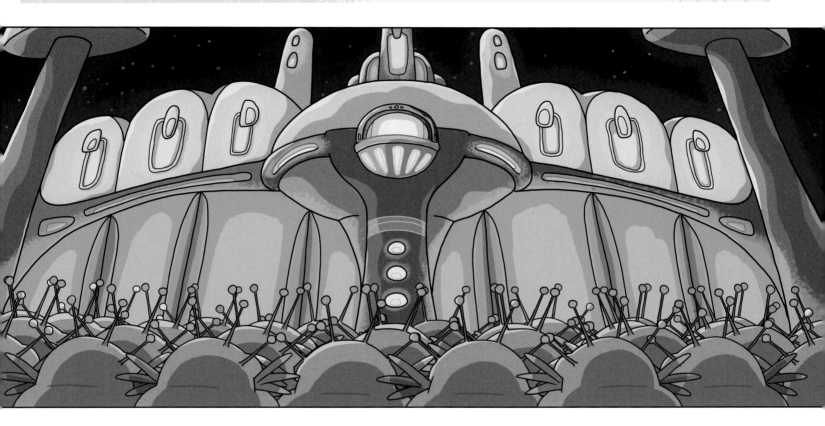

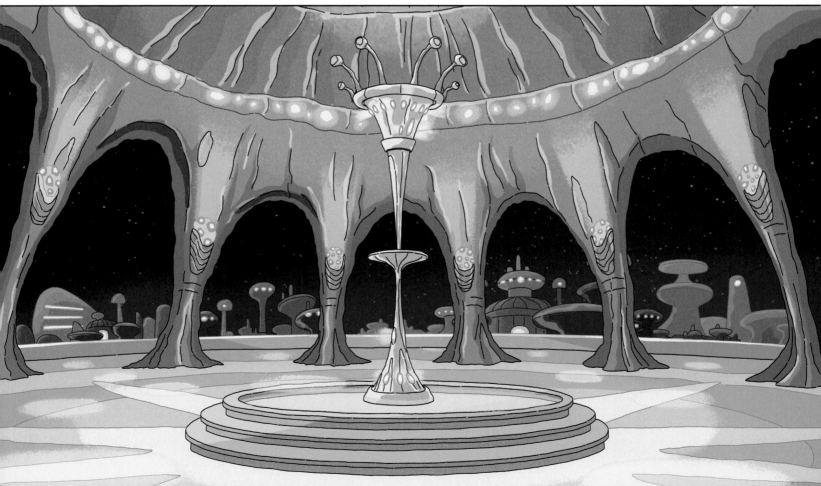

Blips and Chitz

"Do you understand what two humans can accomplish with three thousand flerbos? An entire afternoon at BLIPS AND CHIIIIIITZ!" There were some really cool designs for this intergalactic arcade that didn't make the cut. Just many, many iterations of it, especially considering how briefly we see this master shot on screen (in "Mortynight Run"). Jeff Mertz did the epic final version of the design, shown on top here. As for the infamous arcade game *Roy*, that concept was all the writers—they just loved the idea of having intergalactic aliens playing this insanely sophisticated video game of the most mundane human life possible.

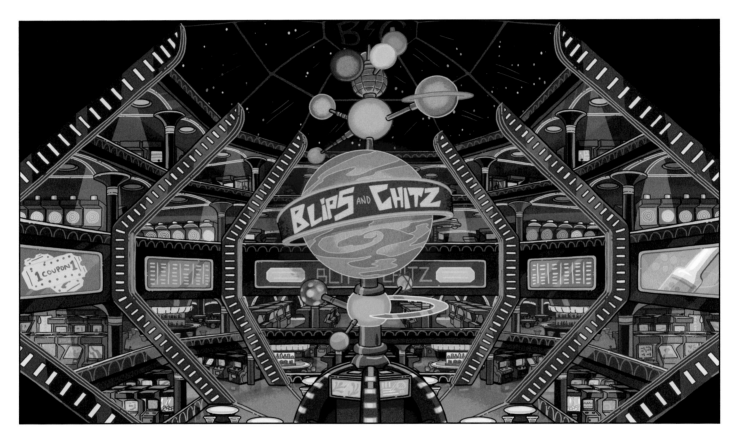

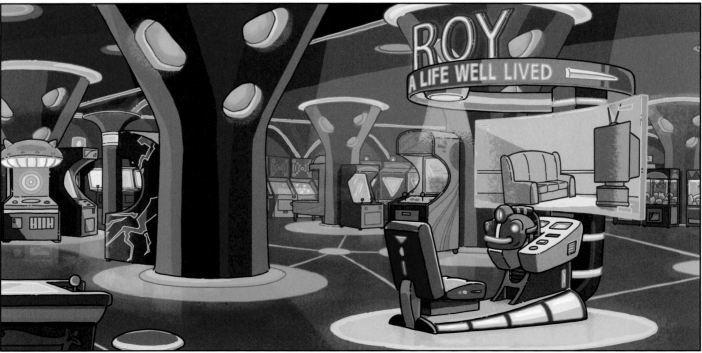

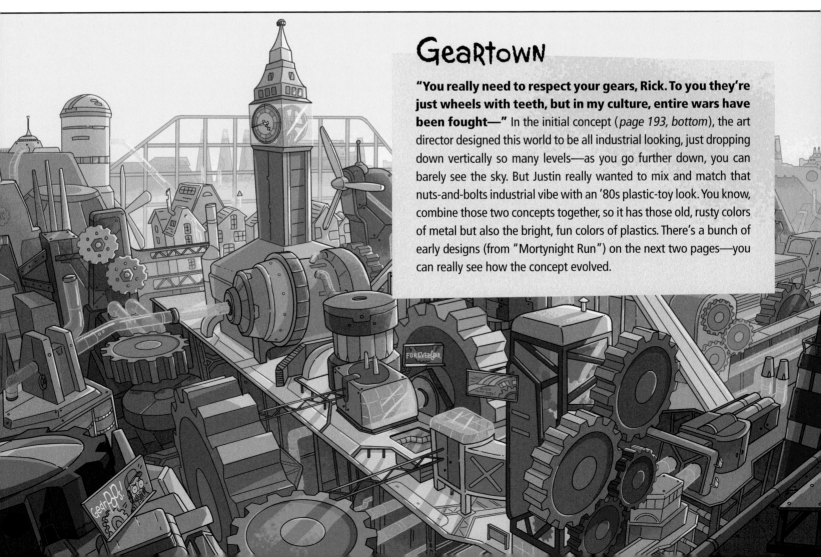

Geartown

"You really need to respect your gears, Rick. To you they're just wheels with teeth, but in my culture, entire wars have been fought—" In the initial concept (*page 193, bottom*), the art director designed this world to be all industrial looking, just dropping down vertically so many levels—as you go further down, you can barely see the sky. But Justin really wanted to mix and match that nuts-and-bolts industrial vibe with an '80s plastic-toy look. You know, combine those two concepts together, so it has those old, rusty colors of metal but also the bright, fun colors of plastics. There's a bunch of early designs (from "Mortynight Run") on the next two pages—you can really see how the concept evolved.

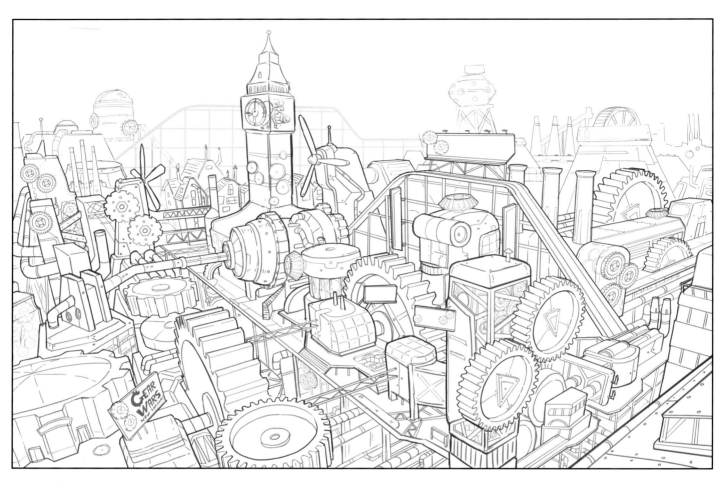

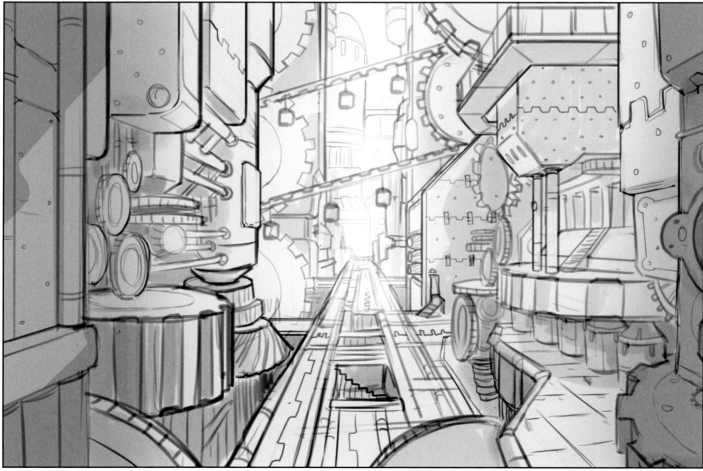

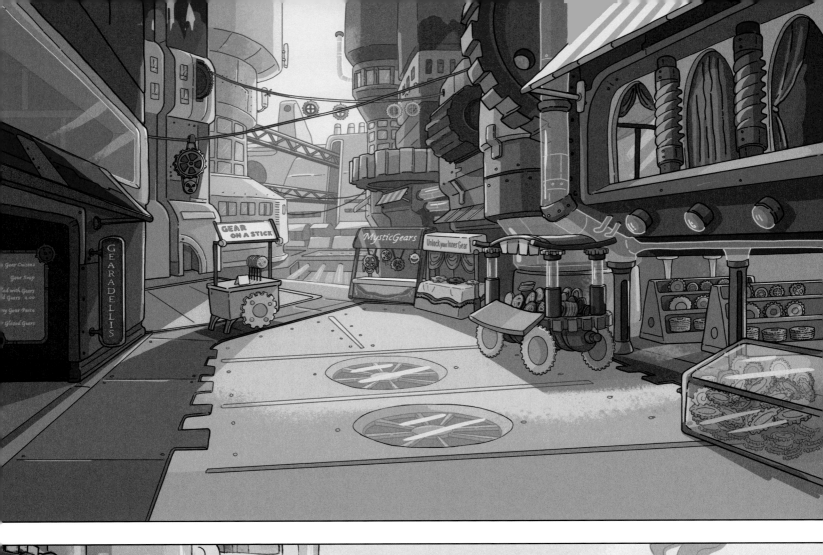

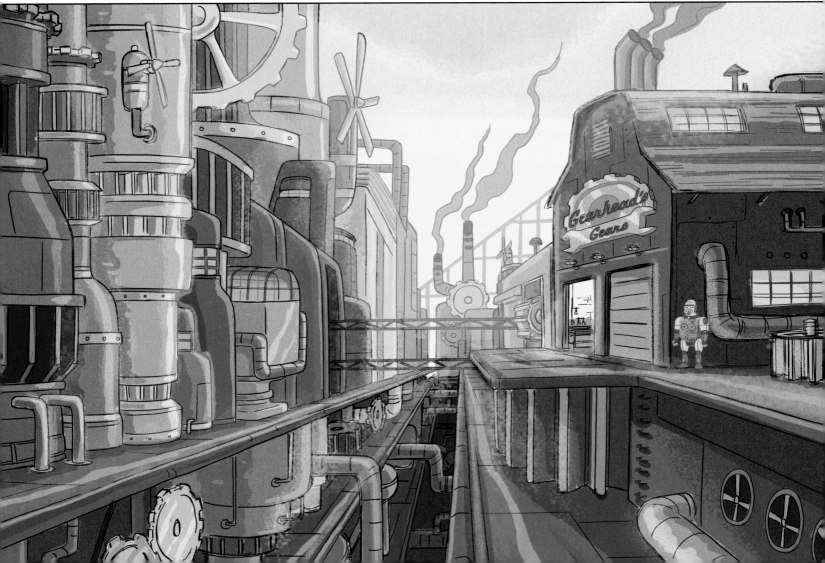

Unity's World

Okay, so 194 pages in—you've probably noticed that most art in the Rick and Morty universe looks pretty phallic. But this was actually the first episode where we decided to go more feminine, you know, more vaginal in the design. If you look at the aesthetics and architecture of this world (like Unity's sports stadium), it's really unmistakable what we were going for.

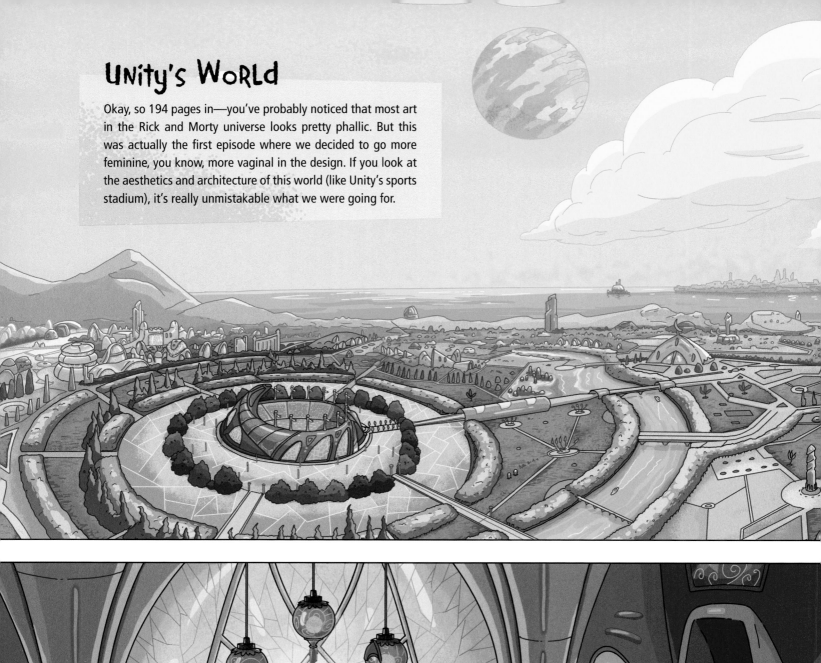

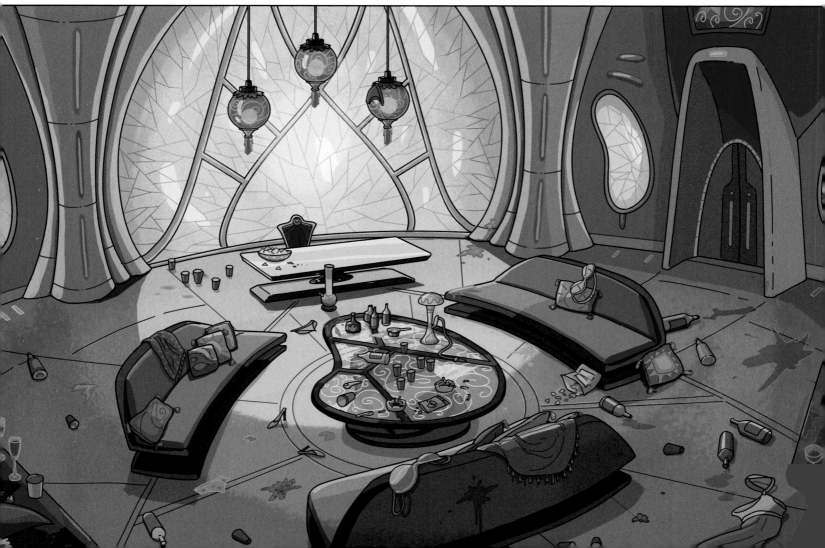

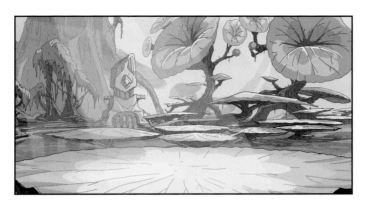 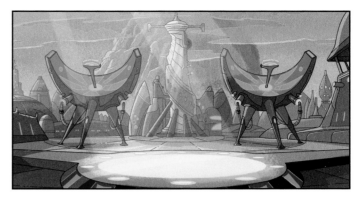

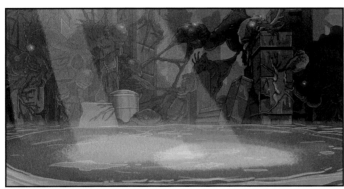 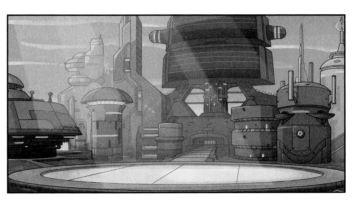

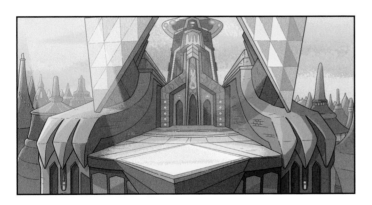 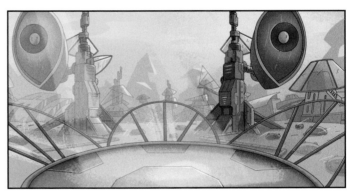

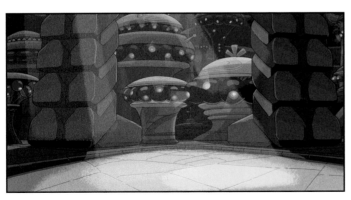

"Twenty-four hours. Five planets. Five songs. But in the end, there can only be one . . . PLANET MUSIC!" All these worlds above are the one-offs from "Get Schwifty"—the planets competing with Earth that we see for, like, two seconds each. It's always a challenge for the artists to not repeat themselves, but this was particularly nuts because there were *so many* new environments to create. Planet Parblesnops, Planet Arboles Mentirosos . . . We wanted each place to feel unique to that alien race, all the way down to the color palette and musical props they used. These designs came out super cool and we loved them all . . . so we did the obvious thing: blew them up with a plasma ray.

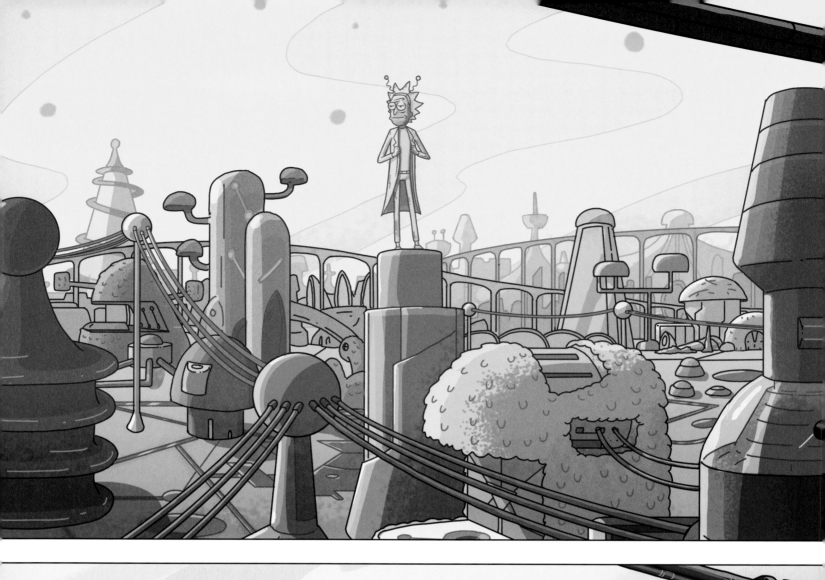

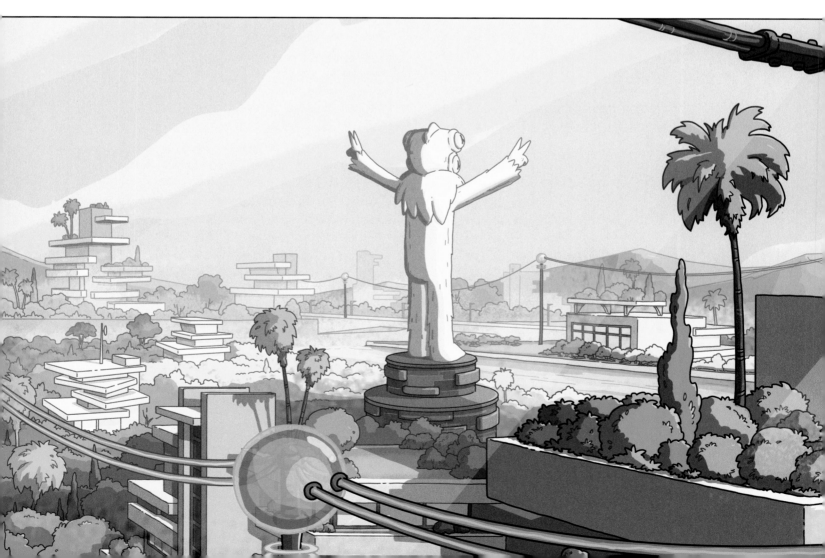

Microverse Worlds

"You have a whole planet sitting around making your power for you, Rick?! That's slavery!" It took quite a bit of planning to sort out all the different worlds inside worlds in "The Ricks Must Be Crazy." For the Microverse that Rick built (where Zeep lives, *top*), we made it more polluted and clunky, with wires everywhere. It's not exactly well built, but it works. For the Miniverse that Zeep built (where Kyle lives, *bottom*), Justin wanted it to have a Frank Lloyd Wright energy, really pristine and clean, blue skies and lush foliage, all the details working in harmony with each other. This contrast was done on purpose—all of it driving Rick's competitiveness, making him hate Zeep for creating a more slick, utopian world.

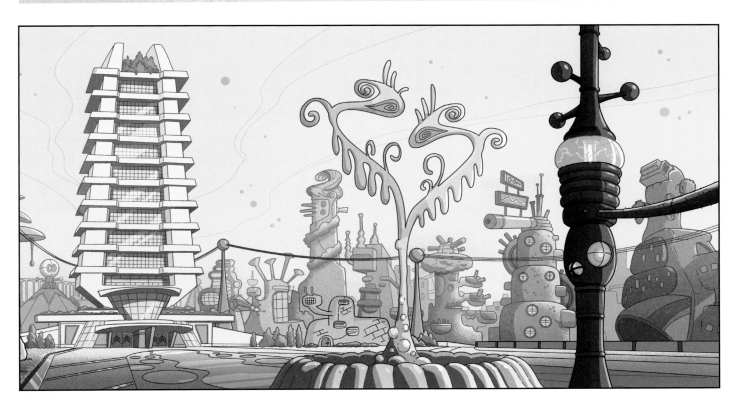

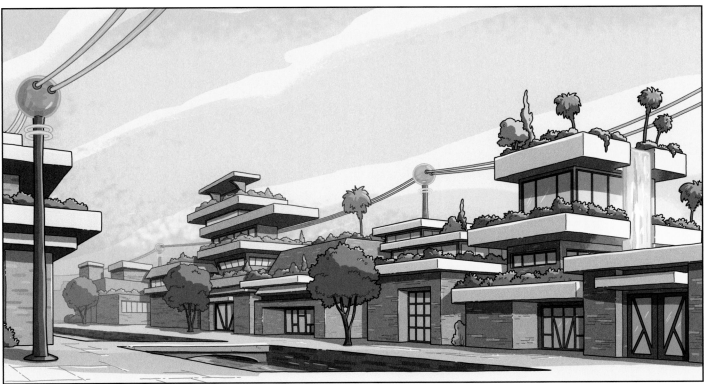

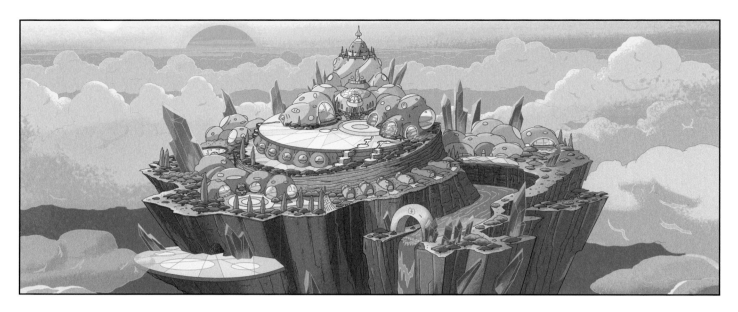

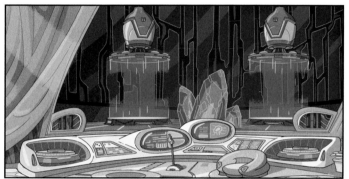

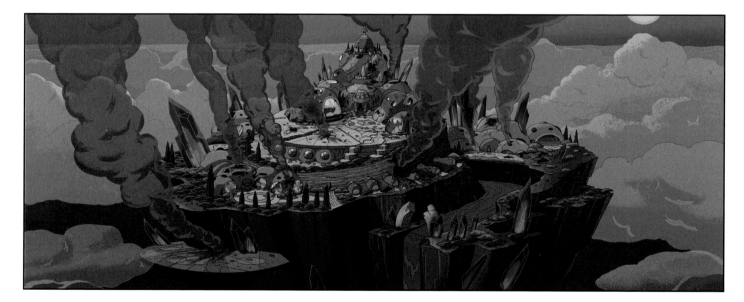

Nuptia Four

Man, we redesigned the shit out of this couples therapy retreat (from "Big Trouble in Little Sanchez"). There must have been eight or nine rounds on the exterior alone. Eventually, the art team landed on what you see above, drawing inspiration from the Bubble Palace in the south of France (a massive estate with all these really cool bubble structures). The mythologue environment (*center*) was also challenging in terms of balancing out the visuals: the place needed to feel like comfortable spa living but also have this crazy science experiment going on that can create these insane, evil monsters like XenoBeth (*pages 60–61*).

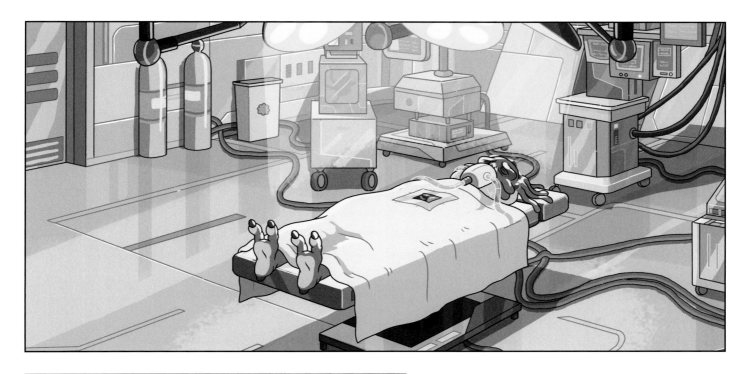

St. Gloopy Noops

"I'm a good person, and I demand that you cut off my penis and put it in that man's chest!" Ahhh, St. Gloopy Noops . . . the best hospital in the galaxy. The art director did some original concepts for the interior areas, giving the backgrounds a polished, clean look—kinda like an Apple product. That really informed the design of this world. Oh, and there's the waiting room (*center*) where Rick rigged the cable box to watch interdimensional cable. It's also where we first saw the Plumbus commercial. Precious memories.

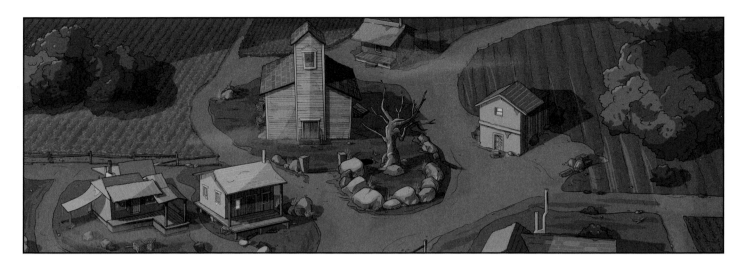

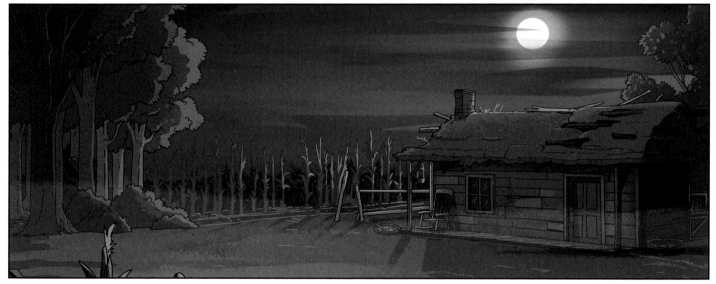

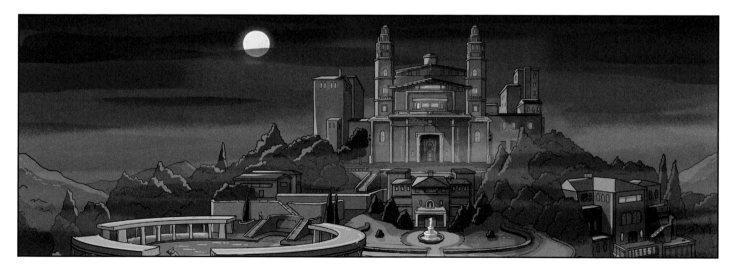

Purge Planet

We kinda wanted the poor people's part of town to feel like an old 1800s farming village—it was a totally different environment from anything we'd done, you know, being sci-fi in a new way. The rich people's mansion (*bottom*) drew a bit of inspiration from Hearst Castle and was supposed to be a safe haven from the Festival. But guess what, though? Those fat cats got purged, son!

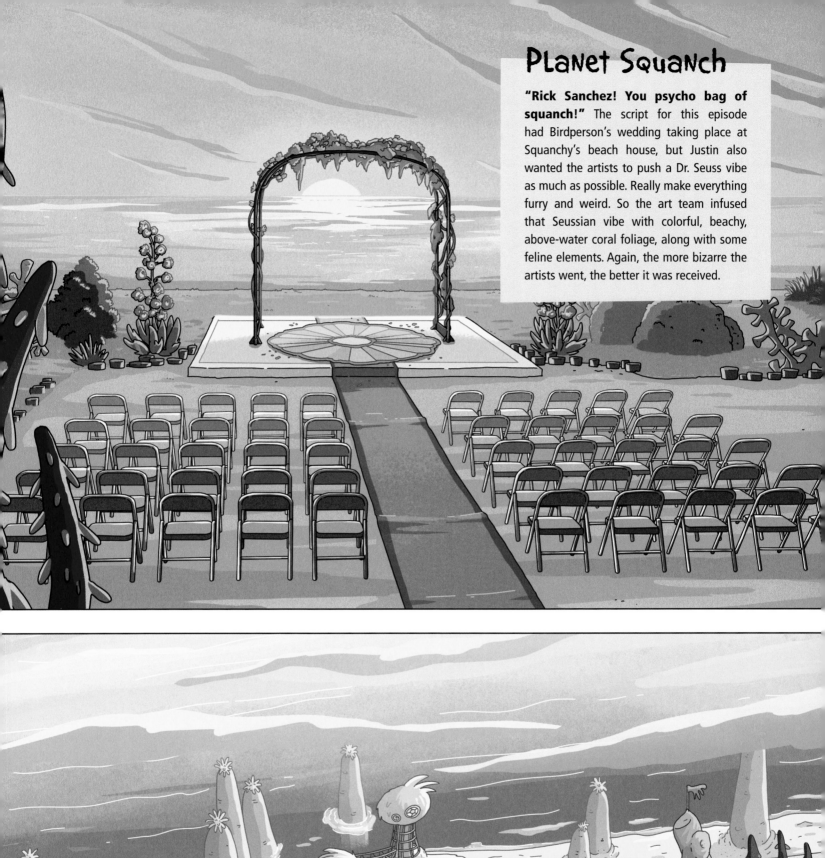

PLANET SQUANCH

"Rick Sanchez! You psycho bag of squanch!" The script for this episode had Birdperson's wedding taking place at Squanchy's beach house, but Justin also wanted the artists to push a Dr. Seuss vibe as much as possible. Really make everything furry and weird. So the art team infused that Seussian vibe with colorful, beachy, above-water coral foliage, along with some feline elements. Again, the more bizarre the artists went, the better it was received.

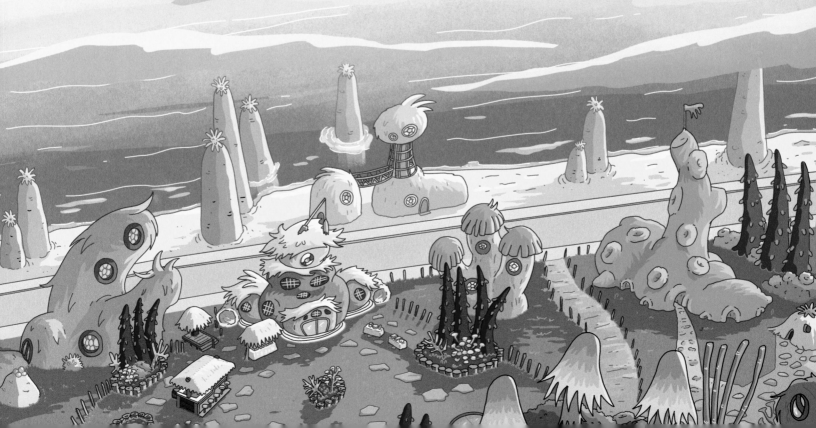

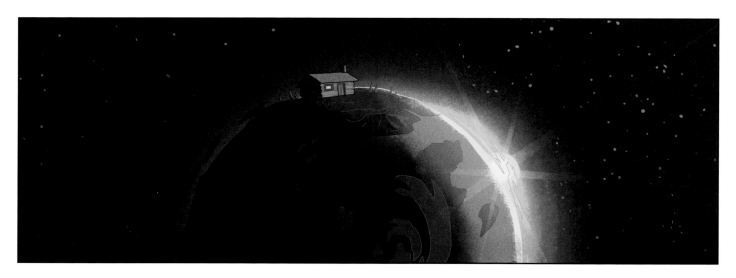

"GET IN THE GOD DAMN SHIP! EVERYTHING'S ON A COB! THE WHOLE PLANET'S ON A COB! GO! GO! GO!" You might remember these three worlds from when the Smiths were on the lam in "The Wedding Squanchers." Up top is Screaming Sun Planet—which is, you know, pretty self-explanatory. Then you've got the infamous On a Cob Planet (*center*). This gem was a pitch by writer Dan Guterman. And on the bottom is Dwarf Terrance-9 (a.k.a. Tiny Planet), where the Smiths briefly lived before Rick turned himself in.

Galactic Federal Prison

Damn, this one is epic—and although it's only briefly shown, it was critical in landing the ending of the season 2 finale ("The Wedding Squanchers"). The creators really wanted the tone of this sequence to be dire and hopeless. So for the prison interior (*top*), the artists designed a special forklift claw to carry Rick's cube through the main prison area, into a separate cavern with even higher security. You know, putting him on ultimate lockdown, really making it seem like he'd never get out. The exterior (*bottom*) was based on an initial concept by James McDermott which Justin really dug. From there, they went back and forth conceptually—how it was gonna work, what the scale was—Justin wanted this place to seem massive. Also, notice the prison's color palette is consistent with that of the Gromflomites (*page 85*). Again, trying to separate out each alien race and stick with a color scheme to help distinguish it from all these other worlds.

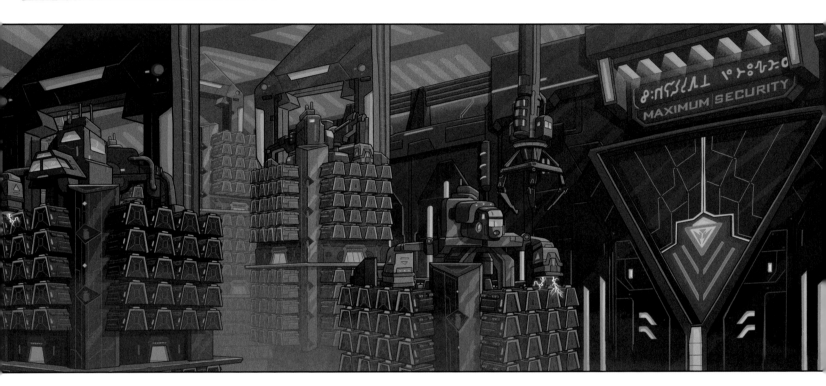

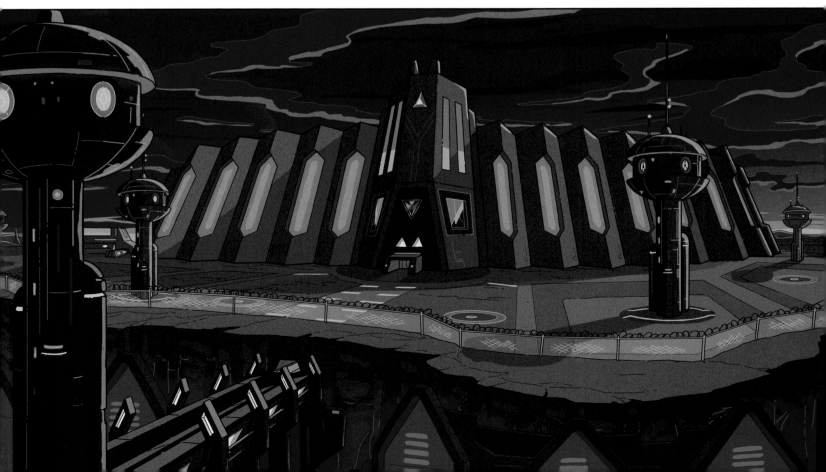

CHAPTER FIVE

Production

Doc and Mharti

"Yes, Mharti! It's the only way to fix our time travel car! You have to lick my balls, Mharti!!" Damn, this is as old school as it gets. *The Real Animated Adventures of Doc and Mharti* was a cartoon short that Justin cranked out super fast for Channel 101 (a monthly short film fest co-created by Dan Harmon), and in it, Mharti basically has to lick Doc's testicles to go back in time. Justin's only goal was to blow off some creative steam and be shocking on purpose, but ultimately, this short became the inspiration for the characters of Rick and Morty. All these heads below are from the original storyboards. Crazily enough, Justin had actually designed better-drawn characters to use in the final animation—but going into production, he couldn't stop laughing at these shitty storyboard drawings. So he scrapped the polished designs and went with these. That's why Doc's and Mharti's heads change in every shot—he wanted to use every single drawing from the storyboard panels.

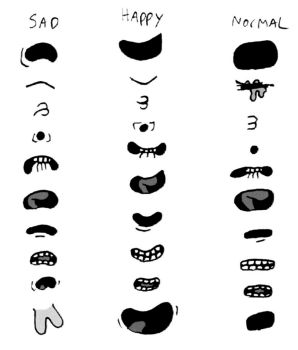

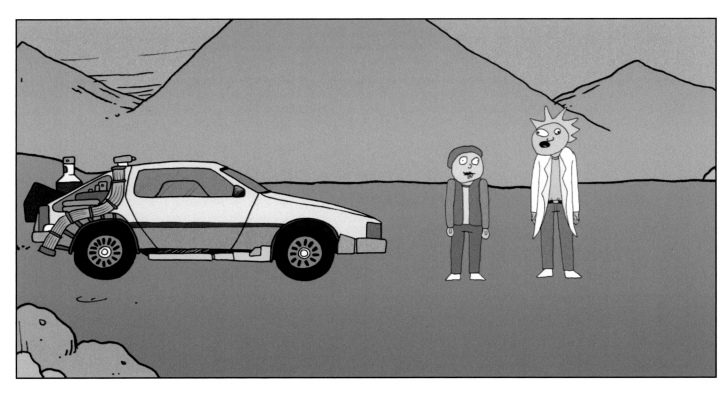

DEVELOPMENT

Going into production on the pilot, Justin really wanted to try to maintain that same kinda energy he had with *Doc and Mharti*. But design-wise, he learned early on that changing the heads in every shot wouldn't work (*as mentioned on page 11*). So he basically decided, "If we can't do a bunch of different builds like *Doc and Mharti*, then let's just do the scribble pupils." To Justin, the hand-drawn scribble pupil look represents the loose, fun nature that this show should have—the "I don't give a damn, I'm just screwing around, having fun" kinda vibe. That was the one main holdover from the original short.

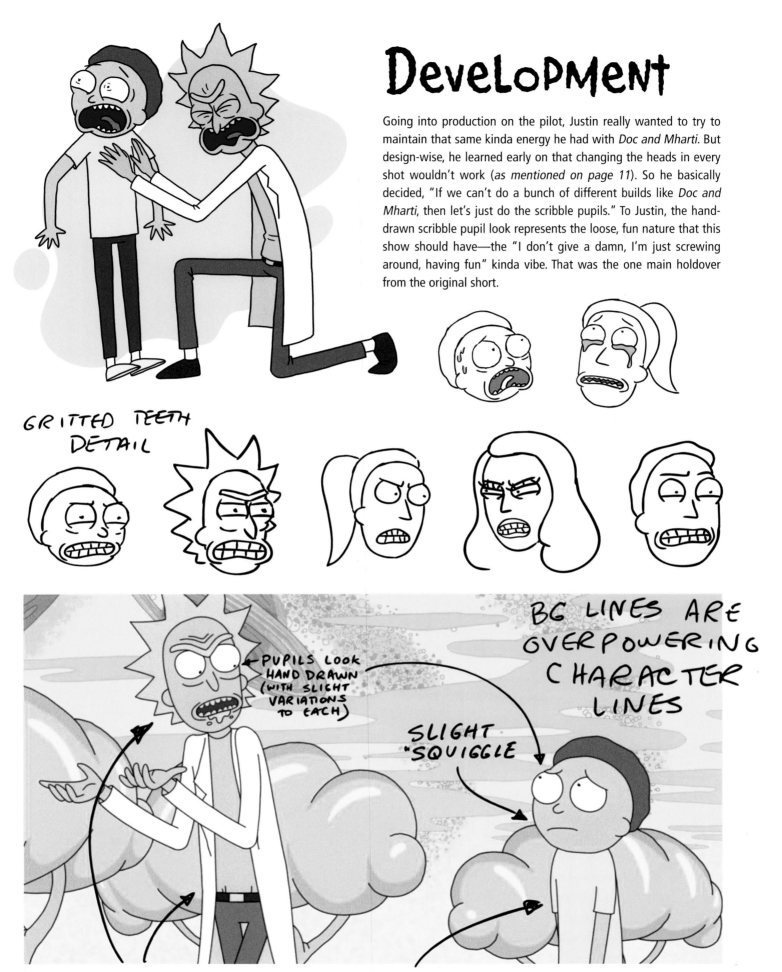

GRITTED TEETH DETAIL

PUPILS LOOK HAND DRAWN (WITH SLIGHT VARIATIONS TO EACH)

BG LINES ARE OVERPOWERING CHARACTER LINES

SLIGHT "SQUIGGLE"

CHARACTER LINES ALL HAVE CLEAN, HAND-DRAWN LOOK

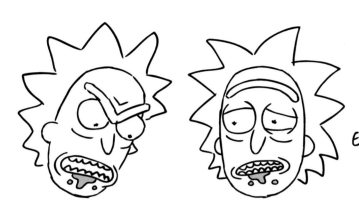

DROOLS ON CHIN WHEN EXCITED OR DRUNK

So the other big change during development? Giving Rick that pill-shaped head (*page 12*). As you can see in *Doc and Mharti*, it used to be muuuuch more circular. This page here is just us getting into the weeds with Rick's style guide—what words he spits on, rules for the unibrow. We really had to clean up and conform the designs before animation could begin.

SPITS ON ACCENTED WORDS WHEN EXCITED (ESPECIALLY WHEN DROOL IS PRESENT)

FOREHEAD LINES ON RICK'S UNIBROW! USE THESE IN EXTREME CASES — AS IF HIS FLESH WAS BEING SQUEEZED BY THE BROW

VERY BUSY SCENE — BUT IT ALL WORKS BECAUSE B.G. LINES NOT TOO THICK, THEREFORE LESS DISTRACTING

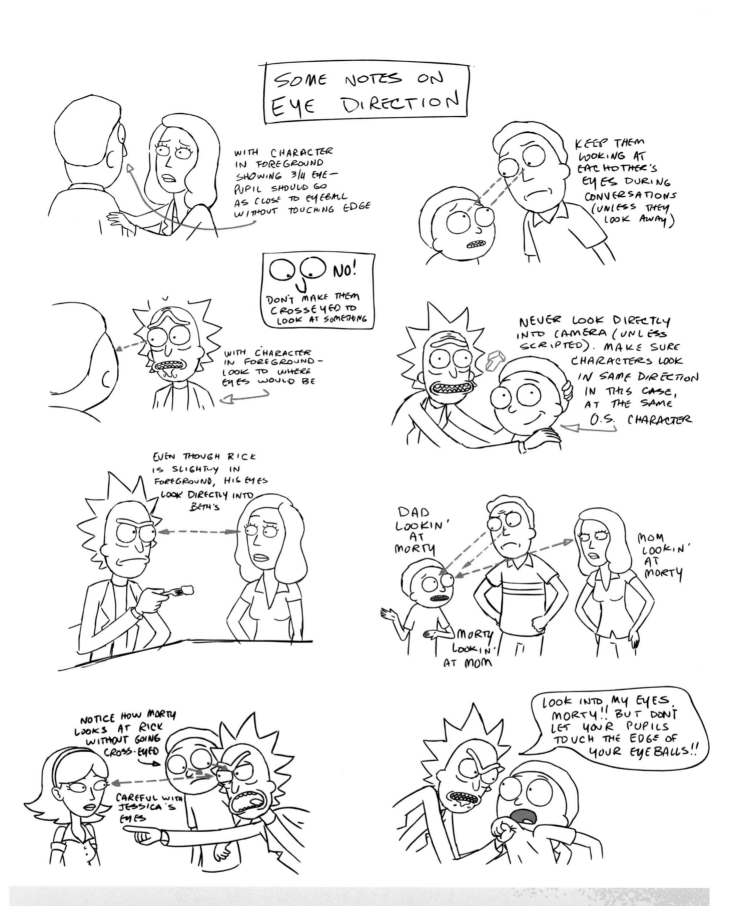

I know you're probably looking at these pages and you're like, whoa—I never even thought about any of this, bro! Holy shit, dawg! That's because of style guides like these. As we moved further into the life of the show, Justin and Pete Michels (the supervising director) started creating these master guides—documents that were the final word on things like eye direction and head shapes. As for "line weight," which you can see noted on the left page—that's basically the thickness of lines. Justin's rule for this: character lines should match the background lines at all times. The more you know!

Scripts

Oh man, buckle up, you're about to see how that *Rick and Morty* sausage gets made, son! Ideas come a lonnnng way from initial pitch to what you see on screen. The writers start off every season by "blue sky" pitching new ideas—no wrong answers—and slowly sift through those ideas until only their favorites are left. From there, the story is broken out into what we call an "embryo" or "story circle" (*page 221*), which then gets turned into a beat sheet, then an outline (*bottom right*), and then a writers' "spit draft"—which is then revised and polished into what you're seeing here: the record draft . . . which still usually gets revised and rewritten even further.

This bad boy with the yellow highlighter is from "Lawnmower Dog," the second script ever. (That and "Rick Potion #9" were actually written before the show got picked up as a series.) On the bottom is Justin's script from the launch meeting of "The Ricks Must Be Crazy." In the margins, you can see his notes about Kyle's Teenyverse ship, as well as a doodle of Rick's "alien" antennae. The final design (*page 102*) looks almost exactly like it.

101 "LAWNMOWER DOG" NUMBERED RECORD (1/28/13) 26.

INT. SCARY HIGH SCHOOL - FIVE DREAMS DEEP - DAY

Scary Terry, dressed like a 90's grunge teenager runs through the halls of his high school.

Regular students? How many?

 SCARY TERRY 189
 I'm late to class, bitch!

The other students in the hallway point at Scary Terry and **laugh.** He looks down.

 SCARY TERRY (CONT'D) 190
 Oh no! I'm not wearing any pants!

INT. SCARY CLASSROOM - CONTINUOUS

Terry walks into class. SCARY OLDERSON, a conservative, British headmaster version of the Freddy Krueger persona stands at the head of the class.

 SCARY OLDERSON 191
 Well, Mr. Terry, so glad you could
 join us, bitch.

 SCARY TERRY 192
 Sorry, bitch.

Terry sits down next to two other kids. It's Rick and Morty disguised as scary school students.

masks? 193

 SCARY OLDERSON
 Why don't you tell the whole class
 the proper wordplay to use when one
 is chasing one's victim through a
 pumpkin patch!

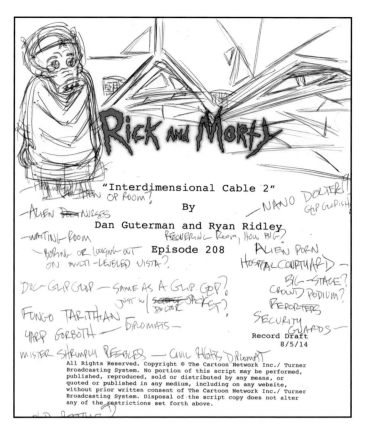

Rick and Morty

"Interdimensional Cable 2"

By

Dan Guterman and Ryan Ridley

Episode 208

Record Draft
8/5/14

All Rights Reserved. Copyright © The Cartoon Network Inc./ Turner Broadcasting System. No portion of this script may be performed, published, reproduced, sold or distributed by any means, or quoted in any medium, including on any website, without prior written consent of The Cartoon Network Inc./ Turner Broadcasting System. Disposal of the script copy does not alter any of the restrictions set forth above.

(handwritten notes): ALIEN OP ROOM? · NANO DOLTER GLIP GLOPISH · ALIEN NURSES · WAITING ROOM · RECOVERING ROOM, HOW BIG? · BORING OR LOOKING OUT ON MULTI-LEVELED VISTA? · ALIEN PORN · HOSPITAL COURTYARD · DOC-GLIP GLOP—SAME AS A GLIP. GOP? · JUST W/ DOCTOR JACKET? · BIG-STAGE? CROWD PODIUM? REPORTERS · FUNGO TARITHIAN · YARP GORBOTH—DIPLOMATS · SECURITY GUARDS · MISTER SHRIMPLY PEEBLES—CIVIL RIGHTS DIPLOMAT

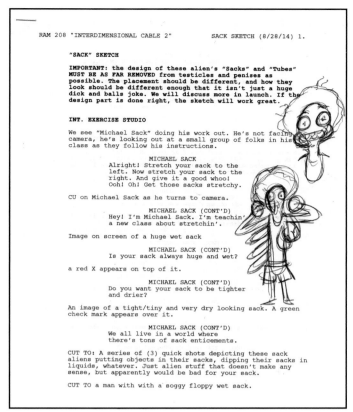

"SACK" SKETCH

IMPORTANT: the design of these alien's "Sacks" and "Tubes" MUST BE AS FAR REMOVED from testicles and penises as possible. The placement should be different, and how they look should be different enough that it isn't just a huge dick and balls joke. We will discuss more in launch. If the design part is done right, the sketch will work great.

INT. EXERCISE STUDIO

We see "Michael Sack" doing his work out. He's not facing camera, he's looking out at a small group of folks in his class as they follow his instructions.

 MICHAEL SACK
 Alright! Stretch your sack to the
 left. Now stretch your sack to the
 right. And give it a good whoo!
 Ooh! Oh! Get those sacks stretchy.

CU on Michael Sack as he turns to camera.

 MICHAEL SACK (CONT'D)
 Hey! I'm Michael Sack. I'm teachin'
 a new class about stretchin'.

Image on screen of a huge wet sack

 MICHAEL SACK (CONT'D)
 Is your sack always huge and wet?

a red X appears on top of it.

 MICHAEL SACK (CONT'D)
 Do you want your sack to be tighter
 and drier?

An image of a tight/tiny and very dry looking sack. A green check mark appears over it.

 MICHAEL SACK (CONT'D)
 We all live in a world where
 there's tons of sack enticements.

CUT TO: A series of (3) quick shots depicting these sack aliens putting objects in their sacks, dipping their sacks in liquids, whatever. Just alien stuff that doesn't make any sense, but apparently would be bad for your sack.

CUT TO a man with with a soggy floppy wet sack.

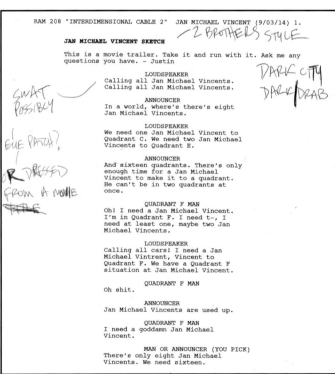

JAN MICHAEL VINCENT SKETCH *(handwritten):* 2 BROTHERS STYLE

This is a movie trailer. Take it and run with it. Ask me any questions you have. - Justin

 LOUDSPEAKER *(handwritten):* DARK CITY DARK/DRAB
 Calling all Jan Michael Vincents.
 Calling all Jan Michael Vincents.

 ANNOUNCER
 In a world, where's there's eight
 Jan Michael Vincents.

 LOUDSPEAKER
 We need one Jan Michael Vincent to
 Quadrant C. We need two Jan Michael
 Vincents to Quadrant E.

 ANNOUNCER
 And sixteen quadrants. There's only
 enough time for a Jan Michael
 Vincent to make it to a quadrant.
 He can't be in two quadrants at
 once.

 QUADRANT F MAN
 Oh! I need a Jan Michael Vincent.
 I'm in Quadrant F. I need t-, I
 need at least one, maybe two Jan
 Michael Vincents.

 LOUDSPEAKER
 Calling all cars! I need a Jan
 Michael Vintrent, Vincent to
 Quadrant F. We have a Quadrant F
 situation at Jan Michael Vincent.

 QUADRANT F MAN
 Oh shit.

 ANNOUNCER
 Jan Michael Vincents are used up.

 QUADRANT F MAN
 I need a goddamn Jan Michael
 Vincent.

 MAN OR ANNOUNCER (YOU PICK)
 There's only eight Jan Michael
 Vincents. We need sixteen.

(handwritten notes): SWAT POSSIBLY · EYE PATCH? OR DRESSED FROM A MOVIE ROLE

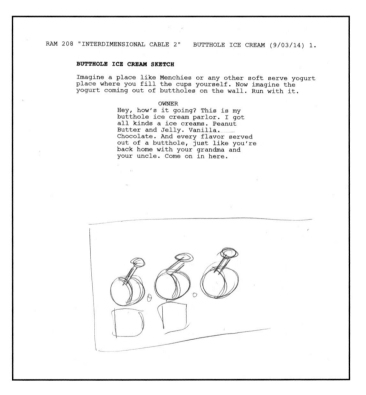

BUTTHOLE ICE CREAM SKETCH

Imagine a place like Menchies or any other soft serve yogurt place where you fill the cups yourself. Now imagine the yogurt coming out of buttholes on the wall. Run with it.

 OWNER
 Hey, how's it going? This is my
 butthole ice cream parlor. I got
 all kinds a ice creams. Peanut
 Butter and Jelly. Vanilla.
 Chocolate. And every flavor served
 out of a butthole, just like you're
 back home with your grandma and
 your uncle. Come on in here.

Check out the art director's notes and doodles from the launch meeting of "Interdimensional Cable 2" (*pages 156–157*). In case you're wondering, "launch meetings" are where Justin, Dan, and/or the writers literally launch the script out to the people in production—many of whom haven't read it yet. This kick-starts designs for locations, characters, storyboards—literally everything—and that's why you see so many questions and notes here. Also worth noting: in the top right, that's a script for a sketch called "Michael Sack" which didn't make the cut. "Alright! Stretch your sack to the left!"

Sketches

Concept sketches are where our artists first try to capture and develop their take on whatever crazy shit they just read in the script. There's tons of awesome concepts for characters from the first two seasons here. Top left, that's an early, early drawing of Zeep Xanflorp (*page 103*) done by James McDermott, and that little dude next to him is his first take on Kyle (*page 104*). Once we had broken the Citadel of Ricks episode (and the multiverse concept in general), Steven Chunn started drawing these versions of Rick and Morty from other shows—printing them out, putting them up all over the office. The original idea was to hide them throughout the Citadel (in "Close Rick-counters of the Rick Kind"), but we eventually decided, nah, bro.

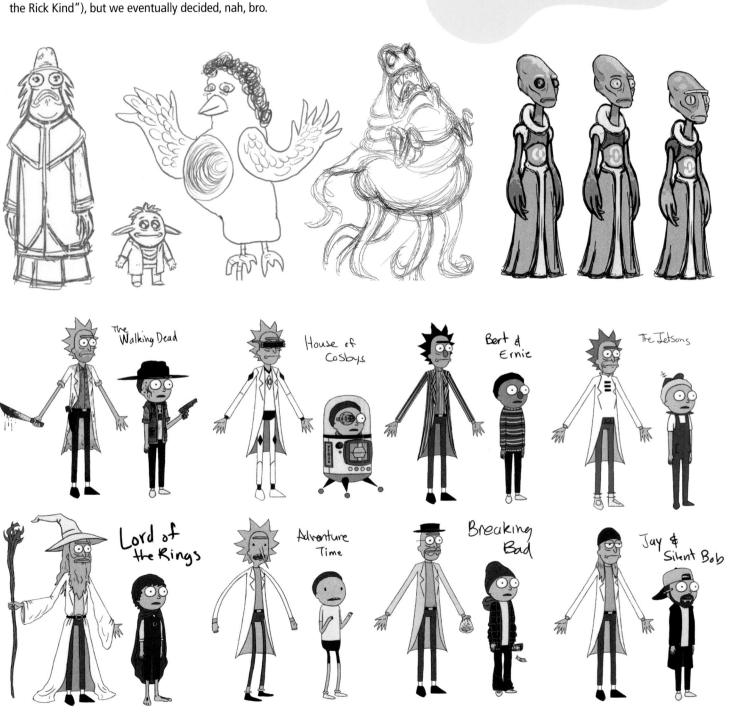

The Walking Dead

House of Cosbys

Bert & Ernie

The Jetsons

Lord of the Rings

Adventure Time

Breaking Bad

Jay & Silent Bob

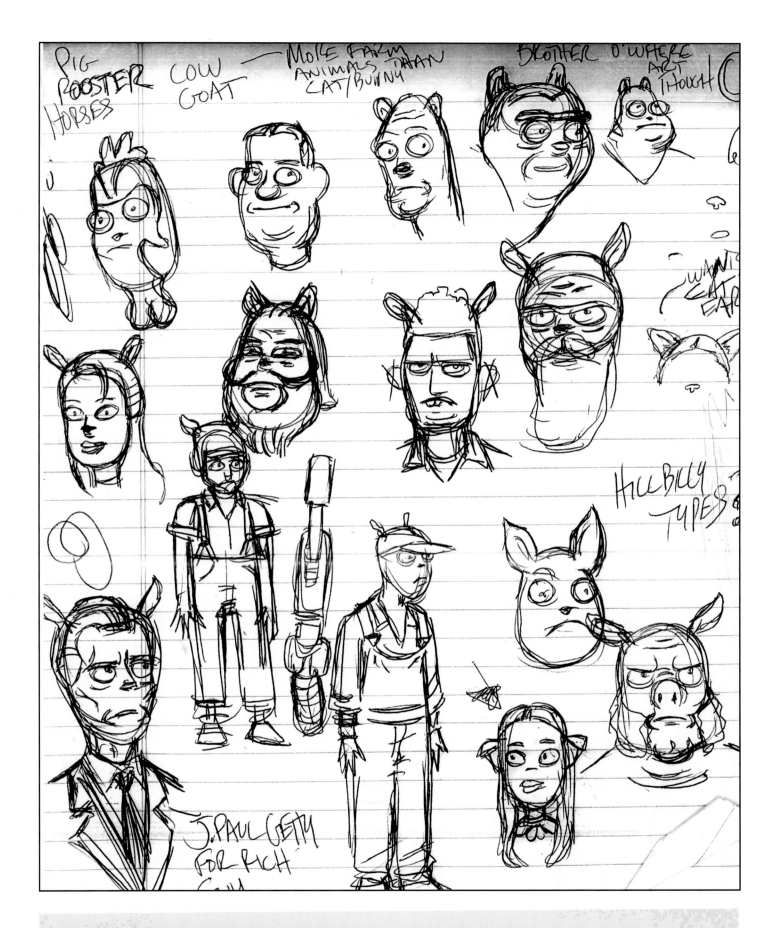

These were the first drawings the art director did for the cat people in "Look Who's Purging Now." You can see he was still trying to figure out that perfect ratio of cat to alien to human. Gotta get that weirdness ratio *jussst* right.

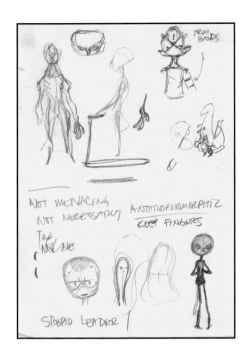

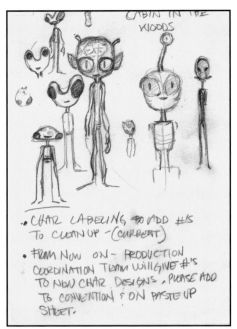

NOT MENACING
NOT NECESSARILY
ANTHROPOMORPHIZE
KEEP FINGERS

STOOPID LEADER

CABIN IN THE WOODS

• CHAR LABELING TO ADD #'S
 TO CLEAN UP - (CURRENT)
• FROM NOW ON - PRODUCTION
 COORDINATION TEAM WILL GIVE #'S
 TO NEW CHAR. DESIGNS, PLEASE ADD
 TO CONVENTION & ON PASTE-UP
 SHEET.

PEACOCK.
USE FLOWERS FOR
REF. FOR ALIENS.

Those three yellow sheets up top are filled with drawings by Carlos Ortega (lead character designer), trying to figure out the mantis-to-Cronenberg transformation in "Rick Potion #9." The red line drawings in the middle are a couple more takes on Kyle from the Microverse episode. As mentioned earlier (*page 104*), he was tough to figure out.

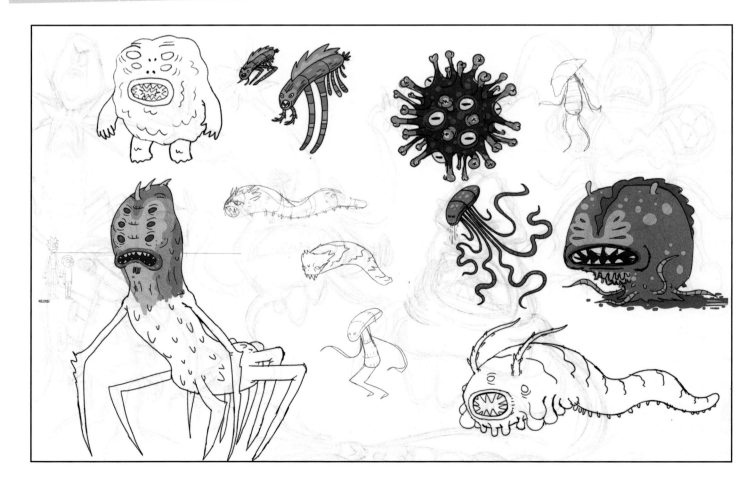

"Shmlantha! Shmlona! Shmluh- Sh-Shmlangela? Shmlonathan?" A bunch more early concepts and alien doodles here. There's a preliminary color take on Glaxo Slimslom from "Big Trouble in Little Sanchez" (*bottom right*). To the left of that is another super-early version of Zeep from the Microverse episode—you can see this one looks more Zeep-ish than the drawing shown on page 212. But of course, the big highlight here is the slightly off-model version of Tony (*top right*) from interdimensional cable's *Shmloo's the Shmloss?*

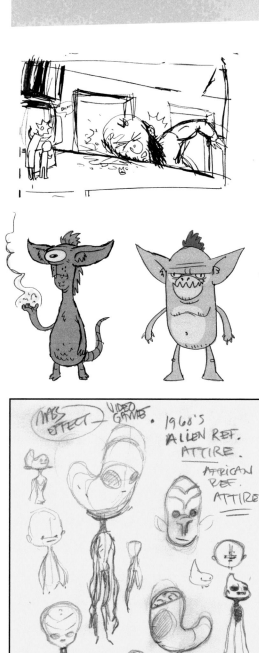

Storyboards

"Boards," bro—that's what they're called in the biz. Once the script is launched to production, the entire thing gets boarded by our insanely talented in-house team. First, the artists make thumbnail sketches ("thumbs"), which then get laid over the audio to give a rough representation of staging and action. After a round of notes, the thumbs get cleaned up into storyboards—like what you see below for "Ricksy Business." These house party boards were exceptionally clean—they were so, so good. And finally, once these are locked down, they get shipped off to Bardel to be animated.

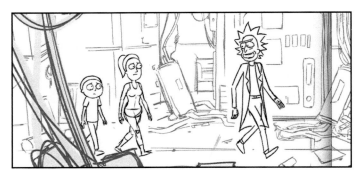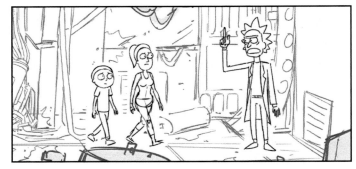

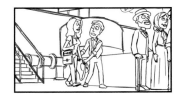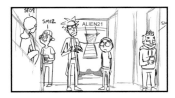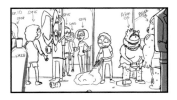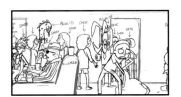

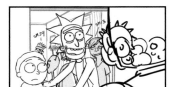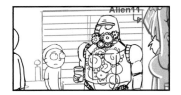

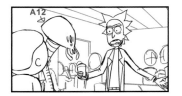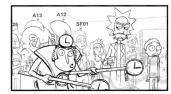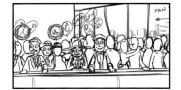

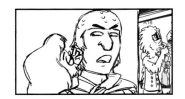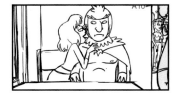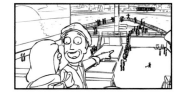

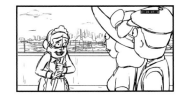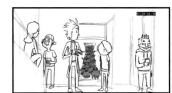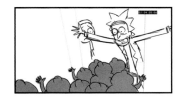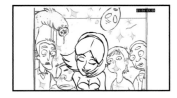

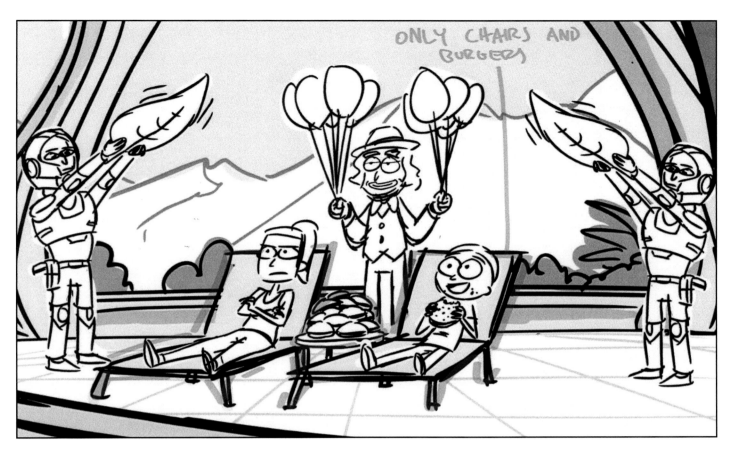

ONLY CHAIRS AND (BURGERS)

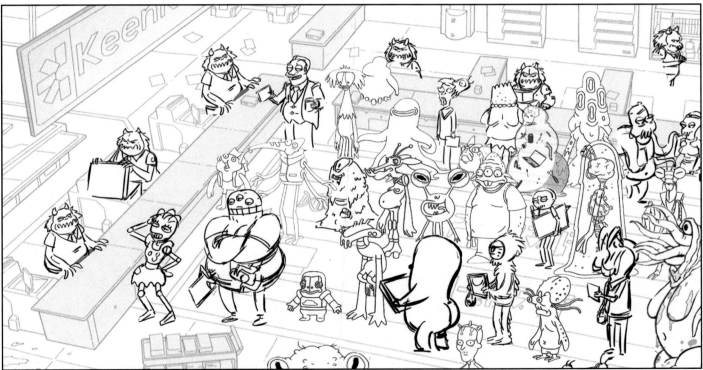

"Oh my god, Morty, what did you do?! You killed the Simpsons, Morty!" This was a board panel (*on the bottom*) from the couch gag crossover we did for *The Simpsons'* season finale, "Mathlete's Feat." Morty went to this Kinko's-like location to make cloned copies of the Simpsons—if you look close, you can actually see him in line there. Oh, and above that? That's a hamburger-filled board from "Auto Erotic Assimilation," where the kids are waiting while Rick has sex with a stadium full of redheads.

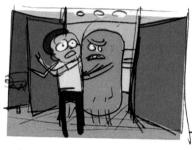

Normally, boards are done in black and white, with notes or camera direction in red. But this is a rarity—Steven Chunn did these unstructured color storyboards as sort of a "scene concept" for the infamous bathroom showdown between Morty and Mr. Jelly Bean (*page 115*, "Meeseeks and Destroy"). Definitely a deep cut—some of our producers hadn't even seen this art before.

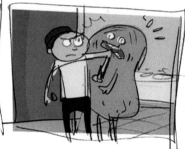
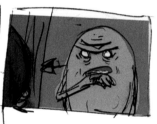

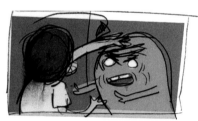
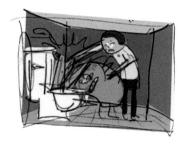

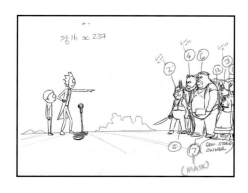

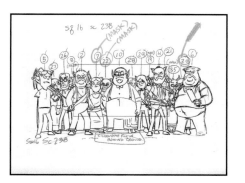

"Morty . . . time to (BURP) purge."
Anytime you see numbered storyboards like these, it means they're final and well beyond the rough stages. These shots from "Look Who's Purging Now" required all these different builds and characters and masks. So all those circled numbers you see are production calling out assets and design elements. Each character gets assigned a number, so Bardel clearly knows who's who and which character to animate.

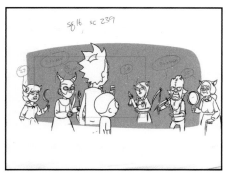

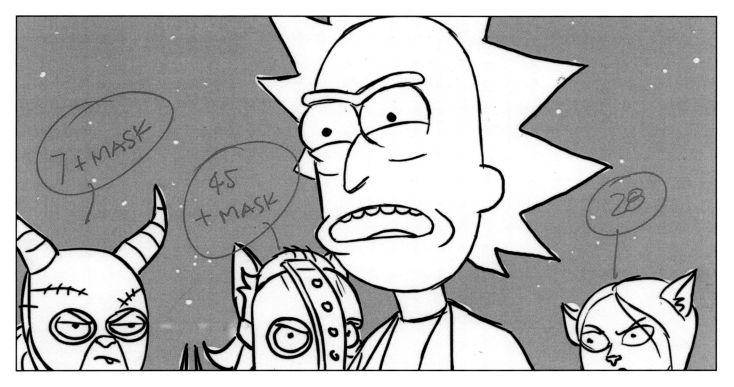

In the Writers' Room

Oooooooooooh snap, son! We're pulling back the curtains, showing you where that script-writing magic happens!! *From left to right*: that's the reception area of our new office, writers Ryan Ridley and Dan Guterman in the room, and one of Justin's dogs, Pup Pup. (FYI, Pup Pup's got the pink nose; Jerry's got the brown nose). Below that is some super hard work going on in Justin's office with writers Matt Roller and Ryan Ridley—and just a small taste of Justin's toy collection.

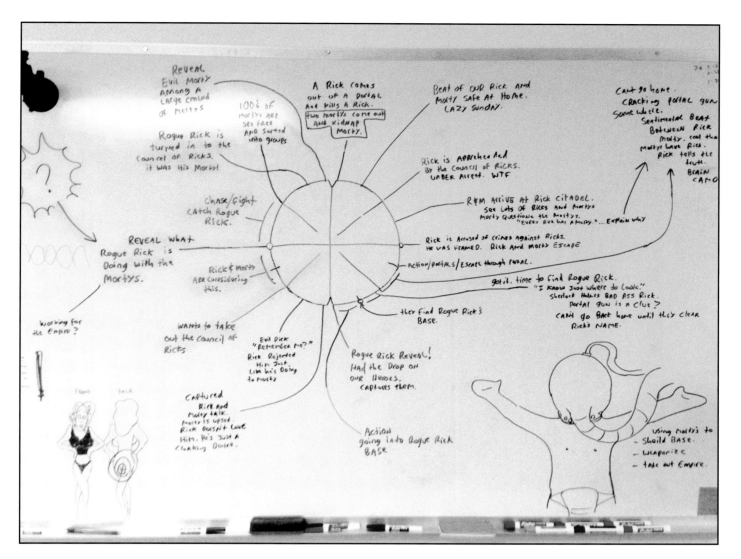

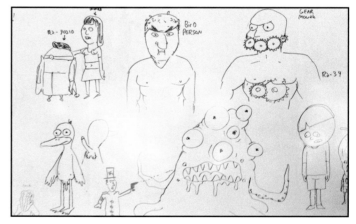

Ahhh, whiteboards. So much of the writers' creative process gets poured onto these erasable slabs of gold: character doodles, testicle monsters, insane pitches, and tonnnns of story circles. In case you're like, huh? Story circles? Those are what Harmon and the writers use as a structural map for stories—based on the idea that all stories follow a similar pattern. This pic up top is a crazy behind-the-scenes look at the story circle for "Close Rick-counters of the Rick Kind." Some details changed, but the final version of that episode was structurally very similar to what's here. Also pretty badass: Justin's original drawings for the stair goblins in "Meeseeks and Destroy" (*bottom left*), and the first-ever doodles of Gearhead and Birdperson (*bottom right*), done while brainstorming the "Ricksy Business" partygoers.

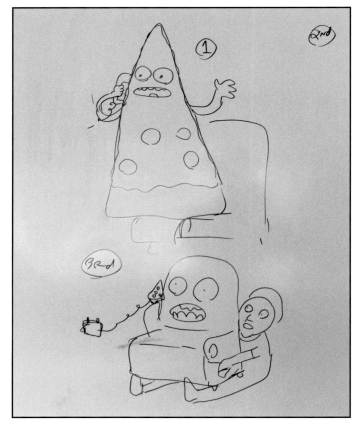

This note card picture is a cool glimpse into the production of season 1. The left strip shows "production order"—meaning, that's the order we wrote and put the episodes into the pipeline. The note cards next to that show "air order"—how we decided to arrange them for broadcast. Kinda nuts. On the bottom here, we got the season 2 writers wearing their "Guterman" shirts (featuring an image of writer Dan Guterman). Guterman's not actually in the picture, but he is on their shirts. So . . . I guess he kinda *is* in the picture? Anyway, that's the book! Wubbalubbadubdub! Rikki-Tikki-Tavi, biyotch!!

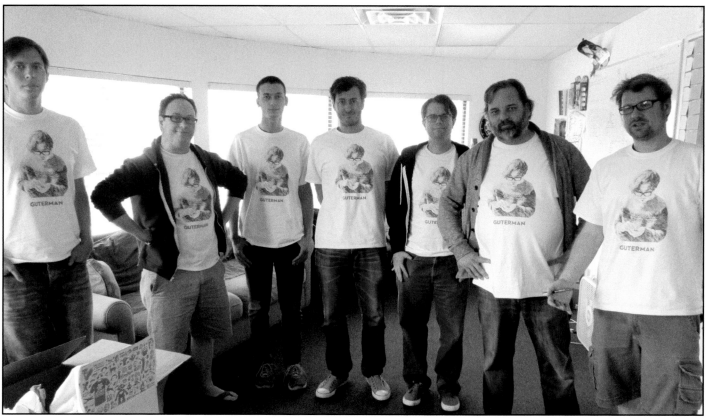

Created by
Justin Roiland & Dan Harmon

Art Direction
James McDermott

Directors
Pete Michels
Wes Archer
Juan Meza-León
Jeff Myers
Bryan Newton
Dominic Polcino
John Rice
Stephen Sandoval

Designers
Myke Chilian
Carlos Ortega
Andrew DeLange
Steven Chunn
Chris Bolden
Ivan Aguirre
Zach Bellissimo
Vance Caines
Ralph Delgado
Bradley Gake
Gerard T. Galang
Jenny Goldberg
Alex J. Lee
Jeff Mertz
Brent Noll
Roger Oda
Maximus Julius Pauson
Stephanie Ramirez
Eunji Lee Roess
Jon Vermilyea
Millet Henson
Sabrina Mati

Color Keys/ BG Painters
Jason Boesch
Carol Wyatt
Kyle Capps
Jack Cusumano
Kali Fontecchio
Juan Garrido
Yaoyao Ma Van As
Christopher Near
Elisa Phillips
Chu-Hui Song
Hedy Yudaw

Storyboard Artists
Scott Alberts
Martin Archer
Rufino Roy Camacho II
Villamor Cruz
John Fountain
Bryan L. Francis
Erica Hayes
Scott Hill
Tim Hopkins
Mark Maxey
Eric McConnell
Dan O'Connor
Fred Reyes
Ted Stearn
Matthew Taylor
J. C. Wegman
Mike Wetterhahn

Special Thanks
Mike Lazzo
Keith Crofford
Ollie Green
J. Michael Mendel
Delna Bhesania
Barry Ward
Florian Wagner
Nathan Litz
Mark Van Ee
Ryan Ridley
Dan Guterman
Mike McMahan
Sydney Ryan
Michelle Pniewski
Mark Estrada
Caroline Foley
David Marshall
Dave Scarpitti
Mike Wodkowski
Andy Riggin
David Weiser
Tamara Henderson
Abbie Maley
James Fino
Joe Russo
Chris Parnell
Spencer Grammer
Sarah Chalke
Janet No
Brandon Lively
Elyse Salazar

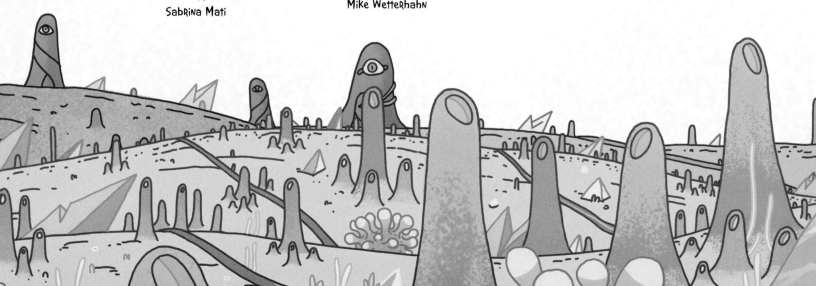